D1593141

Beyond Reproduction

Beyond Reproduction

Women's Health, Activism,
and Public Policy

Karen L. Baird

with Dana-Ain Davis and Kimberly Christensen

Madison • Teaneck
Fairleigh Dickinson University Press

© 2009 by Karen L. Baird

Associated University Presses
2010 Eastpark Boulevard
Cranbury, NJ 08512

Portions of chapter 2 previously appeared in "The New FDA and NIH Medical Research Policies: Targeting Gender, Promoting Justice," in *Journal of Health Politics, Policy and Law*, Vol. 24, Issue 3. pps. 531–65. Copyright 1999 Duke University Press, all rights reserved. Used with permission from the publisher.

The paper used in this publication meets the requirements of the American National Standard for Permanence of Paper for Printed Library Materials Z39.48-1984.

Library of Congress Cataloging-in-Publication Data

Baird, Karen L., 1961–
 Beyond reproduction : women's health, activism, and public policy / Karen L. Baird ; with Dana-Ain Davis and Kimberly Christensen.
 p. ; cm.
 Includes bibliographical references and index.
 ISBN 978-0-8386-4184-2 (alk. paper)
 1. Women—Health and hygiene—United States. 2. Health policy—United States. 3. Feminism—United States. I. Davis, Dána-Ain, 1958– II. Christensen, Kimberly. III. Title. [DNLM: 1. Women's Health—history—United States. 2. Women's Health—legislation & jurisprudence—United States. 3. Feminism—history—United States. 4. Health Policy—history—United States. 5. History, 20th Century—United States. WA 11 AA1 B163b 2009]
 RA564.85.B348 2009
 613'.04244—dc22
 2008046005

Contents

Beyond Reproduction

1

Introduction — Beyond Reproduction: The Women's Health Movement of the 1990s

Karel L. Baird

WOMEN'S HEALTH CARE RECEIVED WIDESPREAD ATTENTION THROUGH-out the decade of the 1990s, and women's health care activists achieved unprecedented success. Carol Weisman (1998) calls this time period "an extraordinary episode of women's health policymaking that seemed to demonstrate new possibilities for women" (1). Some of these achievements include:

- Passage of the 1993 National Institutes of Health (NIH) Revitalization Act that mandates the inclusion of women and minorities in research funded or performed by the NIH;
- Change in the Center for Disease Control's (CDC) definition of AIDS-related symptoms to include conditions more appropriate for women, as well as an increase in NIH funds for research devoted to AIDS-related issues in women;
- Increase in National Cancer Institute (NCI) and Department of Defense (DOD) funds for breast cancer research from $81 million in 1990 to $614 million by 2000; and
- Increased public attention to and medical awareness of domestic violence as a health care issue, passage of the Violence Against Women Act (VAWA), and increased government funding for research on and preven-tion of domestic violence.

Moreover, after it was discovered that most insurance plans provided coverage for the impotence pill Viagra but did not cover oral contracep-tives for women, many state legislatures enacted laws requiring plans to do so. Congress also passed a requirement that any federal insurance plans offering prescription drug coverage must also cover prescription contraceptives. And finally, RU-486 was approved after a decade-long political struggle.

9

Many of these achievements were won because of the hard work of many activists, women in Congress and other government institutions, and physicians and other health care workers who labored tirelessly to improve health care for women. This modern crusade started in the late 1980s, came to fruition in the early 1990s, and follows on the footsteps of an earlier women's health movement of the late 1960s and '70s, though the two movements differ quite remarkably. And this did not occur by accident; many women's health activists consciously chose to differentiate themselves from the earlier movement because it was no longer serving the newly expanded concept of women's health, and different strategies and tactics were required because the political and social context had significantly changed.

In this introductory chapter, a brief overview of the women's health movement of the 1960s and '70s will be provided. Next, an overview of the movement of the 1990s—its composition, strategies and tactics, and reframing of women's health—and the newly formed context in which it operated will follow. This discussion will be embedded in the social movement, public policy, and women and politics literatures as they all contribute to an analysis of the women's health movement. This research on women's health policies and women's health activism falls in what could be construed as a chasm where convergence of these literatures rarely meets.[1] Last, an overview and introduction to the subsequent chapters on various women's health issues of the 1990s will be provided. The driving force of *Beyond Reproduction* is to analyze the composition, approach, strategies, and context of the women's health movement of the 1990s, specifying the many factors that led to its unprecedented success. Not often do we witness such a broad scope and magnitude of policy change; research on this movement can enhance our understanding of the women's, women's health, and other social movements and how, when, and why activists are able to produce significant political change.

THE WOMEN'S HEALTH MOVEMENT OF THE 1960S AND '70S: REPRODUCTIVE HEALTH

The earlier women's health movement[2] occurred in the United States in the late 1960s and '70s and was part of the feminist movement of that time.[3] The movement of this era involved fighting for women's reproductive rights and included gaining control over sexual reproduction

and women's bodies. It was thought that women's ability to achieve equal rights in education, politics, and employment hinged on their ability to control their reproduction, and thus the *health* part of the women's movement was an integral component of this strategy. Contraception, obstetrical and gynecological care, as well as abortion rights, became the focus of the movement and in time women's health became synonymous with reproductive health.

During this time period, the women's health movement worked for a woman-centered or feminist-based medical approach to women's health—as one book's title demonstrates, *The Women's Health Movement: Feminist Alternatives to Medical Control* (Ruzek 1978). The medical establishment was thought of as patriarchal, authoritarian, racist, and demeaning to women in that women's concerns were not taken as serious concerns. Women started clinics specifically run by and for women so that women's needs could be addressed in an effective, supportive environment. Though a few of these clinics offered primary care, most provided contraceptive and gynecological services (Ruzek 1978).

Women wanted more control over their bodies and health care, and the opening of women's clinics was one way to achieve this. Another strategy was to educate women by providing them with information so that medical care would be demystified (Weisman 1998, 73). Conferences, publications, and consciousness-raising groups flourished and women learned about their bodies, the health care system, and how to perform basic medical procedures. The best known work emerging from this time period was the Boston Women's Health Collective's *Our Bodies, Ourselves*. The goal of education was to empower women to take care of themselves and to be able to critically assess the health care system in general and medical procedures, such as mastectomies, specifically. Also during this time, new forms of birthing centers were developed that emphasized natural and/or home births, as well as midwife-assisted deliveries; these birthing methods and locations were developed, or rediscovered, as a reaction to the medicalization of childbirth that had taken place in the twentieth century. Some women, particularly poor and/or women of color, were also fighting against forced sterilization.

Women also fought for the right to have a legal abortion. Many women obtained illegal ones, with numerous health consequences, or were forced to bear unwanted children. With the right to contraception established by the Supreme Court, activists turned their attention toward abortion. In 1967, the newly formed National Organization for

Women (NOW) began their drive to legalize abortion and in 1973, the Supreme Court granted this right in the case of *Roe v. Wade.*

Thus, the movement of the 1960s and '70s focused primarily on re-productive health issues—the legal right to reproductive control, and the right to health information and health care in nonpatriarchal, woman-centered settings. The various strands of the movement shared a concern of women controlling their reproductive health so they could be situated to fully enjoy other rights (education, equal pay, equal op-portunity, etc.) for which they were also fighting.

THE WOMEN'S HEALTH MOVEMENT OF THE 1990S: *BEYOND REPRODUCTION*

Since that time, a new women's health movement has evolved that, although still concerned with reproductive issues, has expanded and taken a new focus and approach. This movement started in the late 1980s, came to fruition in the 1990s, and differs significantly from the previous time period.

Social Movements, Women's Movements, and the Women's Health Movement

Can the women's health advocacy efforts of the 1990s be called a so-cial movement, or more particularly, a women's movement? Social movements can be defined as "collective challenges based on common purposes, in sustained interaction with elites, opponents and authori-ties" (Tarrow 1998, 4). They involve collections of actors, "[a]cting on some element of shared goals, and competing for prominence in defin-ing claims and tactics," that may forge coalitions and networks, even if they do not always act in concert (Meyer 2005, 8). David Meyer (2005) reminds us that we often speak of "the" or "a" movement but social movements are not unitary actors. Furthermore, "cooperation and dif-ferentiation among groups within a movement coalition change over time" (Meyer 2005, 9). Women's movements can be defined as social movements when "women are the major actors and leaders, who make gendered identity claims as the basis for the movement, and who orga-nize explicitly as women" (Beckwith 2007, 314). With such definitions, women's health activism of the 1990s certainly fits the criteria of being a social movement and a women's movement, focusing specifically on health issues. Additionally, women's health activism of the 1990s has

previously been labeled a women's health movement by other analysts (Norsigian 1996; Ruzek and Becker 1999; Weisman 1998), and as Ferree and Hess (1994) point out, the women's movement of the 1980s and early '90s looked more like many specific movements—the battered women's movement, the reproductive rights movement, the pay equity movement, etc. (160). The women's health movement is just another dimension of this facet.

But the disparate and disconnected components of the movement could cause one to question such a labeling. Women fighting to end violence against women and have VAWA passed rarely overlapped with activists struggling to obtain more breast cancer research funds. Ulrike Boehmer (2000), in her research on AIDS and breast cancer activists, notes how the two are disconnected groups: women who participated in AIDS activism in the 1980s did not then turn their efforts toward breast cancer in the 1990s. The various health concerns and organizations have their own constituencies. What justifies drawing a theoretical connection between, in the real world of politics, primarily independent groups? First, previous women's health movements also contained disconnected groups and have, nevertheless, been considered a women's health movement (e.g., Weisman 1998). Second, the many women's health advocacy groups were working, not on the same *specific* goal, but on the *related* goal of improving women's health. They may not act in concert with one another—in fact, groups may even compete for agenda status, government funds, or the attention of women—but they can still be considered a movement. Third, an approach that views the contemporary women's health movement as different from the earlier one(s), an approach that recognizes that movements undergo substantial growth, decline, and change, is a more reasonable and theoretically valid one. When a movement undergoes modification and does not resemble its earlier rendition, this should lead us to examine how, why, and in what manner it changed. Therefore, the approach in *Beyond Reproduction* is that the women's health movement of the 1990s is a movement that has undergone drastic modification from earlier times. These alterations—changes in tactics and strategies, different actors and organizations, and even a different notion of women's health—are the primary concerns of this book.

A distinguishing feature of the 1990s movement, as compared to the earlier movement, is its independent status as a movement. It is *not* connected to or part of a wider feminist or women's rights movement. In fact, as the women's health movement grew and achieved success, the

feminist movement declined in the United States. This is quite interesting in that many arguments for women's health were embedded in a framework of women's rights and equality. One does not need to be a feminist in order to support women's health, and given the antifeminist temperament of the United States in the 1990s, this severance contributed to the success of the women's health movement.

Women's movements can be viewed, not in terms of their organizations and activities, but as a discursive practice—as a "street theory" that arises out of women's experiences that then becomes a perspective that women claim as part of their identity (Mainsbridge 1995). This pushes one to consider the discursive and meaning-making aspects of movements, in addition to their organizations and activities, as they all influence and reinforce each other.

Discursive Politics vs. Interest Group Politics

In *Faithful and Fearless*, Katzenstein (1998) finds that feminists in the military assert claims for equal rights and equal opportunities, as they simply want to have existing laws applied to women in the military. These women are traditional liberal feminists, practicing interest group politics or influence-seeking feminism. They do not attempt to transform the institution of the military; they just want women to be treated fairly within the existing structure.

Feminists within the Catholic Church are more radical in that they seek to transform the culture and institution of the Catholic Church. Their tactics are much more confrontational. They want radical equality and engage in discursive politics, the politics of meaning making (Katzenstein 1998, 17), or stated another way, the politics of reflection and reformulation (107). Since the Church is a private institution, the women cannot resort to equal opportunity laws or equality of rights in the courts. The context requires different strategies. Discursive politics is about rethinking and rewriting the norms that govern institutions and thus relies heavily on language, whereas interest group politics relies on legal rights and the courts. Discursive politics aims to transform the terms of the debate, deploys new "language and symbols to convince others of new possibilities" (Katzenstein 1998, 18), and operates on the premise that conceptual change happens first (17). Feminists in the Catholic Church practice discursive politics, and their particular form is discursive radicalism. Of course no group engages in only one form

or the other; the strategies exist on a continuum and many factors shape why activists choose to engage predominantly in one form or the other.

In *Beyond Reproduction*, discursive practices of the women's health movement and how and in what manner activists engaged in the politics of meaning making will be analyzed. Even though "discursive politics is a strategic component of all women's movement activism vis-à-vis the State" (Beckwith 2007, 327), to what extent do they practice interest groups politics vs. discursive politics? Did activists seeking changes in medical research policies just want to have women included in medical research—an equality position—or did they also seek to transform the very structure of medical research itself? Did breast cancer activists seek to transform the meaning of breast cancer, and if so, in what manner? These types of questions will be analyzed herein.

Insiders vs. Outsiders—"Institutional Protest"

The 1990s women's health movement has taken a new approach to gaining effective health care for women. As one book's title—*Women's Health Care: Activist Traditions and Institutional Change* (Weisman 1998)—demonstrates instead of rejecting the medical establishment, many women tried to work with it, and within it, and alter it. This new strategy has been pursued for many reasons, one being that women have gained more political power. By the late 1980s, many women, bearing the fruits of the earlier women's movement's achievements, had attained high-level positions in government agencies such as the NIH, Congress, medicine, and the business world. Many women had become doctors and achieved other professional degrees. And in 1992 there was a significant spike in the number of women elected to Congress, tagging it the "Year of the Woman." The number of women in the House of Representatives increased from twenty-eight to forty-seven, and the number in the Senate rose from two to six (Dodson et al. 1995, 2). These women were in strategic, influential positions and could now work from within the powerful political institutions to effect change.

Following the 1992 election, women in Congress exerted considerable influence and played significant roles in the passage of much of the legislation discussed in *Beyond Reproduction*. Female legislators have been found to be more supportive of feminist concerns and give a higher priority to women's issues and interests, broadly defined (Carroll 2000; Dodson et al. 1995; Hawkesworth et al. 2001). But getting women into Congress is only the first step; once there, they have to forge coalitions

with their male colleagues, wield influence to have their voices heard, and exert power to have their legislation passed. Much of this work goes on behind the scenes. For example, with regard to medical research and breast cancer legislation in the 103rd Congress, "positional power on Appropriations Committees enabled Congresswomen Nancy Pelosi (D-CA), Nita Lowey (D-NY) and Rosa DeLauro (D-CT) in the House and Senators Barbara Mikulski (D-MD), Patty Murray (D-WA) and Dianne Feinstein (D-CA) to work in committee and subcommittee to protect funding for women's health research" (Hawkesworth et al. 2001, 26). Debra Dodson et al. (1995) note that the "addition of Congresswoman Nancy Pelosi (D-CA), Nita Lowey (D-NY) and Rosa DeLauro (D-CT) to the House Labor, Health and Human Services Subcommittee of the Appropriations Committee resulted in the appropriation of more than $600 million for breast cancer research programs" (4). With regard to violence against women and the passage of VAWA:

> Congresswomen Pat Schroeder (D-CO), Louise Slaughter (D-NY), and Connie Morella (R-MD), along with Congressman Charles Schumer (D-NY), served as VAWA's chief sponsors in the House. As a member of the House Judiciary Committee, Schroeder played a crucial role as watch guard for the legislation, alerting other women members of the need to mobilize to pressure House Judiciary Committee chair, Congressman Jack Brooks (D-TX), who was not enthusiastic about VAWA, to move the proposed bill out of committee. Women also intervened successfully to persuade members of the conference committee to preserve key provisions of VAWA included in the Senate version of the bill that had been omitted from the House version. (Hawkesworth et al. 2001, 18–19)

These are just a few examples of the importance of the presence and influence of women in Congress and other high-level positions.

Women legislators can also wield power by preventing or stopping certain actions. For example, when Republicans gained control of Congress in 1994, female members of Congress had to fight vigorously just to protect and prevent the erosion of the many successes they had achieved in the previous two years (Hawkesworth et al. 2001). Additionally, it was not only women who supported women's health legislation. Rep. Henry Waxman (D-CA) was chairman of the Commerce Committee's Subcommittee on Health and the Environment and was instrumental in pursuing the problem of women in medical research. In the 104th Congress, the new Labor, Health, and Human Services subcommittee chair, Rep. John Porter's (R-IL) support was crucial in

maintaining funding (Hawkesworth et al. 2001, 27). With regard to breast cancer, many men in Congress were extremely supportive and had personal family experience with the disease, such as Sen. Tom Harkin (D-IA). Sen. Joseph Biden (D-DE), chair of the Senate Judiciary Committee, sponsored the original VAWA legislation and made the strategic decision to include VAWA in the Omnibus Crime Bill (Dodson et al. 1995; Hawkesworth et al. 2001). Therefore, the presence of powerful women in high ranking government positions and supportive male colleagues are important factors in the passage of women's health legislation.

"Institutional protest" as coined by Katzenstein (1998), is a new and additional strategy used in the contemporary women's movement, as well as other social movements (See Santoro and McGuire 1997). "Institutional activists" are "social movement participants who occupy formal statuses within the government and who pursue social movement goals through conventional bureaucratic channels" (Santoro and McGuire 1997, 503). In Katzenstein's (1998) research on the Catholic Church and the military, she demonstrates how women used their newfound positions in these traditionally male bastions to bring claims of gender inequity in the military and to challenge norms in the Catholic Church. In other research on comparable worth policies, institutional activists in the women's movement were found to be important, but with regard to affirmative action policies, noninstitutional actors such as civil rights organizations were found to be more important, showing that the significance of actors varies across policy issues (Santoro and McGuire 1997). Santoro and McGuire (1997) conclude that institutional actors play a more dominant role when they have substantial access to the institution. Accordingly, one would expect to find that as women increase their presence in government and other institutions, insider strategies or institutional protest will be utilized more often.

Lee Ann Banaszak (2005) highlights the issue of activists and organizations that straddle the traditionally drawn boundaries between state and social movements, labeling this overlooked area "state-movement intersection" (also see Banaszak, Beckwith, and Rucht 2003). Such actors are self-identified members of a social movement but also hold official positions within government. Highlighting the role of context for such actors, she states that the "size, location, and historical context of this state-movement intersection influence the larger movement's development, strategies, and outcomes" (Banaszak 2005, 151). Feminist activists within the state have a wide array of nonprotest tactics avail-

able to them and tend to engage in street protest only when insider tactics are ineffective (Banaszak 2005, 167). With regard to the present study on women's health, one would expect to find institutional protest utilized more often if institutions provide access points for the insiders and if they are successful.

In a study of the passage of family and medical leave policies of the early 1990s, Bernstein (2001) finds that in order to be successful, activists expressed their demands in culturally acceptable terms and compromised, and insiders are more likely to compromise than outsiders. Institutional protest and its many facets, in addition to the more common protest and pressures from outside government, are important dynamics in the women's health movement and will be explored herein.

Insiders vs. Outsiders — Women's Health Advocacy Organizations

Women's health activists and organizations have been instrumental in the movement of the 1990s and both greatly differ from the activists and organizations of the 1960s and '70s. In the 1990s, women's health advocacy organizations typically focused on one health issue or concern. For example, existing organizations include the National Breast Cancer Coalition (NBCC), the Society for Women's Health Research, Ovarian Cancer National Alliance, and the National Osteoporosis Foundation. Few general women's health organizations exist, and the few that do (for example, National Women's Health Network and Boston Women's Health Collective) have endured from the 1960s and '70s era, and they struggle to survive in the new context. Sheryl Ruzek and Julie Becker (1999) state, "Thus, grass-roots groups [of the 1960s] contracted internally as they were diluted externally by the growing prominence of both mainstream women's support groups (on a wide array of health issues ranging from alcohol problems to breast cancer) and disease-focused health advocacy groups whose efforts supported the growing federal initiatives for greater equity in women's health research" (6).

The new disease- or issue-specific groups do not commonly view themselves as part of a larger social movement (Ruzek and Becker 1999) and thus can pursue their sole cause, even if at the expense of other women's health concerns, and even if at the expense of more pressing women's health needs. Such organizations are typically led by women with professional, medical, biomedical, or jurisprudence degrees, hence the labeling of professionalized groups (Ruzek and Becker

1999). This can also help explain the desire to work with mainstream institutions as many of the leaders are already part of or come from mainstream institutions.

These new women's health groups are a consequence of the political and social context of the United States and changes in the women's movement (discussed later in this chapter), and they develop and implement the new strategies of the movement. Their work, along with the insider protest activities, as the lines between the two are quite blurry, are important contributing factors in the success of the women's health movement of the 1990s.

Expanded, Politicized Notion of Women's Health

Women's health is no longer synonymous with reproductive health. With the demographic shift of the baby boom generation entering their forties and fifties in the 1990s, many women became more concerned with menopause, breast and other cancers, heart disease, osteoporosis, and a host of other conditions associated with growing older and being female. Though reproductive rights were still being contested and defended, the scope of women's health expanded considerably. In the 1990s, breast cancer, AIDS, medical research, and violence against women became some of the many concerns for which activists fought to have government address.

As the emphasis shifted away from reproductive issues and abortion, many of the new women's health matters became politically safe issues. The politically powerful, conservative groups that are concerned about abortion, women's sexual activity, promiscuous behavior, and the possible destruction of the family, are silenced (Haseltine and Jacobson 1997). Older women's health issues are safe issues and thus can easily be pursued, and after years of enduring divisive abortion politics, many legislators were happy to be able to support women's health, in its new formulation (Stolberg 1997). This is certainly one important factor that spurred the success of the activists.

Additionally, women's health issues have been characterized in a new light: women's health issues have become social and political issues.[4] Once only part of the medical domain and thus out of the reach of influence of most individuals, women's health issues were shifted to the political domain where activists can assert claims and pursue grievances. This practice of "politicizing a disease" was first and perhaps best demonstrated by AIDS activists,[5] with breast cancer activists and

others adopting similar tactics after witnessing their success. "[T]his is indeed the first social movement to accomplish the large-scale conversion of 'disease' victims into activists-experts. In this sense, the AIDS movement stands alone, even as it begins to serve as a model for others" (Epstein 1996, 6). In fact, AIDS activism and its "politicization of science" (Epstein 1996, 6) forever changed the landscape so that subsequent single-disease or issue advocacy found a much more hospitable political terrain. When breast cancer activists argued that the disease "disrupts social relationships, jobs, and families" (Myhre 1999, 30), that we know of no cause or cure, and looked to Congress and the NIH to solve the problem, it was not the first time government officials heard such claims. When arguments were presented that violence against women was not natural, was not a private, nonpolitical concern, but was a crime like any other violent crime, government officials had been primed to take heed.

Overall, activists splintered women's health into specific, specialized issues. This was initially in response to the success that the AIDS disease-specific activism enjoyed. But as Ruzek and Becker (1999) note, "To maximize the likelihood of obtaining federal funding for research on women's health, scientists and their consumer allies focused on specific diseases. This narrowing of focus was crucial for navigating federal funding streams that are tied to specific disease and organ systems" (6). This bifurcation is another contribution to the success of the women's health movement of the 1990s and is a facet of the context of the state-movement intersection.

Evidence of Exclusion, Arguments for Inclusion

As stated previously, the women's health movement formulated a new approach to gaining effective health care for women; women now work with and within the medical establishment, attempting to alter it. Another reason women pursued this strategy was that they saw the ramifications of rejecting traditional medicine. For example, clinical research traditionally excluded or underrepresented women as research subjects (Baird, chapter 2 herein). This ostensibly grew out of a concern for fetal damage, as the thalidomide and DES tragedies of the 1960s and '70s demonstrated. Of course, exclusion was not the solution, but the norm in clinical research became one of "protecting" women and their fetuses from the possible harms of medical research. In the late 1980s, women began pushing for inclusion in clinical research after

discoveries were made about how research done on and findings from males may not be responsive to women's health care needs. Also, women's concerns, outside of reproductive concerns, did not receive as much attention and funding: in 1987, NIH spent 13.5 percent of its funds on women's health issues.[6] Thus when menopausal women sought information about estrogen replacement therapy, for example, they found a dearth of research on such matters. Activists argued that these practices were discriminatory and unjust and that women deserved equal treatment and attention.

AIDS activists found that the CDC's definition and thus diagnoses of AIDS was biased and did not include symptoms and manifestations that were more likely to be found in women (Christensen, chapter 3 herein). The process of being excluded by definitional fiat was killing women, activists argued, as pointedly conveyed in the slogan, "Women don't get AIDS. They just die from it." Breast cancer advocates vociferously noted how women were being excluded in a nation that proclaims equality and that the federal government does not care about women who pay their fair share of tax dollars (U.S. Congress, House 1990). "One in Eight" was a slogan the NBCC used to emphasize the number of women at risk for the disease (Baird, chapter 4 herein). Activists pursuing passage of VAWA argued that previous views and laws regarding violence and criminal penalties excluded the type of violence that women experience, namely violence inflicted by a boyfriend, husband, or ex. Again, the exclusion of women left their experiences and needs unrecognized and their bodies and lives in jeopardy. Domestic violence was characterized in the 1990s as a violation of women's rights, and even women's human rights (Davis, chapter 5 herein). The activists of the 1990s demanded that biomedical and government institutions address women's health needs, strategically couching their demands in well-understood and accepted norms of equality and rights. Activists restructured women's association with mainstream institutions and, in the process, altered the institutions themselves.

Furthermore, many activists presented their claims as ones important for all women. Breast cancer activists argued that all women are at risk and all women should fear breast cancer; it knows no race, age, or class boundaries. Research on domestic violence showed that women from all racial, age, and class groups experience violence. Women, arguing for more inclusion of women in clinical trials, demonstrated the harms that all women face because of the lack of medical knowledge. Thus the

new definition of women's health was put forth as an inclusive one; these are concerns that all women face, activists declared.[7]

New Problems, New Solutions

In relation to the newly expanded, politicized notion of women's health, the federal government or the state became the entity that can and should provide a solution to women's health problems. Changing the CDC—a federal government agency—definition of AIDS will drastically improve many HIV-infected women's lives, activists argued. Changing the NIH—another federal agency—policies governing gender and medical research will radically improve knowledge gained from biomedical research and thus women's health. Increasing federal government funds for breast cancer research will help researchers find the cause and cure of breast cancer. And finally, including violence against women in federal level crime legislation and in the federal level Department of Justice (DOJ), and providing funds for state and city level police departments, will prevent battering and save women's lives. All of the problems had existed for many, many years, but with the new characterization of women's health and the newly adopted strategies, the federal government became the target of activism and source of the solution.

Women's health advocates also targeted the state with inventive solutions. For example, breast cancer activists pursued the development of the breast cancer stamp that went into effect in 1998. These stamps are sold at a higher price than first-class stamps, with the difference going to the NIH and DOD for breast cancer research; they have raised nearly $50 million for breast cancer research as of 2005 (U.S. GAO 2005). Domestic violence advocates followed suit with the development of the "Stop Family Violence" stamp, which raised $2 million for DHHS programs for domestic violence prevention programs from 2003 through 2005 (U.S. GAO 2005). NBCC also pursued the creation of the first ever private-public partnership—the National Action Plan on Breast Cancer—to set the agenda for breast cancer research. The movement not only called upon the state to pass new laws and adopt new policies; they demanded that the state create new entities and engage in new functions.

Agenda Setting and Framing of Problems

Definition and framing of social problems has been widely investigated in the area of public policy research called agenda setting. Agenda

setting, in general, is the study of how, when, and why issues come to be viewed as problems that government should address. Countless concerns or conditions exist in the world, most of which the public never pays attention to, but a very small set of things become problems the public believes the government should address. This process of arriving on the agenda is influenced by many factors, including the framing or definition of the problem—the social construction of problems—and the availability of feasible solutions, along with open "windows of opportunity" (Baumgartner and Jones 1993; Bosso 1994; Cobb and Elder 1983; Edelman 1967; Jones and Baumgartner 2005; Kingdon 1984, 1995; Rochefort and Cobb 1994; Sabatier 1999; Sabatier and Jenkins-Smith 1993, 1999; Schneider and Ingram 1993 and 1997; Stone 1988, 1997). And the particular framing of a problem usually leads to potential solutions, as the two go hand-in-hand. In fact, the presence of both diagnostic (diagnosis of the problem) and prognostic (possible remedies) frames were critical in securing rights for the homeless, as advanced by homeless organizations (Cress and Snow 2000).

Problem definitions are not fixed; they are malleable and open to wide interpretation (Rochefort and Cobb 1994). "[P]roblem definition is never simply a matter of defining goals and measuring our distance from them. It is rather the *strategic representation* of situations" (Stone 1988, 106). How objective conditions, ambiguous information, perceptions, and cultural values and norms are socially and politically represented are crucial to a movement's success, as well as the type, if any, of policy that gets enacted.

In addition to the expanded notion of women's health and arguments for inclusion, activists of the 1990s devised innovative framings for women's health issues. Powerful symbolic metaphors were employed and personal stories were told. As Stone (1988) notes, "[S]ymbolic representation is the essence of problem definition" (108) and the construction of stories and the employment of metaphors are two important "weapons" in this representation (122). Breast cancer activists argued that if government can wage war in the Persian Gulf, and if government can bail out the savings and loan industry with billions of dollars, why can't it do something for women and wage war on breast cancer? They requested that the DOD engage in breast cancer research—and won! Battered women told their stories of living with emotional abuse and being pushed, punched, stabbed, and even having their lives threatened, by men that "loved" them. After the death of Nicole Brown Simpson, when the nation heard tape recordings of Nicole Simpson calling

the police during previous violent disputes with the nation's beloved football hero O. J. Simpson, the public was shocked. Women afflicted with breast cancer displayed their bald heads and breast prostheses and described their lives of "surviving" breast cancer, only to live with disfigured bodies and fear of the cancer's return. No one can help but be moved by such stories. Additionally, carefully gathered medical and social data showed that the problems were extensive, and the powerful symbols, personal stories, and statistical data all reinforced each other.

In all areas of women's health explored herein, the media played an important role. The AIDS activists staged specific events to catch the media's eye. The media publicized the issues surrounding women and clinical research, printing many articles on how women were being shortchanged. Breast cancer activists staged walks, runs, talks, and photographic exhibits, all of which the media covered. Such publicity allowed the activists, at the same time, to personalize their issues. We should not forget that these diseases or problems are quite scary and, because they involve women's breasts, quite taboo, and most people would prefer not to think about them. Stories of women with AIDS or women with breast cancer, for example, were broadcast on television; these stories humanized the frightening statistics. Movies such as *The Burning Bed* telling the stories of battered women helped bring the issue of violence to the public's attention and allowed it to see the intimate details of the dynamics of abuse. Overall, the media coverage greatly facilitated the public's awareness of the health issues but it also allowed the public to see the personal side of the concerns, which assisted in the arrival of women's health onto the agenda.

Certainly another reason for the rapid rise of women's health issues and the adoption of many new policies is that little public dissent existed. No one was specifically *for* violence against women, biased medical information, or breast cancer, of course; objection, if it existed at all, came from government officials, scientists, and members of Congress for other reasons. Thus when the issues were framed as women's rights and gender equality issues, and that women's health and lives were at stake, they presented convincing claims that received little argument, and the issues easily advanced onto the agenda. But such arguments and claims have to be received by receptive ears. For many years, women's health issues were not on government's agenda—what changed? The role of the activists has been highlighted, and the influx of women into Congress and other high-ranking positions has been discussed, but did anything change with regard to the political and social context of

the United States or the government itself that made it more receptive to the claims? Did any "window of opportunity" (Kingdon 1984, 1995) open that provided an occasion for women's health issues to advance?

Shift in Social and Political Context

Unsurprisingly, the 1990s was a different social and political world than in the 1960s and '70s. Another reason for the new approach of the 1990s women's health movement was a shift in societal values regarding women's bodies and health concerns; women were no longer going to be silent or feel ashamed about their physical, material being. For example, in the previous era, breast cancer was not a topic of public conversation for most women. But as women openly talked about their experiences with breast cancer, and as support groups formed in the 1970s and '80s, the topic became much less taboo.[8] Such cultural meanings of women's bodies can enhance women's health activism. But in the late 1980s and '90s, breast cancer survivors made Congress, the NIH, and the public aware of the lack of research and the number of women who succumb to the disease; breast cancer is the second leading cause of cancer deaths in women, surpassed only by lung cancer (ACS 2006). Women were also not going to let domestic violence remain invisible, and they were not going to feel ashamed about their experiences of being battered.

The political context also changed over time. In the 1980s, Ronald Reagan was president and the national political culture and agenda shifted to a much more conservative climate, one that was hostile to feminist claims. As Ferree and Hess (1994) point out, this led to major changes in the movement's organization, strategy, and emphasis, and they label the 1980s as one of "defensive consolidation" (159). In 1992, Bill Clinton was elected president, and for his first two years, he also enjoyed a Congress that was controlled by the Democratic Party.

President Clinton's emphasis on health care and his support for many women's issues was crucial to the success of the activists. One of his first acts in office was to sign the NIH Revitalization Act. His predecessor had vetoed the bill. President Clinton welcomed the breast cancer activists' petitions, giving them an elaborate ceremony in the East Room of the White House. President George Bush had ignored the activists' prior delivery of 175,000 letters (Casamayou 2001).

President Clinton also crystallized the public's concern about health care issues in the United States. Managed care structures were growing

and people's concerns about limitations on coverage and services were increasing, as well as the large number of uninsured. Bill Clinton ran a campaign promising to reform the health care system. Promptly after being sworn into office, he formed the President's Task Force on Health Care Reform, with Hillary Clinton as its head, and the committee set out to devise a plan to overhaul the health care system of the United States. Therefore, general problems of the health care system were on the public's mind when women's health care activists raised their specific concerns.

In general, women's rights issues were receiving more public attention (than in the early 1980s). As Davis discusses in chapter 5, sexual harassment received widespread attention as a result of Anita Hill's charges against Clarence Thomas during his Senate Confirmation hearings in 1991.[9] Problems of domestic violence had also gained increasing attention by the early 1990s, as did persistent gender-based pay inequities, the glass ceiling, the erosion of abortion rights, women's double shift, and childcare problems of working women. In general, by the late 1980s and early '90s, calls for women's rights and equality were no longer considered to be the anthems of radical women liberationists; they had become accepted, legitimate concerns that government needed to address and enforce when appropriate. The increasing amount of public attention focused upon women's issues hindered the ability of government institutions and officials to keep a blind eye turned toward women's health problems.

As Davis discuses in chapter 5, the global women's movement focusing on women's rights as human rights, and the need for women to live free from violence, was also burgeoning at this time. In 1979 the Convention on the Elimination of discrimination Against Women (CEDAW) was adopted, and in 1993 the UN World Conference on Human Rights focused on issues of violence against women, and women's rights were incorporated into the resulting Vienna Declaration (Bunch 1999). As a result, the UN adopted the Declaration on the Elimination of Violence Against Women. These events directly contributed to the passage of VAWA but they also helped to focus the public, as well as government officials', attention on women's concerns and women's rights.

One last item that needs to be noted is the ending of the cold war and thus the freeing up of funds that were once devoted to defense spending. The "cold-war dividend" (Ruzek and Becker 1999) from the DOD provided the opportunity for more funding for breast cancer research,

an opportunity upon which the activists seized. Key to this was the presence of Rep. Patricia Schroeder (D-CO) on the Armed Services Committee, more evidence of the important role played by insider activists.

Context, Strategies, and Opportunities

Another aspect of context is how it shapes the strategies utilized by activists. Simply put, context matters. Katzenstein (1998) aptly shows how context affects the strategies chosen by feminists in the military and the Catholic Church. "[W]omen's activism is both the producer and the produced of its institutional environment" (103). Context affects agenda expansion or agenda narrowing (Cobb and Elder 1983; Schattschneider 1960). In the case of the military, the norms of the law and the courts shape the normative culture in which activists operate, signaling the acceptability of some challenges and invalidating others (Katzenstein 1998, 96). In the church, the spaces or habitats that were available—religious congregations, social justice organizations, and academic institutions, to name a few—shaped the form of feminism and the types of claims making that were employed (117–19). And very important, the reforms of Vatican II provided the opportunity for the feminists to raise matters of gender inequality within the Church, as they did not have recourse to the law (148).

All of the advocacy organizations and issues explored herein (medical research, AIDS, breast cancer, violence against women) utilized the state and traditional legal and policy frameworks to pursue their cause. Some *also* engaged in street protest, with the AIDS activists utilizing the most radical forms of protest and breast cancer activists enacting a milder form of street protest with breast cancer runs and walks. What is it about context that shapes such decisions? Is it simply that AIDS activists were the first to "politicize a disease" and thus later groups could easily approach the doors the AIDS activists had opened? "Political Opportunity theory" describes the perspective "that activists' prospects for advancing particular claims, mobilizing supporters, and affecting influence are context-dependent. Analysts therefore appropriately direct much of their attention to the world outside a social movement, on the premise that exogenous factors enhance or inhibit a social movement's" prospect for mobilization and success (Meyer 2004, 126). Opportunities afforded to the various advocacy groups and elements of the context in which they operated will also be explored herein.

Thus the women's health movement of the 1990s differs remarkably from the earlier movement of the 1960s and '70s. Though the new movement is composed of various single-issue or disease-specific groups, pursuing their goals independent of each other, they share some commonalities. All of the strands have engaged in the process of redefining women's health. And not only has the scope of women's health been extended beyond reproductive concerns, the issues have been characterized in a new light. The health issues have been viewed as social and political issues. Issues have been framed as concerns of gender inequality, exclusion, and neglect of women's rights. With regard to all of the issues, the government or the state became the entity that can provide a solution to the newly defined problem. The new movement has proved triumphant. In the areas of medical research, women and AIDS, breast cancer, and domestic violence, women's health activists have achieved unprecedented success. What follows is an introduction and overview of the subsequent chapters on these topics.

OVERVIEW OF THE BOOK

Medical Research, Women, and the NIH

Though a precise moment when the contemporary women's health movement began is difficult to pinpoint, the story can start with a few dedicated activists, the Congressional Caucus for Women's Issues (CCWI), and the NIH. The time was 1990 and the issue was the underrepresentation of women in medical research. A U.S. Government Accountability Office (GAO) report regarding women and NIH funded research was released at a widely publicized congressional hearing. Mark Nadel testified that despite an earlier NIH policy which *"urged* grant applicants to consider the inclusion of women in the study populations of all clinical research efforts" (U.S. GAO 1990, emphasis mine), little had changed within the NIH or research that it funded. Women's health activists held that women were excluded from much medical research and their health was compromised by the resulting lack of pertinent health information. This exclusion was defined as an issue of gender equity and "unconscionable in a Nation of such wealth and that professes equality for all of its people" by Rep. Marilyn Lloyd (D-TN) (U.S. Congress, House 1990, 1).

By this time, the women's health movement had gained force and was

pressuring Congress for changes in many aspects of health care policy; the CCWI was a strong force in this campaign and requested the GAO report. The hearing at which this report was presented was beautifully orchestrated by women's health advocates. A *Science* magazine article on the hearing stated, "If a federal agency can be hoist by its own petard, then the National Institutes of Health suffered that experience at a congressional hearing . . . on women's health" (Palca 1990, 1601).

Throughout the early 1990s, legislative packages were introduced in Congress that addressed women's health concerns regarding research, services, and prevention issues. The first Women's Health Equity Act (WHEA) was introduced on July 27, 1990, and contained twenty separate bills. It called for writing into law the NIH policy regarding the inclusion of women and analysis of gender differences; creating an office of women's health; and increasing funding for research on a variety of women's health issues, including breast cancer. After this, the Office of Research on Women's Health (ORWH) was established within the NIH and was given the mandate to ensure that research supported by NIH includes important issues that pertain to women's health, to ensure appropriate participation of women in clinical research that is supported by the NIH, and to increase the participation of women in biomedical careers.[10]

Thus, the attention given to women's health issues during the decade of the 1990s can be traced back to a 1990 congressional hearing, a GAO report, and some politically savvy and dedicated women's health activists. This was the primary focusing event of the women's health movement and is the subject of chapter 2. In this chapter, the role of insiders and the movement-state intersection will be highlighted as members of Congress, in conjunction with outsiders, provided the impetus and energy for the policy changes. During the same period, activists were challenging AIDS policies, as well as increasing and strengthening breast cancer advocacy. In addition, attention regarding domestic violence was increasing. These are the subjects of the following chapters.

AIDS and Women

Currently, in the United States, AIDS most severely affects women and adolescent girls, particularly those from racial and ethnic minorities and poorer populations. Also women die faster than men do after being diagnosed with AIDS, and AIDS is the leading cause of death of African-American women aged fifteen to forty-four (CDC 2006). How do

women become infected with the virus? Through heterosexual contact, which became the primary mode of transmission in 1992, surpassing intravenous drug use. And importantly, young women are more susceptible to infection during heterosexual contact than men.

As Christensen argues in chapter 3, to understand this prevailing epidemic and the roots of its current affliction among women, we must look back to early AIDS policies and examine the progression of policy changes that occurred after the AIDS activists and women's health care advocates waged war against the system. They persuaded the FDA to change its approval process for some AIDS-related drugs, convinced the CDC to change its definition of AIDS-related symptoms to include more conditions specific to women, and influenced the NIH to perform more AIDS research that is beneficial for women. Though many advancements have been made, the effect of prior policies regarding the exclusion of women in research and ignorance of AIDS related symptoms in women, as well as ignorance about how they acquire the disease, are still taking their toll on the female population of the United States. In 3 the role of activists and their organizing, protests, and demonstrations will be emphasized as "outsiders" provided the primary push for changes in AIDS policies and research.

Breast Cancer

Breast cancer is the area of women's health that received the most attention—by the media, the government, and women themselves—in the 1990s. Karen Stabiner (1997) writes, "Until 1990, there had been no concerted effort to stop [breast cancer]. Now there is" (xxvi). Why? Many committed women who, after facing their own breast cancer and mortality, dedicated their lives to making a difference in the epidemic.

Breast cancer will afflict one in eight women in their lifetime (ACS 2006). The disease claims over forty thousand lives annually, and it is estimated that over two million women have survived breast cancer. Although not the most common cause of death for women,[11] breast cancer is the most feared disease: we do not know what causes it, how to prevent it, or how to cure it.

Activist breast cancer groups sprung up throughout the United States in the late 1980s. Many of the groups merged into the National Alliance of Breast Cancer Organizations (NABCO) in 1986; others formed the National Breast Cancer Coalition (NBCC) in 1991; and still others came together as the National Coalition of Feminist and Lesbian

Cancer Projects in 1991 (Boehmer 2000). These groups have been some of the most active women's health groups in the 1990s.

The advocates enjoyed many successes in the 1990s, but most remarkably, funds for breast cancer research grew from $81 million in 1990 to $614 million by 2000. Rep. Patricia Schroeder (D-CO) and Sen. Olympia Snowe (R-ME) note that the "Senate vote in 1992 to earmark $210 million from the Department of Defense is perhaps the best illustration of the growing clout of the breast cancer lobby, most of whom are survivors of the disease" (Schroeder and Snowe 1994, 104). Other notable achievements are the creation of the "Stamp Out Breast Cancer" postage stamp, development of a National Action Plan on Breast Cancer, and involvement in setting the research agenda regarding clinical trials on breast cancer.

Breast cancer was *the* women's health issue of the 1990s. It received more attention that any other health issue, not because it killed the most women, but because breast cancer advocates organized themselves and successfully projected their cause to women across the nation through effective media and publicity campaigns, and adopted political tactics that utilized the existing structures of government to benefit their cause. But most of all, they effectively "politicized" the disease, reframing and recreating the meaning of breast cancer, and thus chapter 4 highlights this aspect of the women's health care movement.

Domestic Violence

Domestic violence is another issue that received widespread attention from activists and the public at large; it was also the subject matter of a major bill, the 1994 Violence Against Women Act (VAWA). As Carol Warshaw (1994) notes, "Over the past two decades, gender-based trauma has emerged as one of the most serious public health problems facing women in this country. For most women, the greatest risk of physical, emotional, and sexual violation will be from a man they have known and trusted, often an intimate partner" (201). Nearly 25 percent of women experience rape and/or physical assault from a current or former intimate partner (Tjaden and Thoennes 2000a; Warshaw 1994).

Domestic violence is very important for women and the health care system. Since battered women constitute about one-third of women seeking care in emergency rooms and 25 percent of women who attempt suicide or receive psychiatric emergency care (Warshaw 1994, 202), health care providers should be compelled to recognize and treat

such abuse. It is estimated that violence against women costs the health care system about $3 to $7 billion annually (National Center for Injury Prevention and Control 2003; Tjaden and Thoennes 2000b). Despite such knowledge and information, the health care system, the criminal justice system, and the federal government did not address such issues in a direct fashion until the 1990s.

As Davis argues in chapter 5, the struggle for the recognition of do-mestic violence began in the states in the 1970s–80s and moved to the federal level in the 1990s, culminating in the passage of the VAWA. During this time period, activists successfully reframed the issue of do-mestic violence from one of a private matter to a public—a social and political—problem. Violence against women was redefined as an issue of civil rights and women's rights, and one that the federal government should rectify. At the time the legislation was introduced in 1990, bat-tering was still considered "natural" violence by many, and as a result, was "seen by mainstream politicians as a 'fringe' issue trumpeted by radical feminists" (Nourse 1996, 13). A task force, representing over one thousand groups including labor unions, civil rights groups, reli-gious organizations, and community groups, was instrumental to the legislation's passage. The most active members included the National Organization of Women (NOW), the National Women's Law Center, National Coalition Against Domestic Violence, and the Women's Legal Defense Fund. The broad spectrum of political groups supporting the legislation helped convince members of Congress that the issue was popular with and important to constituents. The issue of domestic vio-lence exemplifies how activists utilized existing and acceptable frame-works of rights—civil, women's, and human—to advance their cause by inserting a previously ignored women's issue into the domain of the rights discourse and doctrine. The politics of domestic violence is ad-dressed in chapter 5.

Methodology, Scope, and Conclusion

The various focus areas were chosen because they all center on wom-en's health; the problems had many devoted organizations and activists, both in and out of government, fighting for their recognition; and all had historic policy changes enacted in the 1990s. A drawback of choos-ing only successful cases is that factors found to enhance success are not challenged or confirmed with contrary evidence. For example, one important and hard fought for, though unsuccessfully, issue in the

1990s was universal health insurance. But the primary goal of this book is to examine a related set of policy changes that occurred in a short and distinct period of time, and it is beyond the book's capability to address other unsuccessful issues. The 1990s was a pathbreaking era and it deserves analysis. I hope that other scholars contribute to this knowledge base by investigating other cases.

Additionally, the book does not engage in an in-depth class and race analysis of the various health issues. Most of the activists explored herein were middle-class, white women; this was a characteristic of the movement as a whole. But by omission, I do not mean to imply that no activism existed around specific race/ethnicity women's health issues. In fact, such groups proliferated; the National Black Women's Health Project (now Imperative), National Latina Health Organization, and National Asian Women's Health Organization (Ruzek and Becker 1999) were all started in the 1980s and '90s. These groups no doubt sprung up because the mainstream organizations were not addressing their concerns. Additionally, the federal government, under the direction of President Clinton, became more concerned with health disparities among racial/ethnic groups. Analyses of such topics are also very important but beyond the scope of this book.

I authored some of the chapters/cases, Kimberly Christensen authored the chapter on AIDS activism, and Dana-ain Davis contributed the chapter on violence against women. Kimberly Christensen was an AIDS activist and thus has personal and firsthand knowledge of many important aspects of women and HIV/AIDS policies and politics; her chapter also takes a more activist-oriented approach and is a welcomed perspective in this collection. She has also previously published in the area (Christensen 1991 and 1998). Dana-ain Davis has also previously written on violence against women (Davis 1998 and 2006) and comes to the issue with a background in public health and applied anthropology; her perspective is also a welcome addition to the collection of cases. I conducted extensive and original research involving interviews and document collection for the chapter on medical research policies. I also authored the chapter on breast cancer; some of it based on secondary sources and some of it is based on original analyses.

The book can be viewed or utilized in two fashions. One, each chapter is a stand-alone chapter investigating how and why the policy changes were achieved in the specific area of women's health. Second, the overall book explains an era in women's health policymaking, and in the women's movement, by taking a macro-level perspective with re-

gard to the overall success and the many complex factors that led to the achievements. How did the newly formed notion of women's health come to be a *problem* for government to solve? Why was the overall movement so successful? What does the future hold for women's health in the United States? What can we learn from this era of women's health activism and policymaking? Such questions will be explored in the concluding chapter of *Beyond Reproduction.*

2

Protecting the Fetus: The NIH and FDA
Medical Research Policies
Karen L. Baird

FOR YEARS, WOMEN WERE EXCLUDED FROM OR UNDERREPRESENTED in clinical research studies (Institute of Medicine 1994; U.S. GAO 1990; Kinney 1981; La Rosa, Seto, Caban, and Hayunga 1995; Rothenberg 1996; but also see Kadar 1994).[1] But why were women excluded or underrepresented?[2] Because of their reproductive capabilities, women, or their potential fetuses, were viewed as needing protection from the possible harms of research. This concern for fetal protection is, in the words of one author, "the result of intellectual lassitude, defensive legalism, and a misplaced sense of obligation" (Moreno 1994, 29).

Though the problem of underrepresentation had been well documented for more than a decade, it was not until the early 1990s that federal policies governing women and medical research were revised. Pressured by women's health advocates and members of Congress, the National Institutes of Health (NIH) and the Food and Drug Administration (FDA) revised their policies regarding the inclusion of women in research funded, supported, or approved by the respective institutions.

In this chapter, a history of women and clinical research will be presented. Next, a review of the NIH policies and policy changes will be provided, followed by an analysis of the FDA regulations. Framing the chapter is the role of women's health activists and their work in bringing the issue of women and medical research to the fore.

HISTORY OF MEDICAL RESEARCH POLICIES AT THE NIH AND FDA

Women and Medical Research

Women were excluded from medical research since the late 1960s and early '70s. As Johnson and Fee (1994) point out, this exclusion arose from a variety of political, social, and legal forces. Emphasis on the need to protect all subjects arose in the 1950s and '60s in response to revelations of abuse of research participants by medical personnel. But particularly for women, cases of deformed infants resulting from drugs taken during pregnancy raised concerns about the inclusion of women in drug trials. In the 1960s, many women took thalidomide, a drug used to prevent early miscarriages, and the drug caused over one thousand birth-related defects. Inadequate research standards and failure of the manufacturer to acknowledge early evidence of side effects were blamed. Also in the 1960s and early '70s, problems from the drug DES came to light.[3] DES is a drug that women took in the 1940s and '50s to prevent miscarriages; about twenty years later, many daughters of women who had taken the drug developed reproductive anomalies and had an increased risk of developing cancer of the vagina. From litigation brought by these daughters, the pharmaceutical companies incurred substantial costs. So in the 1960s, companies became more concerned about liability issues surrounding the testing of drugs on women.

Furthermore, women's rights were sometimes abused and ignored. In a study of the side effects of oral contraceptives, placebo pills were given to women who sought treatment to prevent further pregnancies (Goldzieher et al. 1971a, 1971b). None of the women were told they were participating in the study, none gave their consent, and none were told they were given placebos; significantly, most of these women were poor Mexican Americans. There are also ethical questions about the initial testing of the oral contraceptive pill that was carried out on poor Puerto Rican women (Zimmerman 1980).

People belonging to minority groups have been viewed as more expendable and used in dangerous and unhealthy research. One famous example is the Tuskegee syphilis experiment of four hundred African American males. From 1932 to 1972, the Public Health Service (PHS) conducted a study of the effects of untreated syphilis. Poor, illiterate, southern black men were watched for forty years to obtain data on the

progression of syphilis, and as many as one hundred men died (Jones 1981). Most of the men were never told they had the disease, no drugs or treatments were given or tested in this experiment, and, in fact, most of the subjects did not even know they were participating in the trial.[4]

In 1974, the National Research Act was passed calling for the establishment of a National Commission to Protect Human Subjects to identify ethical principles and guidelines for research. Political debates over abortion, artificial reproductive technologies, and fetal tissue research also raged at the time (Johnson and Fee 1994). With the legalization of abortion in *Roe v. Wade* in 1973, the antiabortion movement with its emphasis on fetal rights, grew. Whether written policy or not, excluding women from most medical research became the established norm in the medical community.

In 1983, a PHS Task Force on Women's Health Issues held hearings across the United States to identify perspectives on and important issues regarding women's health.[5] The task force also sponsored a symposium at the NIH that included PHS personnel, task force members, and representatives of various national organizations with specific concerns regarding women's health. "The theme that seemed to dominate all of the regional sessions was that women's health is directly related to their access to sound information and quality medical care" (DHHS 1985, vol. II, 2). Attention was also drawn to the problems of economically disadvantaged women being medically underserved. With regard to medical research, interest was expressed for studies to include women and that there be increased attention on research and health issues that apply specifically to women's health. This conference and resulting report are the first documented evidence of a government institution or group calling for the inclusion of women in clinical trials.

The National Institutes of Health (NIH)

Even though the 1985 PHS report received little attention and most of the recommendations were never addressed, an NIH Advisory Committee on Women's Health Issues was established. As a result, in 1986 the NIH announced a new policy that "*urged* grant applicants to consider the inclusion of women in the study populations of all clinical research efforts" (GAO 1990, emphasis mine). It also stated that if women are not to be included, a clear rationale for their exclusion needs to be made, and researchers should evaluate gender differences in their

study. But despite these directives, little changed within the NIH or the research proposals it funded.

The real catalyst of the surge in attention to women's health research was a 1990 General Accounting Office (GAO) report on the progress of the 1986–87 NIH policy. Florence Haseltine, director of the Center for Population Research at NIH, was a key instigator. She enlisted the help of Joanne Howes, a public relations specialist, who interviewed many women's health groups and activists and found that no one was aware of or concerned about the research practices and policies at the NIH (Haseltine 1998). There were medical groups that focused on women's health issues, such as the American Medical Women's Association (AMWA), the American College of Obstetricians and Gynecologists (ACCOG), the American Psychiatric Association (APA), and the American Nurses Association (ANA), and women's health groups such as the Boston Women's Health Collective and the National Women's Health Network. There were women's rights and general women's groups, such as the National Organization for Women (NOW) and National Abortion Rights Action League (NARAL), and single-issue disease groups, such as breast cancer and osteoporosis organizations. Howes found that many people were interested in increasing the funding for women's health research, but little political activity or advocacy existed at this point.

Rep. Patricia Schroeder (D-CO) and the CCWI were initially interested in more contraceptive research. Since abortion politics dominated most issues of women's health at the time, Schroeder wanted to shift the focus toward contraception since it should be an issue that could unite the various forces (Primer 1998). At this time, Rep. Mary Rose Oakar (D-OH) and the National Breast Cancer Coalition (NBCC), led by Fran Visco, were working to increase funding for research on the prevention and cure of breast cancer (see Baird, chapter 4 herein). The AIDS activists had successfully fought for changes in research funding and policies and they provided a model on which the women's health care activists could build (see Christensen, chapter 3 herein).

When Haseltine, Schroeder, and others turned their attention toward the NIH and clinical research on women, they were quite disturbed at what they found. A major study on the effects of aspirin in reducing heart attacks used 20,000 males and no females; a study on heart disease risk factors was conducted on 13,000 men and not one female; and the National Institute on Aging's largest study excluded women for its first twenty years (Schroeder and Snowe 1994).

Joanne Howes and Haseltine gathered members of Congress and their staffs, people from the scientific and medical establishments, and activists from women's groups. This coalition eventually formed the Society for the Advancement of Woman's Health Research (SAWHR). In considering strategic options, they decided that since the NIH had a policy in place regarding the inclusion of women, this was an effective place to begin. And since NIH was apparently not abiding by its own policy, they decided that NIH needed a push from outside its own institutional walls; it needed a push from Congress. To get other members of Congress to support their issue, they decided that hard, fast, indisputable data was needed. The CCWI worked with Rep. Henry Waxman (D-CA), chair of the Energy and Commerce's Subcommittee on Health and the Environment, to request the 1990 GAO report. The report came to be the "smoking gun" for the government's neglect of women's health research (Schroeder and Snowe 1994, 95).

The CCWI and Rep. Waxman (D-CA) scheduled a hearing for June 18, 1990, in which Mark Nadel of the GAO testified. The media were notified of the event and gave it tremendous coverage. The 1990 GAO report noted that little progress had been made in carrying out the 1986–87 policy: the new directive had not been well communicated or understood within the NIH and the scientific community, the directive had been applied inconsistently, and the NIH had been very slow to implement it. In fact, the application booklet used by most NIH grant applicants was not even updated to include the new information regarding gender until April 1991, over four years after the policy was first developed. Furthermore, the GAO report stated that the component of gender analysis—the evaluation of gender differences in a study—had not been implemented, and it was impossible to determine the impact of the policy as a whole because implementation began so late and no data had been kept on the gender composition of funded studies. Mark Nadel testified that this "has resulted in significant gaps in knowledge" of diseases that affect both men and women (GAO 1990). Following the hearing, articles in newspapers and magazines entitled "In Research, Women Don't Matter" (Berney 1990), "Wanted: Single, White Male for Medical Research" (Dresser 1992), and "Report Says NIH Ignores Own Rules on Including Women in Research" (Jaschik 1990) were published all over the country.

Women's health activists argued that these NIH practices were discriminatory and unjust. Many contended that the NIH policies were biased against women in that women received substandard health care

diagnosis and treatment; that they were systematically excluded from clinical drug trials; and were shortchanged and neglected. Patricia Schroeder and Olympia Snowe (1994) note, "We were outraged that women, who pay their fair share of tax dollars in this country, derived little benefit from these important federally funded research studies" (95). Others labeled this problem one of gender inequity and argued that women's autonomy and ability to give informed consent were not being respected because they were being told not to participate instead of being able to decide for themselves. Rep. Marilyn Lloyd (D-TN) concludes, "The result is unconscionable in a Nation of such wealth and that professes equality for all of its people" (U.S. Congress, House 1990, 1).

Throughout the early 1990s, legislative packages were introduced in Congress that addressed women's health concerns regarding research, care, and prevention issues; these were coupled into a package entitled the Women's Health Equity Act (WHEA), denoting the perceived injustices. Initially, legislation regarding the NIH was vetoed by President George Bush because of the inclusion of provisions regarding fetal-tissue research. In 1990, the Office of Research on Women's Health (ORWH) was established within the NIH and was given the mandate to ensure that research supported by the NIH include important issues pertaining to women's health, to ensure appropriate participation of women in clinical research supported by the NIH,[6] and to increase the participation of women in biomedical careers.

In 1991, the NIH also established the Women's Health Initiative (WHI), a fourteen-year, $625 million effort to study approximately 150,000 women at forty-five clinical centers across the United States. The WHI is the largest research study ever funded by the NIH. Furthermore, with the election of President Clinton, in 1993 the NIH Revitalization Act was signed into law. This act codified the previous NIH regulations mandating the inclusion of women and authorized additional funding for breast, ovarian, and other reproductive cancers, and osteoporosis.

As part of this 1993 NIH Act and internal NIH policy changes, medical research policies regarding women and minorities were drastically revamped in the early 1990s. Now all applications, both for intramural and extramural research, are *required* to include women and minorities as research subjects.[7] "In conducting or supporting clinical research for purposes of this title . . . the Director of NIH shall . . . ensure that—(A) women are included as subjects in each project of such research; and

(B) members of minority groups are included as subjects is such research" (NIH Revitalization Act, 123). The Act also requires that a valid analysis be carried out to show whether the variables being studied affect the various subpopulations in different ways. Exemptions are allowed in cases where the research is inappropriate with respect to the health of the subjects, the purpose of the research, or other circumstances determined by NIH (NIH Revitalization Act). The 1993 act also requires that a "data system for the collection, storage, analysis, retrieval, and dissemination of information regarding research on women's health that is conducted or supported by the national research institutes" be established (Institute of Medicine 1994, vol. I, 68). In 1994, the NIH issued new guidelines for the inclusion of women in medical research in accordance with the 1993 act (U.S. DHHS, "NIH Guidelines," 1994a).

NIH also published an Outreach Notebook. The Notebook is not law but was published in effort to help researchers understand and implement the new guidelines. It offers suggestions for deciding how to include women and minorities and recruitment strategies for obtaining such subjects. The ORWH held conferences with Institutional Review Board (IRB) chairs in 1994 and again in 1996 to discuss and assess the progress of the implementation of the Guidelines.[8] For projects funded in FY 1998, more than 67 percent of the trial participants were women (DHHS, "Monitoring Adherence" 2003). (See Table 2.1 for a listing of events as they relate to the NIH.)

The Food and Drug Administration (FDA)

Before reviewing the FDA policies regarding gender and research, it is important to note the differences between the NIH and FDA. The NIH funds medical research; as with any grant process, researchers submit detailed proposals that are reviewed and deemed fundable or not fundable, as judged by various criteria. The FDA does not regularly fund research. It only issues guidelines as an aid to organizations, typically pharmaceutical companies, involved in the evaluation of new drugs and medical devices for FDA approval; FDA guidelines specify information they expect new applications to include.[9] In addition, the NIH conducts its own research—intramural research; the FDA does not. The FDA is only a regulatory agency with a mission of making sure that drugs and medical devices are safe and effective. The agency sets parameters for the studies it reviews as part of the approval process

for new drugs, but it does not usually ask that studies on certain drugs or devices be performed.

The FDA issues its own guidelines regarding women and clinical studies. In its 1977 guidelines, the FDA states that pregnant women and "women who are at risk for becoming pregnant" should be excluded from Phase I studies (DHEW 1977). They further recommend that "women of childbearing potential" be excluded from large-scale clinical trials, which includes Phase III studies, until the FDA Animal Reproduction tests have been performed (Institute of Medicine 1994, vol. I, 137). Then, "if adequate information of efficacy and relative safety has been amassed during Phase II, women of childbearing potential *may* be included in further studies" (DHEW 1977, 15, emphasis mine). "Women of childbearing potential" are broadly defined as "premenopausal women physiologically capable of becoming pregnant" (DHHS, FDA 1993, 39408). Included in this category are women who are using contraception, celibate, lesbian, and women whose male partners have been vasectomized.

After the women's health advocates were successful with the NIH, they turned their eye toward the FDA. Awareness about research inequities were already heightened; the NIH episode brought such visibility to the problem that there was little substantive argument against it when activists approached the FDA. David Kessler, commissioner of the FDA, brought in Ruth Merkatz, who was instrumental in obtaining many health victories for women at the FDA. Since the GAO report on the NIH policies proved to be so successful, the CCWI and Rep. Henry Waxman (D-CA) asked the GAO to investigate the FDA and the inclusion of women in drug and medical device research. The 1992 GAO report noted that in 60 percent of the drug trials, women were underrepresented and recommended that the FDA revise its policy to ensure the appropriate participation of women and that gender analyses be performed (GAO 1992). Again, because of the established credibility of the issue, little opposition arose to the suggested changes.

In 1993, as a result of the GAO report and public criticism, the FDA issued new guidelines (DHHS, FDA 1993). The 1993 guidelines state that subjects in a given clinical study should reflect the population that will receive the drug when it is marketed, and *suggest* that subjects include both genders in the same trial so that direct comparisons can be made. The FDA expects there to be an analysis of gender differences in terms of effectiveness and adverse effects of the drug. Though the 1977 guideline about excluding "women of childbearing potential" was lifted,

the 1993 guidelines do not *require* that women be included in the early phases of drug trials.

The new FDA guidelines specify precautions that are to be taken in clinical trials that include women of childbearing potential. Investigators should obtain the informed consent of the women, and the investigator should advise participants to take precautions to prevent the exposure of a fetus to potentially toxic drugs. Information should be provided about the risk of fetal toxicity and should recommend the use of contraception or abstinence. But the guidelines still recommend that large-scale exposure of women of childbearing potential should not take place until after the results of animal toxicity tests are analyzed.

The guidelines contain exceptions and other provisions that weaken their ability to affect change in how drug research is actually performed. For example, the guidelines state that the FDA does not perceive a need "for requiring that women in general or women of childbearing potential be included in particular trials" (DHHS 1993, 39408; see also Rothenberg 1996, note 262). Also, the guidelines do not have the force of law. They are only recommended procedures to be followed and may or may not affect the approval of the drug. The FDA recognizes this drawback and states, "[T]he change in FDA's policy will not, by itself, cause drug companies or IRB's to alter restrictions they might impose on the participation of women of childbearing potential" (39408; see also Rothenberg 1996, 1241). It further states that it is "confident that the interplay of ethical, social, medical, legal, and political forces will allow greater participation of women in the early stages of clinical trials" (39408–9). The FDA is only "determined to remove the unnecessary Federal impediment to inclusion of women" (39409).

In 1997, the FDA Modernization Act was passed, calling for the examination of regulations regarding women and minorities; subsequently, a working group found that no revision was needed (DHHS, FDA 1998). In 1998, the FDA issued a new regulation that *requires* that safety and efficacy data already collected be presented separately by gender and racial subgroups in new drug applications. Though the 1998 regulations have the force of law, they do not include specifications about the appropriate number or percentage of women in clinical trials, nor does it require that the data be analyzed by gender; it only requires that the data be supplied separately. Another regulation enacted in 2000 allows the FDA to halt drug trials for life-threatening conditions if eligible men or women are excluded on the basis of their reproductive potential (DHHS, FDA 2000).

The FDA practices were once again analyzed by the GAO in 2001. They found that about one-third of the new drug applications failed to meet the 1998 data presentation requirements regarding gender and no trials for life-threatening conditions had been suspended, though the GAO did not evaluate whether the FDA should have invoked this authority. The FDA has no tracking system in place to monitor such problems and did not even know that the regulations were not being met. All of the applications included enough women to demonstrate the effectiveness of the drug in women; in fact, women were about 50 percent of participants in over one-half of the new drug applications they reviewed. But interestingly, the stages of trials in which women were included varied. Women were about 20 percent of participants in initial, small-scale trials used to set dosage levels but composed more than one-half of the participants in subsequent larger trials (GAO 2001). This is important because the early studies provide information regarding a drug's toxicity and safe dosage levels for later trials. And many of the new drug applications showed significant sex differences in a how a drug is absorbed, distributed, metabolized, excreted, and concentrated in the bloodstream. (See Table 2.1 for a listing of events as they related to the FDA.)

In conclusion, by 1993 the NIH and FDA had revised their policies regarding the inclusion of women in clinical trials, though the NIH enacted more radical alterations; most importantly, the NIH regulations are written into law and no research will be funded that does not adhere to them. There is no similar guarantee with the FDA and new drug applications. In short, the NIH rules are mandatory regulations and the FDA rules are only voluntary inducements. And the later regulations, such as the requirement of presenting data by gender, are not being followed in many cases. As one author noted, the NIH has moved from "encouragement to requirement" and the FDA has moved from "exclusion to encouragement" (Rothenberg 1996, 1230,1236).

Why Were Clinical Research Policies Revised in the 1990s?

Various factors can account for the change in clinical research policies; these include social and cultural factors, as well as changes in the political environment of the United States. But specifically, the work of women's health care activists was the largest contributing factor,

Table 2.1. **History of Clinical Research Policies at the NIH and the FDA**

	NIH	*FDA*
1977		Policy excluding women of childbearing potential instituted
1985	Report of the PHS Task Force on Women's Health Issues	
1986	Policy *urging* the inclusion of women in clinical research instituted	
1990	GAO Report; ORWH established	
1991	Policy *requiring* inclusion of women in clinical research instituted; Bernadine Healy appointed director; Women's Health Initiative began	
1992		GAO Report
1993	NIH Revitalization Act	FDA ussues new Guidelines
1994	NIH isues new Guidelines; NIH Outreach Notebook published	
1998		FDA issues new Regulations
2001		GAO Report

though their efforts may have been in vain if the social, cultural, and political changes had not simultaneously occurred.

Social, Cultural, and Political Factors

In general, women's rights issues were receiving more public attention. Sexual harassment received widespread attention as a result of Anita Hill's charges against Clarence Thomas during his Senate Confirmation hearings in 1991 (for a full description of this event, see Davis, chapter 5 herein). Problems of domestic violence had also gained increasing attention by the early 1990s, as did persistent gender-based pay inequities, the glass ceiling, erosion of abortion rights, women's double shift, and childcare problems of working women. In general, by the late 1980s and early '90s, calls for women's rights and equality were no longer considered to be the anthems of radical women liberationists; they had become accepted, legitimate concerns that government needed to address and enforce when appropriate. Regarding women and medical research, the general public was not initially aware of the problem,

but the increasing amount of public attention focused upon women's issues hindered the ability of government institutions and officials to keep a blind eye turned toward the problem.

Relatedly, demographics played a role. Many baby boom generation women were now of an age to be concerned about more than just abortion rights; issues of menopause, osteoporosis, heart disease, and breast cancer were a few of the concerns that middle-aged women had and they found a dearth of information on such subjects. Furthermore, many more women had entered the medical profession and they began to question the lack of attention to women's health issues. And many more women had entered Congress and attained high-ranking positions in agencies such as the PHS, NIH, and FDA. In fact, Johnson and Fee (1994) note that it was pressure from within NIH that resulted in the PHS Task Force on Women's Issues 1985 Report calling for more research on women's health concerns.

Furthermore, problems of the health care system were gaining increasing public attention. Some cite the health care focused campaign of Harris Wofford of Pennsylvania in 1991 as the point at which the new emphasis on health care arose (Skocpol 1995). Also, Bill Clinton was elected president in 1992, along with one of the most powerful and influential first ladies, Hillary Rodham Clinton. Though President Clinton was not specifically concerned with the issue of women and medical research, he was concerned about health care and equity issues and this may have changed the mood of the administration as a whole. President Clinton's support was paramount; one of his first acts in office was to sign the 1993 NIH Revitalization Act. President George H. W. Bush had previously vetoed the bill.

Another important item to consider is the change brought about by the AIDS epidemic and AIDS activists (see Christensen, chapter 3 herein). In the 1980s, AIDS activists pressured the federal government and the FDA for access to unapproved drugs and treatments. This was the first real challenge to some of the FDA's protectionist type policies. In 1987, the FDA issued regulations expanding access to experimental drugs used to treat serious and life-threatening illnesses (Johnson and Fee 1994, 5). Moreover, AIDS activists successfully pressured the federal government to spend more money on AIDS research.

Women's Health Care Activists

The arduous work of many women's health care activists is the most important variable explaining the revamping of the clinical research

policies. Though many people supported the policy changes, they would not have occurred if the activists had not ferverently and relentlessly pursued and pressured the NIH, FDA, and Congress. The activists include outsiders and insiders—people in high-ranking positions in government. The partnership of the two groups was crucial to their success.

Representatives Patricia Schroeder (D-CO) and Olympia Snowe (R-ME) were key members of Congress—insiders—who could also be described as policy entrepreneurs. Policy entrepreneurs are advocates "who are willing to invest their resources—time, energy, reputation, money—to promote a position" and are found in many locations (Kingdon 1984, 188). Representatives Schroeder and Snowe, along with Waxman, requested that the GAO reports regarding the FDA and NIH be performed; Waxman held hearings in his subcommittee; Schroeder and Snowe's committees held hearings; Schroeder and Snowe testified at other committee hearings; and Schroeder and Snowe worked with the NIH, Bernadine Healy, and the ORWH, as well as many nonprofit organizations such as the SAWHR, to instigate the changes. These actors, because of their interest and positions in Congress, were instrumental in bringing the issue to the fore. The outsiders—primarily SAWHR—were also extremely important, but without the GAO Report, hearings, and bills, it is unlikely that the policy changes would have occurred.

The groups and individuals advocating changes in NIH regulations and laws to ensure that women are included in research performed or funded by any NIH agency included some researchers, NIH officials, PHS officials, women's health advocates, some members of Congress such as Henry Waxman, Patricia Schroeder, and Olympia Snowe (and other members of the CCWI). GAO officials, particularly Mark Nadel, supported the NIH and FDA adopting more gender inclusive measures. On the other hand, some groups and individuals advocated keeping the status quo of excluding or underrepresenting women (and minorities), or, even if they did support such inclusion, they did not want such regulations mandated or written into law. This group was composed of some researchers and some NIH officials. Table 2.2 lists the specific components of each coalition.

Regarding the FDA, two such coalitions can be described that contain some similar and some different members, but it is more difficult to specify the actual coalitions. Some people and organizations advocated the lifting of the 1977 ban and supported the greater inclusion of

women but did not want such inclusion to be required, and others wanted it to be a mandate; there is no evidence of any group or person advocating the retention of the 1977 ban. Thus, the organizations that did not support a policy change were pharmaceutical companies and researchers that did not want any more regulations passed and certainly not ones that increased their research and reporting requirements. But many pharmaceutical organizations such as the American College of Clinical Pharmacy (ACCP) did support the FDA policy change. (See Table 2.2 for a complete listing.)

Framing of the Problem

One important factor is how the activists defined the problem of the underrepresentation or exclusion of women. For both agencies, the exclusionary, protectionist policies that were once supported now appeared to be discriminatory and harmful toward women because of advancements of the women's movement, success of the AIDS activists, and other advancements in medical technology and research.

Women's groups saw the issue as one of women's equality—as one of women's inclusion in what were once male-dominated arenas and ways of thinking—and the inequality was affecting women's health. On the scientific/medical side, many people saw the problem as one of the proper type and mix of subjects that comprise a good clinical study and allow for a valid analysis of gender differences. And with regard to the FDA, a third issue comes into play: should the FDA, Congress, or any agency mandate the specific details of clinical trials performed in private settings?

For the NIH, the problem was defined as a medical, political, and social issue. Inadequate and inaccurate medical knowledge was being accrued by standard clinical research practices and this problem was articulated by some parts of the medical/research community and government institutions and actors. Given the push of the women's health movement, this medical issue also became framed as an issue of equality or equity. Women were not being treated equitably in such a health care system; "there is . . . no reason to treat women as second class citizens ever again," Rep. Marilyn Lloyd (D-TN) notes (U.S. Congress, House 1990, 1). Schiebinger (2003) describes this as "taxation without representation" (975).

For the FDA, the issue was less a medical, political, or social issue, but was thought more of as a regulatory problem by the FDA and oth-

Table 2.2. Coalitions of the NIH and FDA Clinical Research Policies

NIH	*FDA*
*Inclusionary Coalition**	*Inclusionary Coalition*
Organizations: American Medical Association (AMA) American Medical Women's Association (AMWA) Society for the Advancement of Women's Health Research (SAWHR) National Women's Health Network Boston Women's Health Collective Older Women's League (OWL) American Association of University Women (AAUW) American College of Clinical Pharmacy (ACCP)	Organizations: American College of Clinical Pharmacy (ACCP) American Medical Association (AMA) American Psychiatric Association (APA) American Psychological Association National Organization for Women (NOW) Older Women's League (OWL) Society for the Advancement of Women's Health Research (SAWHR)
Federal Government Employees and Groups: Mark Nadel, GAO Office of Research on Women's Health, NIH Vivian Pinn, ORWH	Federal Government Employees and Groups: Mark Nadel, GAO Ruth Merkatz, FDA Ruth Kirschstein (various govt. positions) FDA Advisory Com. on Women's Health Issues Public Health Service (PHS) Coordinating Committee on Women's Health Issues (formerly Task Force on Women's Health Issues)
Members of Congress and Committees: Patricia Schroeder Olympia Snowe Barbara Mikluski Henry Waxman Edward Kennedy Subcommittee on Health and the Environment, Committee on Energy and Commerce, House Congressional Caucus for Women's Issues	Members of Congress and Committees: Patricia Schroeder Olympia Snowe Barbara Mikluski Henry Waxman Subcommittee on Health and the Environment, Committee on Energy and Commerce, House Congressional Caucus for Women's Issues
Exclusionary Coalition†	*Exclusionary Coalition*
Some NIH Researchers Bernadine Healy, director of NIH Some nongovernment researchers	Health Industry Manufacturers Association (HIMA) Pharmaceutical Manufacturers Association (PMA) American Pharmaceutical Association (AphA)

Source: Author's compilation from congressional hearings, journal articles, official comments about the changes, documents, and interviews. See Appendix.

*Inclusionary Coalition denotes those groups and organizations that advocated a policy change mandating/recommending the inclusion of women in clinical research.

†Exclusionary Coalition denotes groups and organizations that advocated keeping the status quo and, with regard to the FDA, not having any more regulations with regard to reporting requirements for new drug applications.

ers, and as a liability and cost problem by the pharmaceutical compa-
nies. What regulations or restrictions should the FDA impose on
private drug researchers and companies? The predominant feature of
the 1993 FDA policy change was the lifting of the ban on the inclusion
of women of childbearing potential in early phases of drug testing. This
could be viewed as a deregulatory move—though certainly backed up
by medical evidence. But that the issue within the FDA was more often
framed as a regulatory problem by many actors is another reason that
can help explain the different policy response. And of course, this is not
too surprising since the FDA primarily regulates, not funds, pharma-
ceutical research.

Novel Strategies and Political Tactics

The activists pursued novel strategies and tactics in order to have
their issues addressed. Instead of rejecting the medical establishment as
the activists of the 1960s and '70s did, the 1990 activists tried to work
within the system to alter it. This strategy served them well and allowed
them to institute many newfound changes.

One strategy with regard to clinical research was the collection of
research and data regarding the underrepresentation and exclusion of
women. The GAO reports served an important role in this situation.
The 1990 GAO report about the progress (or lack thereof) of the
1986–87 NIH policy was a catalyst to the stricter policy and then legis-
lative mandate for the inclusion of women in all NIH-funded research
(GAO 1990). The report was generated by a respected institution and
the evidence it presented unequivocally supported a stricter implemen-
tation of the policy, and this recommendation was adopted.

The hearing at which the GAO report was presented was carefully
orchestrated by the activists. They made sure the media was present so
journalists could publicize the findings. This proved successful in that
many articles were then published in magazines and newspapers. Thus
the tactics, along with the definition of the problem, proved instrumen-
tal to the success of the activists.

Regarding the FDA, a similar GAO report was issued. In 1992, the
GAO found that in 60 percent of drug trials, women were underrepre-
sented, though enough women were included to detect gender-related
differences (GAO 1992). In about one-half of the trials, data were not
analyzed to detect such differences. The GAO recommended that the
FDA *require* drug manufacturers to analyze data by gender and that

they issue more explicit policy guidance regarding when enough women are included to assess potential gender differences. Ultimately, the FDA did not follow the first recommendation but they did provide more information about how to determine when enough women are included in a trial, the second recommendation.

With regard to the FDA, other analyses of the issue were achieved. In 1992, the FDA reviewed its new drug applications for that year and found that women were adequately represented in drug trials and that its guidelines calling for drug manufacturers to analyze data on drug effectiveness by gender were clear. In addition, the American Pharmaceutical Association (APhA) issued a background paper on representative populations in trials and concluded "further policy development was unnecessary because current policies and subject representation in trials were appropriate" (Wermeling and Selwitz 1993, 907). Furthermore, the Pharmaceutical Manufacturers Association (PMA) conducted a survey in 1991 of thirty-three companies regarding their practices for including women in drug development. They found that all the companies collect data on gender; over three-quarters said they deliberately recruit representative numbers of women; and most said they rarely detect gender differences and, when they do, they are rarely clinically significant (PMA 1991). Therefore conflicting data and analyses of the issue were presented, making the problem appear ambiguous.

CONCLUSION

In conclusion, many social, cultural, and political factors greatly influenced and worked in conjunction with the skilled activists. Their moving of the problem from the medical arena to the political arena and their framing of the problem as one of discrimination and inequity was instrumental. Insiders and outsiders worked in partnership to pursue women's health issues, though the actions of insiders were paramount. It was necessary for all such factors to be present in one period of time for the policy changes to be accomplished. By the early 1990s, both the NIH and FDA had revised their policies regarding the inclusion of women in clinical trials, and great strides have been made in women's health as a result.

APPENDIX

The following documents were used to compile the Coalitions described in Table 2.2.

Hearings:

U.S. Congress. House. Subcommittee on Health and the Environment. Committee on Energy and Commerce. 1991. *NIH Reauthorization.* 102nd Congress, 1st Session, April 16. Washington, D.C.:U.S. Government Printing Office.

U.S. Congress. House. Subcommittee on Housing and Consumer Interests. Select Committee on Aging. 1990. *Women Health Care Consumers: Short-Changed on Medical Research and Treatment.* 101st Congress, 2nd Session, July 24. Washington, D.C.:U.S. Government Printing Office.

U.S. Congress. House. Subcommittee on Regulation, Business, Opportunities, and Energy. Committee on Small Business. 1992. *U.S. Pharmaceutical Research and Development, and Its Impact on Women's Health: The Technology Deficit in Contraception, Cancer, and Reproductive Disease and Conditions.* 102nd Congress, 2nd Session, May 8. Washington, D.C.:U.S. Government Printing Office.

U.S. Congress. Senate. Committee on Labor and Human Resources. 1992. *Women's Health: Ensuring Quality and Equity in Biomedical Research.* 102nd Congress, 2nd Session, June 29. Washington, D.C.:U.S. Government Printing Office.

U.S. Congress. Senate. Subcommittee on Aging. Committee on Labor and Human Resources. 1991. *The Role of Menopause and Gender Difference in Aging on the Development of Disease in Mid-life and Older Women.* 102nd Congress, 1st Session, April 19. Washington, D.C.:U.S. Government Printing Office.

Reports:

U.S. Dept. of Health and Human Services. Food and Drug Administration. 1995. "Gender Studies in Product Development: Scientific Issues and Approaches." Rockville, MD.

U.S. Dept. of Health and Human Services. National Institutes of Health. Office of Research on Women's Health. 1992. *Report of the National Institutes of Health: Opportunities for Research on Women's Health.* September. Bethesda, MD: National Institutes of Health, NIH Publication No. 92-3457.

U.S. Dept. of Health and Human Services. Public Health Service. 1985. *Report of the Public Health Service Task Force on Women's Health*

Issues, Volumes I and II. May. Hyattsville, MD: Public Health Service. DHHS Pub. No. (PHS):85-50206.

U.S. General Accounting Office (GAO). 1990. "National Institutes of Health: Problems in Implementing Policy on Women in Study Populations." Testimony of Mark Nadel before the Subcommittee on Health and the Environment, Committee on Energy and Commerce, House of Representatives. Washington, D.C.:Government Printing Office.

———. 1992. "Women's Health: FDA Needs to Ensure More Study of Gender Differences in Prescription Drug Testing." Washington, D.C. GAO/HRD-93–17.

Interviews:

Greenberg, Phyllis. 1998. Personal Interview. March 3.
Haseltine, Florence. 1998. Personal Interview. March 4.
Howes, Joann. 1998. Personal Interview. March 9.
Primmer, Lesley. 1998. Personal Interview. March 26.

Articles:

American College of Clinical Pharmacy. 1993. "ACCP White Paper: Women as Research Subjects." *Pharmacotherapy* 13(5):534–42.
Hayunga, Eugene, and Vivian Pinn. 1996. "NIH Response to Researchers' Concerns." *Applied Clinical Trials* 5(Nov., 11):59–64.
Merkatz, Ruth and Suzanne Junod. 1994. "Historical Background of Changes in FDA Policy on the Study and Evaluation of Drugs in Women." *Academic Medicine* 69 (September):703–7.

Miscellaneous:

U.S. Dept. of Health and Human Services. Food and Drug Administration. 1993. Written comments received regarding proposed "Guideline for the Study and Evaluation of Gender Differences in the Clinical Evaluation of Drugs."

3

Vessels, Vectors, and Vulnerability: Women in the U.S. HIV/AIDS Epidemic

Kimberly Christensen

> Increasingly, then, the face of AIDS is a woman's face. However, not all women are at increased risk of infection with HIV. Among women, as among men, the incidence of new infections has a striking pattern. It is poor women, by and large, who must wrestle with this grave danger. The cumulative effects of lives of poverty and sexual exploitation force many women into circumstances where [HIV risk is greatly heightened]. —Simmons et al., 1996

ACCORDING TO THE CENTERS FOR DISEASE CONTROL (CDC), WOMEN constitute approximately 20 percent of adults and adolescents diagnosed with Acquired Immune Deficiency Syndrome (AIDS)[1] in the United States, a rate that has grown steadily since the early days of the epidemic (CDC 2004a). Even more ominous for women's health activists are the findings on HIV infections among thirteen to twenty-four year olds, as infections in this age group are indicative of future trends in the epidemic. In 2000, in the thirty-four states and localities with confidential HIV reporting, adult and adolescent females composed an astounding 47 percent of those newly diagnosed with HIV infection (CDC 2004a).

But the burden of the HIV/AIDS epidemic has not been borne equally by all American women. Poor women, especially poor women of color, have been disproportionately affected. "African American and Hispanic women together represent less than one-fourth of all U.S. women, yet they account for more than three-fourths (78 percent) of AIDS cases reported to date among women" (CDC 2004a). Gender, race, and especially class inequalities form a matrix of vulnerability that

dramatically increases the chances that some women, and their children, will contract HIV.

Economic inequality can greatly exacerbate HIV risk. Despite significant progress in the past generation, white women who work full time still only make about three-quarters as much as white male full-time workers (DOL 2006). The economic situation for women of color is even worse. For instance, African American women who work full time earn only about 90 percent of what white women earn, which means they earn only about 68 percent of what white men earn (DOL 2006). And, due to the expense and scarcity of childcare, many mothers who would like to work full time are unable to do so, further lowering their incomes (Crittenden 2002; Folbre, 2001). The result is that many women, particularly women who have children, are economically dependent upon men—husbands, boyfriends, exes, etc.—for their own and their children's comfort and even survival.

Women who are economically dependent on their sexual partners are much less able to demand, and enforce, consistent condom use, even if they suspect that their partners are engaging in risky behaviors such as infidelity or drug use (Weeks 1995). This vulnerability is exacerbated for women who have experienced or been threatened with domestic violence. And while domestic violence exists among all classes and races, the ability to escape from violence is very much related to income.[2] Clearly, the intersections of economic discrimination by race and gender, insufficient family support policies, and the continued existence of domestic violence combine to dramatically increase poor women's vulnerability to HIV infection.[3]

This chapter will first explore several reasons why women's vulnerability to HIV/AIDS has not received adequate attention by researchers, journalists, and educators, particularly during the early days of the epidemic. Next, the resulting sexist conceptualization of HIV/AIDS and how it has skewed many aspects of AIDS policy from data collection to research priorities to the very definition of AIDS will be discussed. Third, the responses to these problems by one group of feminist AIDS activists, the Women's Caucus of ACT UP/NY, of which I was a member, and the results of these efforts, will be considered. Finally, the several remaining challenges for feminist health activists who wish to slow the spread of this devastating epidemic among women today will be addressed.

INADEQUATE ATTENTION TO WOMEN'S POSITION
IN THE EARLY STAGES OF THE EPIDEMIC

It is common knowledge that AIDS was first discovered in 1981 among previously healthy young gay men who began dying of formerly rare diseases such as PCP pneumonia and Kaposi's sarcoma.[4] But there is some evidence that HIV/AIDS may have existed for years in low-income communities of color and may have gone undetected because of these communities' lack of access to medical care. For instance, Norwood (1988) reports that in the late 1970s and throughout the 1980s, there were significant and unexplained increases in deaths from pneumonia, tuberculosis, rare parasitic infections, nephritis, and chronic obstructive pulmonary disease among low-income women in New York City; Newark, New Jersey; Hartford, Connecticut; and Washington, D.C. These exact areas would later become known as epicenters of the national AIDS epidemic (Norwood 1988).[5] By contrast, Idaho, which would later have the lowest per-capita rate of HIV/AIDS, saw no increase in these causes of death during this period (Norwood 1988, 65). Similarly, Denenberg (1990) reports that between 1981 and 1988, "there was an unexplained and significant increase in deaths from pneumonia and influenza in women aged 15 to 44 in several urban centers in the United States" (33). Denenberg theorizes that these deaths may also have been the result of undiagnosed opportunistic infections due to HIV.

We will probably never know when HIV/AIDS first began to infect—and to kill—low-income women in this country. But this lack of attention to their situation would, unfortunately, continue past the initial stages of the epidemic. The reasons women's (particularly low-income women's) vulnerability to HIV/AIDS did not receive adequate consideration include homophobia, the myth of "First World Uniqueness" of HIV/AIDS, overall inattention to the health problems of the poor, and sexism.

Homophobia

Due to the population in which it was initially discovered (gay men), AIDS was initially portrayed in the media as a gay male disease. Reports of various aspects of gay male sexual practices proliferated and such practices were supposedly responsible for the disease's spread.[6] And since it was assumed that men who have sex with men *only* have

sex with men and not with women, it was assumed that AIDS would stay confined within this population. We know now, of course, that HIV can be passed very efficiently during ordinary heterosexual intercourse.[7] We also know that gay men are not the only people having anal sex; the practice is a significant method of birth control (and of preserving technical virginity) in some communities. In addition, many men, whether or not they define themselves as gay, have sex with both men and women. But the conceptualization of AIDS as a gay male disease lodged in the public mind and, unfortunately, in the minds of many public officials and AIDS researchers. Combined with the country's virulent homophobia, this stereotyping undoubtedly reduced early data-gathering, funding for AIDS research, and, especially, public attention to this dangerous disease.

The Myth of "First World Uniqueness"

Even though it became clear that women in the Developing World were contracting HIV/AIDS at an astonishing rate (a rate at least as high as their male counterparts), poor women in the United States and other developed countries were still not considered to be at high risk for HIV/AIDS. Possible explanations abounded as to why women in developing countries were uniquely vulnerable. Was it female genital mutilation? Possibly, even though the sub-Saharan African regions in which HIV prevalence among women was the highest did not match the areas where female genital mutilation occurs. Was it male promiscuity? Promiscuity is not unique to developing countries, of course. Was it the presence of other sexually transmitted diseases (STDs) that make HIV infection more likely? Possibly, but STDs are also not unique to the developing world. Nevertheless, many people of the "First World" searched for explanations, no matter how irrational, as to why they were not vulnerable to the disease.

But as HIV prevalence among poor American women of color approached or exceeded that of poor American men of color, it became frighteningly clear that the developing world pattern of HIV infection was not a Developing World pattern at all; rather, it was a pattern of HIV infection that occurred among poor and disenfranchised communities whatever their geographic location.

Inattention to the Health Problems of the Poor

In part, the lack of attention to HIV infection in poor women is just a continuation of the persistent lack of interest in the health problems

of the poor at home and abroad. Diseases of the poor have never been profitable for pharmaceutical companies to research, as the potential consumers of any resulting drugs or treatments will probably not be able to afford them.[8] In theory, government-funded biomedical research could compensate for this inadequacy, but typically has not done so. In addition, the poor of the United States do not constitute a well-organized voting bloc; they are significantly less likely to register, vote, or contribute to political candidates than those with more resources (Overton 2002). Hence, their health concerns are rarely acknowledged or addressed.

Sexism

Even though AIDS was thought of as a gay man's disease, when it was acknowledged that heterosexual women were at risk for HIV/AIDS, they were often treated primarily as "vessels or vectors";[9] i.e., as vessels who might infect their children and/or as potential vectors of transmission to men (Christensen 1990; Denenberg 1990, 31; Fadden et al. 1996, 252–53; Leonard and Thistlethwaite 1990, 179; Pies 1995, 323; Patton 1990, 99–100;).[10] As Fadden et al. (1996) state, "until recently, the only significant interest in women in the huge national research effort on AIDS concerned women's potential to infect others, either as sexual partners (especially as prostitutes) or, more significantly, as gestators. The health interests of women themselves largely were ignored" (252–53).

Clearly, until women's lives are valued as highly as those of their fetuses and/or their male sexual partners, it will be impossible to adequately address women's position in this epidemic. The next section will discuss two results of this devaluation: the sexist definition of AIDS and the exclusion of women from crucial clinical trials.

RESULTS OF THE FAULTY CONCEPTUALIZATION OF HIV/AIDS

This inaccurate conceptualization of AIDS as a white, gay, male disease has affected many aspects of public policy regarding the AIDS crisis, from data collection to research priorities. This section will briefly examine two important examples: the sexist definition of AIDS and the exclusion of women from experimental AIDS drug trials. Next, how one group of feminist AIDS activists, the women's caucus of ACT UP/

NY, struggled to bring these problems to public attention and to change government AIDS policies concerning women, will be explored.

The Sexist Definition of AIDS

Unlike most diseases, AIDS is a *syndrome*, and the immune deficiencies that accompany persistent HIV infection can manifest themselves in a variety of medical conditions or symptoms. These manifestations vary depending on a range of factors—from geography (e.g., what fungal organisms are present in the soil in ones geographic area?); to one's contact with animals (e.g., pet cats and birds can carry the organism that causes toxoplasmosis); to one's class and access to medical care (e.g., whether one has previous exposure to tuberculosis); and to one's gender (e.g., an HIV-positive man will tend to get candidiasis in his throat, while an HIV positive woman might get the same organism in her vagina).

Due to the wide variety of possible manifestations of HIV infection, the definition of AIDS will necessarily be epidemiologically based, i.e., it will be based upon those symptoms and diseases that are actually seen in the HIV-infected population. Prior to 1992, AIDS was officially defined as the presence of antibodies to HIV, combined with one of a number of indicator diseases that indicate immune suppression. But given the prevailing conceptualization of AIDS as a gay male disease, the indicator diseases that were used to signal AIDS were overwhelmingly those which tended to occur in white, gay men. For example, although both HIV-infected men and women tend to contract PCP pneumonia, for reasons not well understood, HIV-infected women also tend to contract atypical bacterial pneumonia. Women also may be more likely to contract cryptococcosis, a potentially life-threatening fungal infection, and to develop anemia and other blood abnormalities (Caschetta 1992, 2). HIV infected women also tend to suffer from very aggressive forms of pelvic inflammatory disease and invasive cervical cancer, diseases that are obviously not on the "indicator list" for gay men (Anastos and Marte 1989; Wilson and Lein 1992). Thus, many symptomatic (sometimes terminally ill) HIV-infected women were systematically excluded from having officially defined AIDS. Quoting Denenberg: "Since the CDC definition for AIDS was developed from observations of men, women often die of an [HIV-related] opportunistic infection before they are even considered eligible for an actual AIDS

diagnosis. Women are thus excluded from the total statistical picture" (Denenberg, "What the Numbers Mean," 1990, p. 2).

This official definition of AIDS is important for at least three reasons. First, although official AIDS cases must legally be reported to the CDC, until recently, cases of HIV infection were not reported; they were only estimated. Thus, if women with symptomatic HIV infection were systematically undercounted, government data on the entire epidemic were systematically biased. The data therefore not only underestimated the impact of the epidemic on women, they also tended to underestimate the impact of the epidemic on low-income communities of color where women are more heavily represented among the HIV infected. Accurate HIV/AIDS data are crucial to properly informing the public regarding who is at risk, and to setting priorities for HIV/AIDS educational policies. Accurate data are also essential for setting priorities, and allocating monies, for HIV/AIDS-related research. Without accurate epidemiological data, public health officials are unable to develop successful educational and benefit programs or to set relevant research priorities.

Second, one's eligibility for various social and healthcare programs, such as Social Security Disability Insurance (SSI/SSDI) and Medicare, often depends on being officially diagnosed with AIDS, not just HIV infection. Again, quoting Denenberg (1990): "[Women] not only won't get counted, they also won't get treated, they won't qualify for health benefits, child care, rent subsidies, or other support services PWAs (People with AIDS) and AIDS activists have pressured the government to provide, and they won't be provided with information on how to take care of themselves and how to protect the people with whom they are having sex or sharing needles. Statistics, in other words, only count women who fit into the CDC's narrow definition for AIDS; all the other women just remain invisible" (Denenberg, "What the Numbers Mean," 1990, p. 4). The impact of the denial of these benefits and services on the lives of individual women and their children can be devastating.

Third, most HIV-infected people are not diagnosed by AIDS specialists, but by general or family practitioners, or, in the case of women, by their OB/GYNs. It is therefore essential that OB/GYNs and other front-line doctors are aware of the types of symptoms that may indicate early HIV infection. This can result in earlier diagnosis and treatment, and, hence, in longer and more symptom-free lives. But if the conditions that characterize early HIV infection in women are excluded from the

definition of AIDS, most practitioners will not associate their patients' symptoms with HIV. Hence, women with aggressive pelvic inflammatory disease or unusually aggressive cervical cancer, for example, will not be tested for HIV. Thus, such women will not be diagnosed until much later in the course of their diseases when effective treatment is much more difficult and much less successful (Anastos and Marte 1989, 6–7; Corea 1992; Denenberg 1990, 3–4).

The importance of this factor is demonstrated by a simple comparison: in 1990, women newly diagnosed with AIDS lived about half as long as men *of their same race and class background*. But a later study *that corrected for the time of diagnosis in relation to the time of infection* showed that women had lifespans that were nearly identical to men (Caschetta 1992, 1). In other words, it is primarily lack of access to care—and practitioner ignorance regarding the symptoms of HIV disease in women, not any inherent biological differences, that are causing HIV-infected women to die faster than HIV-infected men.

The Exclusion of Women from Clinical Trials for Experimental AIDS Drugs

As was stated in chapter 2, the traditional rationale for the exclusion of women from clinical drug trials has been twofold. First, an experimental drug represents a potential source of harm to a potential fetus and, therefore, a potential financial liability to the drug company sponsoring the trial. And, second, premenopausal women's hormonal cycles, higher percentage of body fat, and other biological differences might affect the metabolism and efficacy of the experimental drug and interfere with the results of a trial. (Of course, one could easily argue that these differences are precisely why experimental drugs *must* be tested on women—in the controlled and monitored atmosphere of a clinical trial—before being released to the public and taken by women patients.)

In the era before combination AIDS drug therapy, often an HIV-infected person's only hope for survival was to enroll in an experimental drug trial and pray that s/he didn't get assigned to the placebo wing of the trial. Thus, in the case of AIDS drug trials, the traditional policy of excluding women was profoundly inhumane. It also often bordered on the absurd. In one case, a seriously ill HIV-infected woman who had had a complete hysterectomy (and hence, had neither potential risk to a potential fetus nor "disruptive" hormonal changes) was excluded from a trial for a tat-gene-inhibitor, a then-promising new drug being

tested by Hoffman-LaRoche (ACT UP/NY 1993). In other cases, women who agreed to take birth control pills or who had been surgically sterilized were excluded from drug trials that might have prolonged their lives.

In addition, in the case of HIV/AIDS, one of the traditional rationales for exclusion—potential harm to the fetus—was ironically not only irrelevant, but tragically reversed. A pregnant woman's viral load (virus circulating in her blood) during pregnancy and, especially delivery, strongly correlates with the chances that she will transmit HIV to her child. Women were systematically excluded from trials that could have reduced their viral loads, and thereby could have *prevented* the transmission of this deadly virus to their children.

Nevertheless, as Fadden et al. (1996) demonstrate, the participation rate of women in AIDS clinical drug trials in the early days of the epidemic was abysmally low.[11] Quoting Fadden et al. (1996), "An abstract presented in 1991 at the VIIth International Conference on AIDS reported that women accounted for only 6.7% of ACTG [AIDS Clinical Trials Group] study entrants. . . . Women of childbearing potential (therefore, almost all HIV-infected women) were excluded from some of the earliest trials" (260–61). As a sign carried by the AIDS Coalition to Unleash Power (ACT UP) and Women's Health Action Mobilization (WHAM) activists on International Women's Day in 1990 stated, "Male mice have a better chance of getting experimental AIDS drugs than women!"

ACTIVISTS' RESPONSES TO THESE PROBLEMS

This section will briefly recount how one AIDS activist group, ACT UP (in particular, ACT UP/NY's Women's Caucus) responded to these problems of a sexist definition of AIDS and women's exclusion from clinical drug trials.[12] Although there is still much work to be done, activists were successful in changing some of the exclusionary practices of both government agencies and pharmaceutical companies.

In March of 1987, ACT UP/NY was formed in response to the media silence and government and corporate inaction surrounding the mounting AIDS crisis. ACT UP's philosophy and tactics built upon the history of the Lesbian/Gay/Bisexual/Transgendered (LGBT) liberation movement, the women's liberation and health movements, and the heritage of nonviolent direct action of the civil rights movement. We recited

at the beginning of every meeting: "We are a diverse, nonpartisan group of individuals, united in anger and dedicated to direct action to end the AIDS crisis." As a direct action group, ACT UP specialized in media-savvy nonviolent civil disobedience designed to pressure corporate and government officials into changing their HIV/AIDS policies.

ACT UP/NY's first action was a sit-in on Wall Street to protest Bur-roughs-Wellcome's perceived price gouging on their drug AZT and foot-dragging by the government in testing potential anti-HIV agents. Shortly after the demonstration, the Food and Drug Administration (FDA) announced a two-year reduction in its approval process for drugs intended to treat life-threatening illnesses; on the *CBS Evening News*, Dan Rather credited ACT UP with the victory (Heiwa-Loving 1997). Other early ACT UP demonstrations targeted

- the White House to protest the Reagan administration's complete lack of an AIDS policy;
- New York City Hall for the inadequacy of Mayor Koch's AIDS policies;
- Northwest Orient airlines for refusing to allow people with AIDS to board their flights; and
- the New York Memorial Sloan-Kettering offices of the AIDS Treatment Evaluation Units (ATEU), demanding more clinical trials, more partici-pants admitted to existing trials, and that more diverse populations be ad-mitted to the trials (ACT UP 2004).

Other important early actions included protests at all of the major international AIDS conferences demanding significant changes in re-search priorities. And in December 1989, activists waged the controver-sial "Stop the Church!" demonstration at St. Patrick's Cathedral in New York City, to protest the Church's long-standing opposition to condom use to prevent HIV transmission.[13]

In January of 1988, the popular women's magazine *Cosmopolitan*, published an article by psychiatrist Robert Gould claiming that "there is hardly any danger of contracting AIDS through ordinary sexual in-tercourse" (Gould 1988; Rossi 1998, 39). At a time when women al-ready constituted 8 percent of the AIDS caseload, his outrageousness claims prompted the women of ACT UP to form the first of many incar-nations of the Women's Caucus. Hundreds of people protested at *Cosmo* headquarters, demanding a retraction. Although Gould and *Cosmo* edi-tor Helen Gurley Brown refused to recant, the demonstration gener-ated a great deal of publicity and made the point that women who

engaged in ordinary sexual intercourse were not necessarily safe from HIV/AIDS.

Although ACT UP/NY's Women's Caucus, as an official ACT UP Committee, met separately from the larger group, we were all also active members of that broader organization and participated in their demonstrations and other actions. We also demanded, with various degrees of success, that our predominantly white and male colleagues in ACT UP incorporate the interests of women and people of color into their actions, demands, and strategies.

Changing the Sexist Definition of AIDS

By the late 1980s, it was clear to both women AIDS activists and frontline AIDS doctors that the CDC's definition of AIDS was inadequate and was resulting in the systematic undercounting of women with symptomatic HIV infection, their exclusion from AIDS-related benefits and services, and their exclusion from many clinical drug trials. Activists from ACT UP, the American Civil Liberties Union (ACLU), Women's Health Action Mobilization (WHAM), and legal aid lawyers began to pressure the CDC to revise the definition. In particular, we demanded the expansion of the list of indicator diseases to include fifteen opportunistic infections that HIV-infected women and/or injection drugs users tend to get, such as atypical bacterial pneumonia, refractory (resistant to treatment) pulmonary TB, aggressive cervical cancer, refractory pelvic inflammatory disease (PID), and invasive and chronic vaginal candidiasis. We also demanded that the CDC institute a process of periodic review and revision of the AIDS definition, based upon surveillance statistics and the experiences of frontline AIDS doctors and researchers (ACT UP 1991a,1991b; Wilson and Lein 1992).

The CDC agreed that there were problems with the AIDS definition. Increasing use of HIV antiretroviral drugs (such as AZT) and increasingly sophisticated and widespread prophylaxis against opportunistic infections[14] (including the indicator diseases) had artificially lowered the numbers of those living with HIV-related severe immune deficiency. But the CDC's proposed remedy was not to expand the list of indicator diseases; it was to add a whole new category of "indication": the existence of 200 or fewer T4-cells per milliliter of blood.[15]

While few activists opposed the expansion of the definition to include the T4-cell indicator, most believed that it would have very little impact on sick HIV infected women. Most low-income women with HIV dis-

ease do not have the money for basic health care, let alone for expensive, sophisticated blood tests such as regular T4 counts. But more basically, the proposed change would not solve women's diagnostic problem; if aggressive cervical cancer, refractory PID, and similar female-specific opportunistic infections were not added to the list of possible HIV symptoms, most doctors would not suspect HIV in their patients and the women would never get tested for HIV in the first place. Quoting Terry McGovern, an ACT UP/NY member and lawyer for Mobilization for Youth Legal Services, "It won't solve the problem of women not getting diagnosed because you don't get a T-cell count until you know that somebody is positive!" (Navarro 1991, D-21).

In numerous meetings with the activists, the CDC representatives first claimed that the proposed new indicator diseases were not life-threatening. The activists responded that many of the then-current indicator diseases, such as thrush, were also not life-threatening, and that several of the proposed indicators, such as aggressive cervical cancer, were, in fact, imminently life-threatening. The CDC representatives then claimed that the proposed indicator diseases were not HIV-specific—that they occurred with some frequency in people without HIV infection. The activists responded that several of the then-current indicator diseases, including genital herpes, also occur regularly in HIV-negative people. In addition, since a positive HIV antibody test is also required for an AIDS diagnosis, this "specificity" problem was nonexistent. Last, the CDC representatives claimed that more research was needed and that, by nearly doubling the official caseload of AIDS patients, the proposed changes would be too expensive. In response, the activists cited the numerous research studies and individual case studies by frontline AIDS doctors documenting the frequency of presentation of the proposed new indicators in women and/or intravenous drug users (IDUs). And while activists agreed that the proposed changes would cost the government more in disability benefits and medical care, the activists argued those affected by the change were people desperately in need of help; denying medical care to dying women was not an ethical austerity measure!

By late 1989, women AIDS activists were fed up with the CDC's foot-dragging and sexism. On January 9, 1990, hundreds of activists From ACT UP and WHAM descended on the CDC's headquarters in Atlanta, blocking the main entrance for three hours, raising a flag with an AIDS-definition message, and tossing around hundreds of Ping-Pong balls that represented T cells. One particularly adventurous af-

finity group scaled the roof of the building and unfurled a banner saying "CDC AIDS definition kills women!" before the police could reach them. By the end of the day, forty-nine activists had been arrested, and CDC officials made it clear that they intended to pursue the maximum possible legal charges against the activists (O'Neill 1990b, 18).

Despite generally favorable publicity for the action, the CDC refused to budge on the basic issues. They continued to maintain that adding the T-cell indicator was a sufficient response to the changing demographics of the epidemic. By late 1990, activists once again took to the streets. On December 3, 1990, hundreds of women and men from ACT UP, WHAM, and AIDS organizations all over the country once again demonstrated at CDC headquarters. Once more, they demanded the inclusion of the fifteen opportunistic infections common in women and/or IDUs, and the periodic revision of the CDC definition in consultation with researchers and frontline AIDS doctors. The activists also demanded more research into the possibility of woman-to-woman HIV transmission, and that the CDC begin to keep their epidemiological statistics not in terms of risk groups—e.g., heterosexual—but in terms of specific HIV-transmitting practices, such as vaginal/penile intercourse, to more accurately assist in tracking the epidemic and in educating people about prevention (ACT UP 1991b).

In 1991, CDC officials offered a compromise; they proposed a new definition of AIDS that included the 200 or fewer T4 count criterion, but also added refractory cervical cancer, atypical bacterial pneumonia, and pulmonary TB. Other female-specific opportunistic infections, such as refractory vaginal candidiasis and invasive pelvic inflammatory disease, were put on a "clinical definition watch list" to be distributed to doctors as possible early symptoms of HIV infection (Navarro 1991). Although this represented a significant improvement, activists were none too pleased with this aspect of the compromise. Quoting Nina Reyes, "For all practical purposes, . . . the surveillance definition is the only part of the definition that matters—the public, the government, the media, and perhaps most importantly, physicians, all recognize AIDS according to the CDC surveillance definition alone" (Associated Press 1992; Reyes 1991). And while they refused to change their statistical collection methods, the CDC did agree to fund studies on woman-to-woman transmission, and the findings of these studies are currently reflected on the CDC Web site (CDC 2004b).

Fortunately, the continuing controversy had an impact beyond the CDC. In May 1993, the Social Security Administration (SSA) an-

nounced that it was adding a whole range of female-specific infections to its definition of AIDS. This was a huge victory, as it opened up the possibility of disability benefits and Medicare for women living with "symptomatic, non-AIDS, HIV infection." It also opened the door for other agencies and other benefit programs to do the same.

In sum, the activists achieved an incomplete but important victory in the battle over the definition of AIDS. The official definition now contains several female-specific infections that are often early symptoms of HIV, aiding in the earlier diagnosis and treatment of HIV-infected women and giving them access to medical and social benefits and to clinical drug trials. The controversy surrounding the AIDS definition change also brought widespread attention to the problem, educating health practitioners about women's vulnerability to HIV/AIDS. But as HIV/AIDS moves into new demographic groups who may exhibit different symptoms and infections—the surveillance definition will require continuing oversight and revision. If the experience of ACT UP activists is any indication, such oversight and political pressure can be at least partially effective.

Fighting for Access to Clinical Trials

Broader access to clinical drug trials for HIV infected people had always been an important goal of ACT UP. In October of 1988, ACT UP/NY, in conjunction with newly forming ACT UP chapters across the country, staged its first major national demonstration at the FDA's headquarters in Rockville, Maryland. Over one thousand activists swamped the FDA campus, wearing lab coats stained with fake blood, staging "die-ins" in the parking lot, hoisting an ACT UP flag, and setting up an "alternative FDA," dedicated to "helping people, not drug companies" (ACT UP 1988; ACT UP/MACWAC 1988; Duggan 1988; Gorman 1988). The organizational demands for the demonstration included faster testing and approval for drugs for life-threatening conditions, access to unapproved drugs for those who had failed standard treatment, and an end to placebo-controlled AIDS drug trials.

ACT UP, in its formative days, did not generally conceptualize this "broader access to AIDS drugs" in terms of gender, race, or class. Nor were women's specific problems entering drug trials—such as women's automatic exclusion from many trials, the lack of childcare facilities, and no OB/GYN care at trial sites—specifically addressed by the broader, overwhelmingly male, organization. For instance, at the FDA

demonstration, the Women's Caucus (WAC), working in conjunction with the people of color committee (Majority Actions Committee, MAC), wrote and distributed a leaflet comparing the representation of women and people of color in the AIDS population with their representation in clinical trials and demanding increased access.[16] MAC/WAC also demanded the representation of HIV-positive people on the Institutional Review Boards (IRBs) that oversee drug trials, more research into opportunistic infections that disproportionately affect the poor, and comprehensive medical care for all participants in clinical trials, regardless of ability to pay (ACT UP MAC/WAC 1988). The demand for the inclusion of more women and/or people of color into clinical trials began a long process of raising this issue with government officials and pharmaceutical representatives. It also kept the issue in the sights of our fellow activists.

Over time, tensions developed within ACT UP over the extent to which the organization should be concerned with the interaction of HIV with racism, sexism, homophobia, class, and the other forms of inequality, all of which fuel the crisis, versus demands for the development of AIDS drugs, per se. Not surprisingly, women and/or people of color (in committees like MAC/WAC, the Housing Committee, and the Latino Caucus) generally favored the former position, while wealthier, white gay men often favored the latter.[17] Nevertheless, despite the tensions over the topic, over time, there was a gradual, but very real, shift in the broader organization's positions on these issues.

By 1990, AIDS activists realized that the problems with drug approval reached further back than the FDA approval process; the problems began with the process of AIDS research itself. On May 21, thousands of AIDS activists from around the country converged on Bethesda, Maryland to "Storm the NIH!" Among other things, activists demanded significant increases in National Institutes of Health (NIH) funding for AIDS research, an end to the NIH's seeming obsession with testing AZT, more treatments for opportunistic infections, and a restructuring of decision-making processes to end conflicts of interest at the AIDS Clinical Trials Groups (ACTGs). Eighty-two people were arrested while engaging in activities such as setting up a mock graveyard on the NIH lawn, hanging a banner reading, "Ten years. One Billion dollars. One Drug. Big deal!" and sitting down in front of the horses that the Park Police rode into the crowds (Hilts 1990, C-2; Jennings and Gladwell 1990, B-1; O'Neill 1990, 14).

But unlike the 1988 FDA demonstration, this time the interests of

women and/or people of color were prominently featured in the group's demands; "Ending medical apartheid" by "open[ing] trials to all people infected with HIV . . . including women, people of color, and present and former drug users" was demand number six out of fourteen in the official ACT UP handout for the demonstration (ACT UP 1990). After much struggle, MAC/WAC demands were becoming part of the agenda of the broader organization.

For the NIH action, women in ACT UP formed an affinity group dubbed "Invisible Women" and we wrapped ourselves in medical gauze to symbolize women's invisibility in the AIDS crisis. The activists also called for a meeting with Bernadine Healy, then director of the NIH, to demand the establishment of the Office on Research on Women's Health (ORWH), and to reinforce the importance of the inclusion of women in the clinical trials process. To our surprise, Healy agreed to the meeting, and was open to discussion about both sets of demands. In demanding this meeting, and in a subsequent meeting with Donna Shalala, then-secretary of Health and Human Services, ACT UP and the "Invisible Women" affinity group were part of a greater movement of women's health activists who were voicing demands to Healy for women's inclusion and representation in clinical research. As described in chapter 2, this movement was eventually successful in changing the criteria for inclusion in clinical trials, for establishing the ORWH and for directing greater research funding towards breast cancer and other women's health concerns. It is now general practice to include women in clinical trials, particularly for life-threatening illnesses such as HIV/ AIDS, cancer, Alzheimer's, Parkinson's, and heart disease. Because of this change, many more HIV infected women have earlier access to potentially lifesaving anti-HIV medications. And women throughout the country are better protected from unexpected side effects of all drugs.

WHY WERE THE ACTIVISTS SO SUCCESSFUL?

ACT UP and other AIDS and women's health activists have been moderately successful in changing the government's sexist HIV/AIDS policies in terms of the definition of AIDS and the exclusion of women from experimental drug trials. In so doing, we helped to reduce the spread of HIV to women, and have helped to ameliorate conditions for HIV positive women, women with AIDS, and their families. Many factors contributed to our success.

We Were Passionately Committed to Our Cause

For many of us in ACT UP, HIV/AIDS was not just another impor-
tant social issue. Members of our own group—our friends and loved
ones—were sick and dying from this disease. Indeed, many ACT UP
meetings began with one or more obituaries of members who had died
that week. In short, for those of us in ACT UP, this issue was very
personal. Witnessing the almost-unbelievable suffering and early deaths
of our friends and colleagues pushed us to give generously of our time
and money—and sometimes to risk our safety—in order to change the
corporate and government policies that we believed were contributing
to the deaths of our friends.

Our anguish about our friends' deaths was exacerbated by the fact
that the disease—and the deaths of thousands of Americans—seemed
to be receiving so little attention from the mainstream media, from phar-
maceutical researchers, and from our elected representatives. Indeed,
as stated earlier, it was this contradiction between the virtual state of
emergency in some communities and the lack of government, corporate,
and media attention to the epidemic that led to the founding of ACT
UP. Quoting ACT UP member Vito Russo: "Living with AIDS is like
living through a war which is happening only for those people who hap-
pen to be in the trenches. Every time a shell explodes, you look around
and you discover that you've lost more of your friends, but nobody else
notices. It isn't happening to them. They're walking the streets as
though we weren't living through some sort of nightmare. And only you
can hear the screams of the people who are dying and their cries for
help. No one else seems to be noticing" (Vito Russo, "Why We Fight,"
Speech given at ACT UP demonstration in Albany, New York, May 9,
1998). We in ACT UP made it our job to do what was necessary to
draw attention to this modern-day plague.

*We Saw the Fight Against AIDS as Part of a Larger Political Struggle
Against Inequality*

As stated earlier, members of ACT UP, particularly the Women's
Caucus and Majority Actions Committee, saw the struggle against
AIDS (and the relative lack of attention it was receiving from the main-
stream media) as part of a larger struggle against racism, class bias, sex-
ism, and homophobia. We therefore saw ourselves as heirs to a long
tradition of civil disobedience struggles for social justice, from the civil

rights movement of the 1950s and 1960s to the gay and women's libera-
tion movements of the 1960s and 1970s. MAC/WAC, for instance, regu-
larly studied texts from these movements (e.g., Martin Luther King's
"Letter from Birmingham Jail" and Mahatma Gandhi's *An Autobiogra-
phy or My Experiments with Truth*) and tried to learn from their successes
and failures. We drew both tactical lessons and inspiration from these
and other social justice activist forebears.

We Used the Power of the Media

One of the lessons we drew from our study of history was the power
of direct action. MAC/WAC, and ACT UP in general, was perfectly
willing to discuss issues and to negotiate with our adversaries. ACT UP
members served on government committees and testified at congres-
sional hearings and before school boards. And we often found that com-
bining insider tactics (e.g., negotiating) with outsider actions (noisy
demonstrations) was particularly effective. But our emphasis was al-
ways on direct, public action to draw attention to the problems and to
pressure the corporation, government agency, or other institution to
change its ways. To quote a rap song written by ACT UP members
Mollioris and Kleinman for the 1990 NIH action:

> You'd better change your ways or we're on a bus.
> You ever been embarrassed by a thousand of us?
> We're ACT UP. We demand health care for all
> Summer to spring, Winter to fall
> We don't act without 'cause but before we're done
> If ACT UP's there, then something's wrong, right?

Over time, ACT UP became masterful at planning and executing mas-
sive, loud, colorful, nonviolent direct actions that attracted significant
media attention. We were helped in this regard by ACT UP's many vi-
sual artists, who designed logos (e.g., Silence = Death), posters, and
banners that attracted attention and got our point across. Several ACT
UP members had worked in the mainstream media (including one who
had been a producer for a major network newscast). They helped us to
perfect the art of the sound bite, the twenty-second summary of an issue
or crisis that could make it into the evening news. And ACT UP's many
professional writers wrote press releases, magazine articles, and news-
paper copy that helped to bring attention to our cause.

We Educated Ourselves Before We Acted

In addition to artists, writers, and media people, ACT UP/NY also included biomedical researchers and frontline medical personnel (doctors and nurses), many of whom worked in ACT UP's Treatment and Data Committee (T&D). These people took it upon themselves to educate the general membership of the organization about the biology of HIV/AIDS, the efficacy of potential treatments, and the organization of both the medical research and the clinical trials processes.

To accomplish this hefty goal, T&D conducted numerous teach-ins, including several during regular meetings of the general membership. They put out the *T&D Digest,* a weekly multipage handout summarizing medical and related progress since the last ACT UP meeting. The Committee wrote several substantive handbooks on the medical aspects of HIV/AIDS,[18] including a major medical-update handbook before every national action (e.g., *The FDA Action Handbook* or *Storm the NIH!*) These action handbooks contained not only information about the particular medical issues involved, but also about proposed solutions to the problems. They also often included detailed information on the political obstacles to the proposed solutions, and detailed information about the institution that we were targeting, including maps, personnel charts, etc.

Combined with the pre-action teach-ins, these resources ensured that the general membership of ACT UP/NY was thoroughly educated about both the medical and political issues involved. For instance, before we "stormed the NIH" on May 21, 1990, every member of our organization was knowledgeable about the problems with both the pharmaceutical company–sponsored and government-sponsored AIDS research and the clinical trials programs and aware of several proposed solutions to these problems. We also knew the structure of authority at the NIH (who reported to whom), who within that structure might be responsive to our demands, and even the layout of the NIH campus.

In short, by taking advantage of the human resources in our membership, and by stressing education of the general membership, T&D ensured that every member could contribute to truly informed discussion about any proposed action, could answer even fairly complex questions posed by reporters, and could truly feel a part of the action.

We Believed in the Power of Direct Democracy

As previously stated, ACT UP/NY included many people with relevant professional skills and/or community experience. And our decen-

tralized committee structure allowed us to take advantage of these talents and knowledge.

ACT UP medical personnel educated the entire membership (and many of our adversaries) about the biology of HIV/AIDS. ACT UP artists designed striking and memorable graphics, posters, and fliers for demonstrations. ACT UP's experienced media people taught us how to speak so that we would be heard, including the art of the sound bite. Those in ACT UP who had contacts in government or in corporations explained how the bureaucracies of these organizations functions and helped us to target our actions effectively. And those ACT UPers who had done community organizing helped us to understand the experiences of people in diverse communities so that we could develop more effective HIV/AIDS education and prevention strategies and form coalitions that addressed the needs of diverse groups.

All of this seemingly uncontrollable energy and expertise was held together by "the floor," the direct democracy of Monday night ACT UP general meetings. There, each group or committee gave a weekly report and received praise, complaints, and criticism. Anyone and everyone could have a say. The debates were often messy, and sometimes contentious. Meetings often went on until the wee hours of the morning. But it was understood that "the floor ruled"; that the direct vote of the floor could modify or overturn proposals from even the most experienced, professional members of the organization. Along with our intense personal commitment to ending the AIDS crisis, this commitment to "the floor"—to direct democracy and maximum participation—gave every member of the organization a stake in every ACT UP decision and in every ACT UP action.

In short, in ACT UP, a relatively small group of committed laypeople, educated ourselves about the issues, wrote letters, petitioned, met with officials, and demonstrated until we were successful in bringing about significant changes in both government and corporate practices. To quote the last line of the Mollioris/Kleinman NIH rap song: "Remember, if you don't like something, CHANGE IT!" And, to some extent, we did.

REMAINING CHALLENGES

Despite ACT UP's significant successes, the AIDS disaster continues, both at home and abroad. Women, especially young, poor women,

are still the fastest-growing group of people with HIV infection in the United States today. This section will briefly discuss several remaining challenges that confront women in the United States. In particular, I will focus on the unique economic, social, and cultural conditions that make some women particularly vulnerable to HIV/AIDS, and the inadequacy of much current HIV/AIDS education to address women's realities.[19]

Conflicts Between Female Socialization Regarding Sexuality and Safer Sex Negotiations

Successfully negotiating safer sex practices with a partner requires a significant amount of specific sexual information, information that is often not available to frontline AIDS researchers, let alone sexually active young women. For instance, what are the risks of performing oral sex on a man without protection? Are they higher or lower than the risks of vaginal intercourse with a condom? Does risk vary with the "time of the month"? With other (non-condom) methods of birth control that might be used? Is it really risky to perform oral sex on a woman? Such detailed information is hard to obtain.

Successful safer sex negotiation also requires a certain degree of sexual self-confidence and the ability to freely discuss both specific body parts and specific safer sex paraphernalia—condoms, dental dams, etc. Safer sex obviously requires that at least one of the partners have condoms or other relevant supplies available. And last but not least, successful negotiation requires the ability to refuse to engage in sexual behaviors if minimally acceptable conditions are not met.

The post-WWII generation has witnessed enormous changes in our culture regarding attitudes toward women and sexuality. Young people have more access to sexual information; some of it accurate, some not. There is less public condemnation of premarital heterosexual sex and cohabitation, and there is more, if still limited, acceptance, of lesbian and gay relationships/families. But it is unfortunately still true that most young women, including those who are sexually active, are not sufficiently knowledgeable about and comfortable enough with their bodies to even mention, let alone negotiate, safer sex (Christensen 1991).

These young women are not acting irrationally; they have accurately absorbed and are acting upon our schizophrenic cultural beliefs about sex. For instance, studies show that a young heterosexual man who carries condoms *gains* respect from his peers, both male and female—he is

a "stud." But a young heterosexual woman who carries condoms routinely *loses* respect from her peers, *particularly her male peers*—she is a "slut" (Sacco et al. 1993). In other words, the double standard is alive and well among America's youth. And it is inhibiting the ability of young heterosexual and bisexual women to demand precautions to protect themselves from HIV/AIDS infection.

Young bisexual and lesbian women face not only a lack of concrete and specific knowledge regarding the risks associated with woman-to-woman sex, but also the discomfort in discussing sexual practices induced by societal homophobia. Unfortunately, these often combine to make it very difficult for a young bisexual or lesbian woman to demand safer sex, even if her partner has a history of high-risk behavior such as injection drug use or unprotected sex with men.

The Impact of Women's Economic Inequality

As mentioned above, women's inequality in the labor market and our often-disproportionate financial responsibility for children combine to create a situation in which many women are financially dependent upon men—boyfriends, husbands, and/or the fathers of their children. This is particularly true for poor women, not coincidentally, the very women among whom HIV infection is growing at alarming rates.[20] For economic dependence makes it difficult to impossible for women to demand condom use and safer sex practices. Quoting Margaret Weeks: "For women to insist on their partners' condom use, they must feel that the health risk associated with not using condoms is greater than the risk to childbearing, a stable primary relationship, social support and economic security, should they try to enforce consistent use of condoms" (Weeks 1995, 254). Very few women, particularly poor women, are willing to risk their children's short-term economic well-being to protect their own long-term health. But the realities of poverty and lack of social support for child-rearing in this country put millions of women in this situation every day.

The Impact of Violence (or the Threat Thereof)

The demand by a woman for safer sex in an established heterosexual or lesbian/gay relationship is often received as an accusation of past or current infidelity on the part of one or both partners. In the case of a heterosexual relationship, this is exacerbated by the fact that AIDS, as

we have seen, is strongly associated in the public mind with gay male sex. Therefore a woman's request of a man for safe sexual behavior is often met with responses such as, "What do you think I am? Gay?" Given the prevalence of actual domestic violence, and the even greater prevalence of threats of violence, it is not surprising that many hetero-sexual women find it frightening or "just not worth it" to bring up the subject of safer sex, even if they are reasonably certain that their hus-bands/boyfriends are "straying."

Once again, if the choices are one's (or one's children's) short-run safety and security vs. a theoretical long-term health threat, it is not surprising that many women, particularly many poor women, "choose" to take the risk of contracting HIV. Unfortunately, the structural prob-lems that still make many American women vulnerable to HIV/AIDS are not easily solved with well-planned demonstrations and ingenious media campaigns. They will require, among other things, changes in the culture's attitudes toward sexuality, a reduction in economic inequality and women's economic dependence upon men, and the drastic reduc-tion of violence in intimate relationships. In other words, they will re-quire that we address that matrix of vulnerability that leaves the least powerful among us the most affected by this devastating HIV/AIDS epidemic.

4

One in Eight: The Politics of Breast Cancer
Karen L. Baird

BREAST CANCER IS THE AREA OF WOMEN'S HEALTH THAT RECEIVED the most attention—by the media, the government, and women themselves—in the decade of the 1990s and beyond. Karen Stabiner (1997) writes, "Until 1990, there had been no concerted effort to stop [breast cancer]. Now there is" (xxvi). Why? Many committed women who, after facing their own breast cancer and mortality, dedicated their lives to making a difference in the disease of breast cancer.

Breast cancer will afflict one in eight women in their lifetime. The disease claims over forty-thousand lives annually, and it is estimated that over two million women have survived breast cancer (ACS 2006). Although not the most common cause of death for women,[1] breast cancer is one of the most feared diseases: we do not know what causes it, how to prevent it, or how to cure it.

In this chapter, a short history of women and breast cancer will be presented. The rise of breast cancer advocacy in the 1970s will be detailed, and how activism changed in the 1980s, and again in the 1990s, will be examined. The changing politics of the disease, the activism of many women who have been diagnosed with the cancer, and the great increase in funding and research will be assessed and explained. Breast cancer activists successfully "politicized" the disease, effectively reframing breast cancer from a personal medical concern to a political and social issue that the federal government should address.

ADVOCACY, EDUCATION, AND SUPPORT: BREAST CANCER ACTIVISM OF THE 1970s–'80s

Though Rose Kushner has been credited as the leader of the breast cancer movement, breast cancer activism can be found as far back as

1913 when the American Society for the Control of Cancer was formed (Patterson 1987). Rose Kushner is the mother of the breast cancer movement that began in the late 1970s and lasted until the mid 1980s; this era of breast cancer activism has been labeled as pre-AIDS (Boehmer 2000), in that its tactics and goals differed somewhat from activism of the 1990s. The post-AIDS era of breast cancer activism, deemed so because AIDS activism served as a model for organizing around a single disease, began in the late 1980s and continued throughout the 1990s. Breast cancer activism of the 1970s and '80s primarily entailed providing advocacy and support for women with breast cancer, and educating all women on the risks of developing the disease.

Women greatly fear the disease. Breast cancer affects what many women consider to be the most feminine part of their body and is associated with embarrassment, disfigurement, and death. For years, women kept silent about the disease and their suffering. But in 1975, Rose Kushner published *Breast Cancer: A Personal and Investigative Report*. In this book, and in the breast cancer movement of the next fifteen years, an approach that focused upon women's need for information and access to services was taken. Kushner detailed her own experience with breast cancer, critiquing the then current medical approach to treating the disease and the treatment she received as a female patient of male doctors. Kushner specifically questioned the one-step procedure of putting a woman under anesthesia, conducting a biopsy of the breast tissue, and if cancer is found, immediately performing a mastectomy. In this standard procedure, women were unable to consider options, get a second opinion, or participate in any decisions about the matter. She also questioned the Halstead radical mastectomy, arguing that less severe surgeries could be just as effective in many cases. Kushner was able, almost single-handedly, to change these medical procedures by publicizing the problems in her book and in newspaper articles and by appearing on television shows; in this manner she educated the public. She also brought her criticisms directly to doctors at medical conferences, the American Medical Association (AMA), and the American Cancer Society (ACS) (Lerner 2001a, 2001b).

Also in the 1970s, many public figures announced their diagnosis and publicly discussed their experiences. Shirley Temple Black, Betty Ford, Happy Rockefeller, and in the 1980s, Nancy Reagan, all went public with the disease (Altman 1996; Casamoyou 2001). Women's breast cancer activism initially centered on assisting women through the process of handling the disease after diagnosis. Education about treatment op-

tions so women could be informed consumers and offer peer support were the initial goals of breast cancer activism. One such example is the American Cancer Society's "Reach to Recovery" Program in which former breast cancer patients assist newly diagnosed women. Another was Rose Kushner's Breast Cancer Advisory Center (BCAC), founded in 1975, to provide women—and men—with information about all aspects of the disease.

In the 1980s, organizations committed to fund-raising and advocacy arose. In 1982, the Susan G. Komen Breast Cancer Foundation was created, now called Susan G. Komen for the Cure, raising more than $7 million dollars with fifteen hundred volunteers in its first seven years of existence (Casamayou 2001). The organization sponsors the popular annual "Race for the Cure." The Komen Foundation is an organization "to save lives and end breast cancer forever by empowering people, ensuring quality care for all and energizing science to find the cures" (Komen 2008). It raises money and operates its own grant program to fund research. Additionally, the Y-ME foundation was organized in 1978 for the purpose of advocacy and as a support and information center for women with the disease.

Mammography screenings became a controversial issue in the 1980s. In 1983, the ACS reformed its guidelines; it recommended biannual screenings for women between the ages of forty and forty-nine and annual screenings for women aged fifty and over. Evidence clearly showed the benefits of early breast detection methods. Education and awareness about the need for early detection of breast cancer dramatically increased in the 1980s. In addition, the issue of the expense of mammograms came to the fore. Rep. Mary Rose Oakar (D-OH), a relentless breast cancer advocate, lobbied for Medicare to cover routine mammograms. Rose Kushner pushed for women to write letters to their members of Congress to take this "first small step for womankind" (as quoted in Casamayou 2001, 56). After a vicious political battle, such coverage was included in the 1988 Medicare Catastrophic Coverage Act. But an unexpected turn of events transpired. The Medicare Catastrophic Coverage Act was repealed just a year after its passage. Still, Rep. Oakar pursued the issue. She demanded to meet with leaders of the House and the Democratic Caucus and ultimately won. Mammography coverage was included in the 1991 budget reconciliation bill even though it had not been in either the House or Senate version.

Another issue that activists pursued in the 1980s was funding for breast cancer research. Again, Rose Kushner and Rep. Oakar, along

with the Congressional Caucus for Women's Issues (CCWI), were at the fore of the issue. Rose Kushner founded a breast cancer political action committee, Breast PAC, to contribute to the political campaigns of people supportive of increased funding for research. Rose Kushner testified at hearings comparing funding for research on breast cancer with research on AIDS and Oakar obtained an $11 million increase in funds for fiscal year 1990 (Casamayou 2001). This was only the dawning of a dramatic increase in funding that was to occur throughout the 1990s.

Thus, activist grassroots breast cancer groups sprung up throughout the United States in the late 1980s. These groups, unlike the earlier survivor groups of the 1970s, were advocacy organizations that began to understand that breast cancer was a political issue as well as a personal one. But as Carol Weisman (2000) notes, "The definition of breast cancer as a social problem in the United States might be dated to the 1970s. ... The 1990s, however, witnessed an unprecedented spate of consumer advocacy and governmental action on breast cancer, and it is this episode that most observers associate with breast cancer policymaking" (213–14).

"POLITICIZING" THE DISEASE: BREAST CANCER ACTIVISM OF THE 1990S

The decade of the 1990s began with many local breast cancer groups successfully promoting early detection methods, education and awareness, patient advocacy, and fund-raising. With Rep. Oakar in the lead on breast cancer, the CCWI was beginning to place various issues of women's health at the top of their list of priorities. Clinical research policies of the NIH were receiving widespread governmental and media attention, and AIDS activists emphasized women's concerns. Thus, women's health was on the public's mind and was already receiving attention in these other areas; this is the climate in which breast cancer activism of the 1990s commenced.

Many of the earlier local and national groups merged into the National Alliance of Breast Cancer Organizations (NABCO) in 1986. This organization served as an umbrella organization for state and local breast cancer groups and served as a resource for women around the country. The National Breast Cancer Coalition (NBCC) was formed in May 1991 by Dr. Susan Love, Susan Hester, and Amy Langer of

NABCO with the mission of eradicating breast cancer through action and advocacy. Fran Visco became its first president. Susan Love wanted an organization that focused exclusively on political activism and raising awareness about the disease. The NBCC serves as a network provider for activists: more than 600 organizations and 70,000 individuals compose the organization (NBCC 2006). Still other groups came together as the National Coalition of Feminist and Lesbian Cancer Projects in 1991 (Boehmer 2000). This centralization of forces, money, and activism proved to be a quite successful mobilization effort that was instrumental to the popularity and success of breast cancer advocacy in the 1990s. The political activism around breast cancer resides primarily with the NBCC as other organizations approach the disease from different perspectives. For example, Olson (2005) notes that the Komen Foundation promotes "awareness" while the NBCC promotes "activism." Amy Blackstone (2004) notes how volunteers in the Komen Foundation do not see themselves as engaging in political work; what they do is "fun" and "its just about being fair."

The breast cancer activists worked with the CCWI. Many members of Congress and the Caucus had personal or family experiences with breast cancer and thus their sensitivity to the issue was heightened.[2] In addition, after twenty-plus years of abortion politics, and the 1991 Clarence Thomas confirmation hearings at which Anita Hill testified and accused him of sexual harassment, many members of Congress were quite happy to support a woman's issue, and specifically a woman's health issue (Weisman 1998, 2000). The issue of breast cancer also resonated with many women across the United States. Since no cause for breast cancer had been discovered, and since one in eight women will develop the cancer, the activists presented the disease as one that *all* women should fear. As framed by the activists, the "epidemic" knows no age, race, or class boundaries.[3] This "politicizing" of the disease entailed four elements: crafting an "epidemic"; transforming the meaning of breast cancer; invoking political measures to end the epidemic; and broadening the participation of survivors in setting the breast cancer research agenda, thus democratizing biomedical research processes and institutions.

Crafting a Breast Cancer "Epidemic"

"One in Eight" is a slogan the NBCC used to convey the number of women at risk for breast cancer and call attention to the urgency of the

matter. Activists cited statistics, emphasizing how the disease is increasing. In the 1970s, the risk was one in fourteen; now it was one in eight. The incidence of breast cancer increased over 30 percent throughout the 1980s (Ries et al. 1994). But during this same time period, knowledge of breast cancer, use of mammography, and self-examinations were also on the rise. One has to wonder if the great increase in numbers is really an artifact of the greater use of screening methods and *not* a rise in the actual incidence of breast cancer. In other words, the number of cases of breast cancer may not have increased; what may have increased is detection of the cases. Lantz and Booth (1998) review the research on this matter, arriving at the conclusion that "the published results (beginning in 1991) concluded that most, if not all, of the recent increase in U.S. breast cancer incidence in specific states and the nation as a whole can be attributed to the increased use of mammography screening" (907).

In a study of how breast cancer was portrayed in popular magazines from 1980 to 1995, it was found that approximately 50 percent of the articles mentioned that breast cancer had increased, but approximately 50 percent of such articles did not mention *why* the incidence had increased (Lantz and Booth 1998, 912). In these articles, the discourse on breast cancer rates conveyed the idea that the numbers are not well understood, that they are alarming, and that breast cancer is out of control. Phrases such as "insidious rise," "sobering statistics," and "unexplained upsurge" were used (Lantz and Booth 1998). Women's perception of their risk also increased over time (Kedrowski and Sarow 2007), with perhaps the most telling being that in 1992, 44 percent of women indicated they worried "a great deal" or a "good amount" about developing breast cancer. No other health risk received such a high rating from women in the survey (Kedrowski and Sarow 2007, 117). In 1998, 30 percent of women estimated they had a better-than-even odds of developing breast cancer (the real chance was about 10 percent), and many incorrectly thought their risk of breast cancer was higher than for heart attack, stroke, or diabetes (Kedrowski and Sarow 2007, 117; Taylor 1999).

Therefore, activists were able to exploit the numbers and the perceptions by focusing on the rise in breast cancer diagnoses. By not focusing on the *reason* for the rise, a rapid increase in breast cancer, i.e. an "epidemic," appeared to be looming. But breast cancer was not the leading cause of death for women and not even the leading cause of death from cancer for women. In conclusion, advances in technology and the suc-

cessful educational campaigns of the earlier era set the stage for activists of the 1990s to label the rapid rise in breast cancer diagnoses an "epidemic."

Reframing the Problem of Breast Cancer

The activists of the 1990s transformed the meaning of breast cancer. How objective conditions, ambiguous information, perceptions, and cultural values and norms are socially and politically represented are crucial to a movement's success, as well as the type, if any, of policy that gets enacted. For breast cancer, what was once viewed as a personal tragedy, was now a political crisis. What was once a medical issue—a medical problem with a (potential) medical cure—was now a social and political problem. Thus breast cancer activists extensively utilized discursive politics and engaged in "meaning making" with regard to the issue (Katzenstein 1998). In fact, "[a]s long as cancer was perceived as a personal issue, it lacked conflict and insurgency" (Boehmer 2001, 141).

This strategy partially arose from the background of the activists. Most breast cancer activists were drawn to the movement from their personal experience with the disease (Boehmer 2000; Casamoyou 2001; Van Willigen nd). For many survivors, the experience of breast cancer becomes politically focused as they begin to attain a shared collective identity with other survivors (Boehmer 2000; Casamoyou 2001). As individual women struggle to make sense of the disease and experience for themselves—an individualized meaning making—many simultaneously engage in a political meaning making by engaging in a collective construction of meaning. In fact, the initial draw to activism can be seen as a desire to engage in this collective process, as Casamayou (2001) documents that many activists first met in support groups and doctor's offices. "Turning the struggle with their own cancer into a community-wide struggle with breast cancer has allowed more women to share with others the wisdom they have gained, to bond with others afflicted with the disease, and to find a larger purpose in their own suffering" (Weijer 1995, 44). Therefore, breast cancer survivors became "politicized" through their experience with the disease; most were not political, in any sense of the word, before their diagnosis (Boehmer 2000).

This collective formation of meaning evolved from their anger that the debilitating treatment they had endured had not changed in many, many years, and that virtually no progress had been made in finding the

reason why they had developed the disease in the first place. Sharon Batt (1994) writes, "Women with breast cancer have entered treatment turf largely because they question current treatments. Many are angry to learn that punishing treatments which had been promoted as cures have uncertain and limited benefits. They are shocked to discover how little mortality rates have changed in 50 years" (290). *Dr. Susan Love's Breast Book* was first published in 1990 and many women read it, arming themselves with information, but the book also confirmed the lack of progress in treating or curing the disease. Why is so little research on prevention of breast cancer being conducted, women wondered? Susan Love notes that as she toured the country publicizing her book, she saw the untapped energy and anger of women all over the nation. This was the beginning of the NBCC.

Amy Langer (1992) states that the NBCC was formed to encourage women and their families "to turn their attention from the personal dimensions of breast cancer to its broadest public policy and political dimensions" (207). The NBCC "will propose new approaches, because women in the United States will not wait. They are tired of hearing about the benefits of early detection while watching their friends die. They are tired of being encouraged to take care of themselves, only to find that they cannot afford to. They are tired, and angry, and live with tremendous fear that they will wake up one morning with their disease back again, or that they will watch powerlessly while their daughters are diagnosed" (Langer 1992, 209).

Myhre (1999) argues that one element in the reframing of breast cancer was the argument that breast cancer is not just a physiological process but a "problem that disrupts social relationships, jobs, and families" (30). Activists gave personal meaning to their illness by publically telling their stories. Sharon Batt (1994) even refers to breast cancer survivors who go public as "[w]omen who come out of the closet" (305):

> Like crime victims, we confront a conflict that has private and public meaning. If we are to really participate, we must also take on the institutions that are society's response to the disease, and reshape them so they are meaningful to us. If we limit our quest for involvement to the private sphere, we abandon a large part of the conflict that is ours as well. We will continue to feel that others are doing things *to* us, rather than *for* us. A feminist revisioning of breast cancer will break down the wall between the public and private definitions of the disease. (Batt 1994, 287–88)

Activists told their personal stories of what life is like with breast can-
cer, thus making public what was once private and shameful. Many
memoirs have been written (for example, Batt's *Patient No More*) but
women also told their stories in front of Congress. Ellen Hobbs of Save
Ourselves (SOS), a breast cancer survivor and activist, stated at a con-
gressional hearing:

> My name is Ellen Hobbes. I am 35 years old and the mother of four chil-
> dren. In October of 1990, I was told that I had breast cancer. . . . In Decem-
> ber, the doctors took off my breast—and they said that I would probably
> die anyway. They said they had treatment that would work but probably
> my insurance wouldn't pay for it and I would need $150,000 to pay for it
> anyway—that was an oncologist bone transplant. Then they gave me this
> [holding up the prosthesis]—a breast and they said it would make me feel
> better. Then they gave me this [taking off her wig] and they said it would
> make me feel better. . . . Well, guess what? I don't feel better. And I won't
> feel better till we get the research we deserve. . . . I won't feel better until
> the federal government recognizes that 51 percent of the population is at
> risk and approves more than a pittance of money for research. . . . I won't
> feel better until we get more than 40 minutes in one year of the military
> budget for breast cancer research. . . . I have a 13 year old daughter named
> Angela. She asked me "Will I get breast cancer, Mom?" I said, "Maybe."
> She asked me, "What can I do to prevent it?" I have to tell her," Nothing"
> "Can they cure it, Mom?" she asked. "No," I answered. (quoted in Casa-
> mayou 2001, 113–14)

Marieke Van Willigen (nd) writes, "In some instances, the body has
been used as a symbol to educate the public and to illustrate how pros-
theses and breast reconstruction have hidden the epidemic of breast
cancer from the public consciousness" (29). In 1991, the artist and
model Matuschka was diagnosed with breast cancer and had a mastec-
tomy. Using an image of herself, revealing her mastectomy scar, she
hoped to increase awareness of breast cancer. *The New York Times Maga-
zine* published a picture of Matuschka's bare chest on its cover, accom-
panying the article entitled "You Can't Look Away Anymore: The
Anguished Politics of Breast Cancer" (Ferraro 1993). The caption by
the picture read, "Forcing people to see what cancer does" (Ferraro
1993, 25).

Activists emphasized the role of women as mothers, wives, sisters,
and caregivers, as Ellen Hobbs, above, refers to her daughter. Fran
Visco, president of NBCC, introduced herself at a congressional hear-

ing in 1992, "I am Fran Visco. I am a representative and the President
of the National Breast Cancer Coalition. I am a mother, a wife and a
breast cancer survivor" (U.S. Congress, Senate July 21, 1992, p. 487,
quoted in Kolker 2004, 831). Another activist states at a rally, "This
year, 46,000 women will die of breast cancer. . . . I will probably be
one of them. I will leave behind my husband and partner of 18 years, a
motherless child, a devastated family and too many friends" (Sherry
Kohlber, quoted in Ferraro 1993, 27).

Activists also emphasized the economic costs of the disease. NBCC
president Fran Visco continued at the 1992 congressional hearing,
"When you wanted to help the economy by creating jobs, you found a
way to transfer millions for foreign aid to transportation. Recognize the
impact of breast cancer on the economy. Breast cancer costs this coun-
try more than $8 billion [annually] in medical costs and lost productiv-
ity" (U.S. Congress, Senate July 29, 1992, p. 487, quoted in Kolker
2004, 827).

In 1992, the NBCC created "The Many Faces of Breast Cancer" to
humanize the statistics. The photographic exhibit contains the pictures
and stories of eighty-four women who have died from breast cancer; the
display traveled to forty cities between 1993 and 1997 and it was exhib-
ited in the Capitol Building in Washington, D.C. The display raised
awareness of the disease, put stories and faces behind the statistics, and
called upon men and women to join the movement to eradicate breast
cancer.

As discussed in chapter 1, problem definition and framing of issues is
crucial for movements. As Stone (1988) notes, "[S]ymbolic representa-
tion is the essence of problem definition" (108) and stories and meta-
phors are two important "weapons" in this representation (122).
Activists transformed the meaning of breast cancer, for themselves and
for others, thus engaging in discursive politics. The new activists
framed the issue as a family, social, economic, and political issue, politi-
cizing the issue by publicizing the personal aspects of the disease. Pow-
erful symbols, personal stories, and data about the great increase in
breast cancer all reinforced each other. This transformation was neces-
sary so that they could effectively utilize political tactics, or "interest
group politics," to enact change.

Invoking "Politics" to End the Epidemic

Integral to the new meaning of breast cancer was the notion that po-
litical measures will be required to end the epidemic. No longer were

survivors just going to educate newly diagnosed women; no longer were they just going to lead support groups; they were now going to draw up petitions, write letters, hold rallies, march in Washington, lobby members of Congress, and testify at congressional hearings. With supportive insiders (primarily members of Congress), new policies and legislation could force federal institutions to address breast cancer. The cure will be found in the political system, not the medical system (Myhre 1999). As Batt (1994) notes, activists went from "passive optimists to impatient activists" (xiii) and from "silence to language [and] action" (283).

The NBCC, formed in 1991 with the express mission to eradicate breast cancer through action and advocacy, engaged in many political activities—traditional interest group politics. First, in 1991, the NBCC collected over 600,000 letters asking for more research funds to be devoted to breast cancer research; this campaign was called "Do the Write Thing." When these were delivered to President George H. W. Bush, he received the demands in a "lukewarm fashion" (Kaufert 1998). Rather than disparaging the activists, the president's reticence catalyzed them. In 1993, the NBCC engaged in a signature campaign and delivered 2.6 million signatures demanding a national plan to eradicate breast cancer to President Clinton. As a result, in 1994, a National Action Plan on Breast Cancer was developed (discussed below).

The NBCC sought to find the cause and cure of breast cancer, and this can only be achieved through clinical research, the activists thought. Either not enough research was being done, or the right kind of research was not being conducted, or both. This was the main point that needed to be rectified, activists reasoned, and they must pressure the NCI to engage in more and better research. In 1991, breast cancer activists confronted the NCI and Congress, demanding more spending for breast cancer research (Brenner 2000). They met with the director of the NCI, Samuel Broder, and were unimpressed with his reaction. The activists then met with Rep. Mary Rose Oakar (D-OH), who was sponsoring a bill for increased research funds. The outsider activists quickly found that Congress was a much more hospitable location in which to pursue their interests, and they effectively joined with insiders to pursue their common concerns. In fact, the CCWI notes that the policy successes were achieved *precisely* because of the breast cancer activists' labor (Schroeder and Snowe 1994; Weisman 2000). Moreover, Congress was an entity that could pressure or force federal biomedical research institutions to engage in more breast cancer research.

AIDS activists had already brought drastic changes in AIDS policies

by the late 1980s. The breast cancer activists followed the AIDS model
of disease-specific activism and also enjoyed many benefits that the
AIDS activists had won. The cancer advocacy groups credit the AIDS
activists as serving as a model for organizing around a single disease,
politicizing the disease, directing public attention to a previously taboo
disease, and claiming that government funding for the disease was inad-
equate (Boehmer 2000; Brenner 2000; Kaufert 1998; Weisman 2000).
Also, AIDS activists had brought forth changes at the FDA with regard
to the drug approval process. In the 1980s, AIDS activists pressured
the federal government and the FDA for access to unapproved drugs
and treatments (see Christensen, chapter 3 herein). This was the first
real challenge to some of the FDA's protectionist type policies. In 1987,
the FDA issued regulations expanding access to experimental drugs
used to treat serious and life-threatening illnesses (Johnson and Fee
1994, 5).

Members of Congress and President Clinton were quite supportive
of the breast cancer activists' concerns. Many members of Congress,
such as Sen. Tom Harkin (D-IA), had wives, sisters, mothers, or other
family members that had been diagnosed with the disease. President
Bill Clinton's mother had breast cancer. Thus, when the activists turned
their attention toward Congress, many government officials were eager
to support their cause; they found a receptive and eager audience. Also,
the CCWI, in the early 1990s, was pursuing a strategy of unity by fo-
cusing on issues on which most women could agree; they explicitly
avoided the controversial issue of abortion (Schroeder and Snowe
1994). Breast cancer was one such noncontroversial issue and thus they
focused on it, along with a number of other women's health issues.

Moreover, the increased number of women elected to Congress and
their location on many strategic committees was very important. With
regard to medical research and breast cancer legislation in the 103rd
Congress, "positional power on Appropriations Committees enabled
Congresswomen Nancy Pelosi (D-CA), Nita Lowey (D-NY), and
Rosa DeLauro (D-CT) in the House and Senators Barbara Mikulski
(D-MD), Patty Murray (D-WA) and Dianne Feinstein (D-CA) to
work in committee and subcommittee to protect funding for women's
health research" (Hawkesworth et al. 2001, 26). Debra Dodson et al.
(1995) note that the "addition of Congresswoman Nancy Pelosi (D-
CA), Nita Lowey (D-NY) and Rosa DeLauro (D-CT) to the House
Labor, Health and Human Services (LHHS) Subcommittee of the Ap-

propriations Committee resulted in the appropriation of more than $600 million for breast cancer research programs" (4).

Activists also invoked gender issues and claimed that the government was perpetuating gender inequality. "Many people believe that breast cancer has been ignored for decades because it is a woman's disease" (Ferraro 1993, 27). Breast cancer advocates vociferously noted how women were being excluded in a nation that proclaims equality and that the federal government does not care about women who pay their fair share of tax dollars (Lloyd 1990). Breast cancer activists argued that if government can wage war in the Persian Gulf, and if government can bail out the savings and loan industry with billions of dollars, why can't it do something for women and wage war on breast cancer? They requested that the Department of Defense (DOD) engage in breast cancer research—and won! Susan Love once commented regarding "the breast-squeezing mammogram apparatus that so many women hate: 'it was indeed invented by a man, and I think there's a good tool we could invent for them with a little of our money' " (Ferraro 1993, 58–61). And we need to recall that at the same time, women were pushing for changes at the NIH to include more women in research and to devote more research to women's issues. Breast cancer appeared to be a prime area of neglect. The medical system is gender-biased and it needs repair if women are going to survive. Because the problem is political, activists thought, the strategies to address the problem must also be political.

The women's health advocates also targeted the state with inventive solutions. For example, activists pursued the development of the breast cancer stamp that went into effect in 1998. These stamps are sold at a higher price than first-class stamps, with the difference going to the NIH and DOD for breast cancer research. Nearly $50 million as of 2005 had been raised for breast cancer research (GAO 2005). Though others have followed suit (for example, the end family violence stamp), the breast cancer stamp was the first. Moreover, activists pursued participation in setting the breast cancer research agenda and having a voice in how research is carried out.

Increased Participation in Setting the Breast Cancer Research Agenda

In addition to more money and more research, activists wanted a seat at the research table and to participate in setting the research agenda, thus attempting to democratize biomedical research institutions and processes. This was a bold idea, but the AIDS activists had achieved a

degree of participation in AIDS research. Created in 1994, the National Action Plan on Breast Cancer (NAPBC) was a monumental achievement.[4]

After President Clinton warmly received the petitions asking him to develop "a comprehensive plan to end the breast cancer epidemic," he asked Donna Shalala, Secretary of Health and Human Services, to convene a conference to develop such an approach (Jones and Visco 2000, 1). The conference brought together advocates, scientists, government officials, and researchers and the NAPBC was born. The steering committee was composed of individuals from government, research institutions, breast cancer advocacy organizations, and industry, and was run out of the DHHS. It was funded by the NIH and the NCI (Jones and Visco 2000). The Plan was led by two co-chairs, one representing government and one representing the nongovernment sector, reflecting a unique—the first of its kind—public-private partnership. Fran Visco, president of NBCC, was elected to serve as its first co-chair.

The NAPBC's mission was "to stimulate rapid progress in eradicating breast cancer" (Jones and Visco 2000, 2). It identified gaps in knowledge, research, policy, and services and provided a coordinated government and non-government effort to fill such gaps. Though it ended in 2000, the NAPBC "developed new ways of doing business," "exceeded the boundaries of traditional partnerships," "successfully brought government and consumer organizations to the same platform," and "can serve as a model and foundation for future efforts on critical health issues" (Jones and Visco 2000, 4). The Plan awarded nearly one hundred grants, monitored insurance coverage, addressed informed consent issues, published a paper on genetic testing, and conducted conferences and workshops (Weisman 2000, 223).

The NBCC also created an innovative training program, Project LEAD (Leadership, Education, and Advocacy Development) in 1995. Workshops are held in which scientists train consumers in the biology of breast cancer and the process of biomedical research so that they can serve on advisory panels, institutional review boards, and grant reviewing panels. The NBCC wanted to train more lay people to serve on such boards so they could have a greater influence on breast cancer policymaking and how research is carried out. The actual influence of such participants and thus the success of such a strategy is unclear (see Brenner 2000), but activists have certainly broadened the participation of breast cancer survivors in the biomedical institutions and power structures governing research on breast cancer.

Success of Breast Cancer Activism

Many breast cancer bills were introduced in Congress between 1990 and '98, and many of the legislative initiatives were enacted. (See Table 4.1 for a listing of enacted legislation.)

Some of the major policy achievements include the Breast Cancer and Cervical Mortality Prevention Act of 1990, which funded the CDC to provide mammography and pap test screenings for low-income, medically underserved women.[5] In 1991, Medicare coverage for biennial screening mammograms for women aged sixty-five and over was restored. The Mammography Quality Standards Act of 1992 established standards and an accreditation procedure for mammography facilities. Medicare coverage of mammography was expanded, and in 1997, includes annual mammograms for women over the age of thirty-nine (Weisman 2000).

Most remarkably, funds for breast cancer research grew dramatically throughout the decade—from $81 million in 1990 to $614 million in 2000 (see Table 4.2). Funds for research are allocated to the NCI at the NIH and the Department of Defense (DOD). Patricia Schroeder and Olympia Snowe (1994) note that the "Senate vote in 1992 to earmark $210 million from the Department of Defense is perhaps the best illustration of the growing clout of the breast cancer lobby, most of whom are survivors of the disease" (104). After rejecting efforts to transfer money from the defense budget to the domestic budget for breast can-

Table 4.1. Key Breast Cancer Legislation, 1990–1998

Congress	Breast Cancer Legislation
101st Congress (1989–90)	Breast and Cervical Cancer Mortality Prevention Act of 1990; Omnibus Budget Reconciliation Act of 1991 (Mammography Reimbursement)
102nd Congress (1991–92)	Mammography Quality Standards Act of 1992
103rd Congress (1993–94)	NIH Revitalization Act of 1993; DOD Authorization Act; Breast and Cervical Cancer Mortality Prevention Act Reauthorization
104th Congress (1995–96)	DOD Authorization Act
105th Congress (1997–98)	Balanced Budget Act of 1997 (Medicare Mammography Coverage); Stamp Out Breast Cancer Act

Source: Weisman (2000, 221); Women's Policy, Inc. (1996 and 1997)

Table 4.2. Congressional Funds Allocated for Breast Cancer Research (in millions)

Year	NCI	DOD	Total
1990	$81	0	$81
1992	$145	$25	$176
1995	$309	$150	$359
2000	$439	$175	$614
2005	$560	$150	$710

Source: DHHS, NIH, NCI 1996, p. 47; DHHS, NIH, NCI 2000, p. B-8; DHHS, NIH, NCI 2005, p. B-8.

cer research, an amendment was offered to direct the DOD to engage in research; senators expected it to fail and opposed it. After it was clear the amendment would pass, many senators returned to the Senate floor to change their votes, not wanting to be on record as opposing breast cancer research (Schroeder and Snowe 1994). The amendment passed by a vote of 89–4.

CONCLUSION

Breast cancer was *the* women's health issue of the 1990s. It received more attention than any other health issue, not because it kills the most women, but because breast cancer advocates organized themselves and successfully projected their cause to women across the nation through effective media and publicity campaigns, adopted political tactics that utilized the existing structures of government, and effectively worked in partnership with insiders who were also concerned about breast cancer. The "politicizing" of breast cancer transformed the disease to an "epidemic" and from a personal issue to a political and social crisis. Breast cancer activists have been very successful and have drastically increased the amount spent at NIH for breast cancer research and have had much favorable legislation passed.

5

Rights and Remedies: The Public Identity of Violence Against Women

Dana-Ain Davis

VIOLENCE AGAINST WOMEN HAS BEEN VIEWED AS A SOCIAL PROBLEM since the 1970s, a view attributable to the tireless efforts of activists in the women's movement. One of the hard-won victories of the movement occurred in the 1990s when the Violence Against Women Act (VAWA) was signed into legislation. This notable achievement came on the heels of domestic violence being viewed as a health issue in the 1980s. As Carol Warshaw (1994) notes, during the decades of the 1970s and '80s, "gender-based trauma . . . emerged as one of the most serious public health problems facing women in this country. For most women, the greatest risk of physical, emotional, and sexual violation will be from a man they have known and trusted, often an intimate partner" (201). Nearly 25 percent of women experience rape and/or physical assault from a current or former intimate partner (Tjaden 2000a; Warshw 1994).

Consequences of domestic violence are important dimensions of the health care system. In the 1980s and early '90s, battered women constituted about one-third of the women seeking care in emergency rooms, and 25 percent of women who attempted suicide or received psychiatric emergency care (Warshaw 1994, 202). Of the 4.8 million intimate partner rapes and physical assaults perpetrated against women annually, about 2 million will result in injury and over one quarter will result in some type of medical treatment (Tjaden and Thoennes 2000b). Approximately 30 percent of women injured in their most recent intimate partner rape/assault received some type of medical care (National Center for Injury Prevention and Control 2003; Tjaden and Thoennes 2000b). It is estimated that violence against women costs the health care system about $3 to $7 billion annually (National Center for Injury Prevention

and Control 2003; Tjaden and Thoennes 2000b). In addition, issues of bias against battered women were evident in health care coverage. Cases arose in which women, after seeking medical treatment for injuries resulting from intimate partners, had their health insurance canceled or were denied benefits; in other cases, their life insurance premiums were raised or their policies were canceled. The cases involved major insurance companies, such as Aetna, State Farm, and Nationwide. Federal legislation prohibiting such discrimination has been introduced but never enacted, although many states have enacted legislation prohibiting insurance discrimination against victims of domestic violence (Women's Law Project 2002). Despite such knowledge and information, the health care system and the federal government did not address such issues in a direct fashion until the 1990s with the signing of VAWA.

The Violence Against Women Act was first introduced in 1990, and its passage in 1994 marked the culmination of a multiyear struggle. The bill specifies that violence against women is a form of gender discrimination, and involves civil and equal rights protection from violence. For the first time, violence against women was seen as an issue of equality. Praise must be given to members of the battered women's movement who persevered in reframing the issue of domestic violence from that of a private matter protected by the sanctity of the family to a public civil rights, gender equity, and social justice issue.

Ironically at the time the VAWA legislation was introduced in 1990, "battering was still considered 'natural' violence by many, and as a result, was seen by mainstream politicians as a 'fringe' issue trumpeted by radical feminists" (Nourse 1996, 3). The interesting question is, although considered a fringe issue, how and why did domestic violence come to the forefront of the public's eye during the decade of the 1990s? Many factors explain VAWA's passage in 1994, but this analysis proposes that the dominant reason lies in the ascendancy of the public identity of violence against women as it was shaped by various constituents, particularly battered women's advocates, the media, and research communities. Circulating around this public identity was a series of events that I categorize under two principles: rights and remedies. Events linked to these principles influenced the national discourse of violence against women and compelled policymakers and the public to accept the issue as one deserving of focus. What follows is a discussion of how the construction of the public identity of violence against women led to it receiving unprecedented attention by the public and policymakers.

The Public Identity of Violence Against Women

The identity an issue assumes in the public sphere is germane to its acceptance by policymakers. Issue identity formation, according to Hancock (2004), holds the potential for reasonable democratic consideration of policy options to address said issues. In the 1960s, grassroots organizations and members of the battered women's movement amplified the subject of violence against women, shifting it from being viewed as acceptable to being unacceptable. This was possible in part because as political institutions opened up in the 1960s, the public experienced increased contact in the halls of legislative power. "Marginal" groups, such as racial and ethnic minorities who had traditionally been bereft of political power, participated on the political stage in greater numbers. Increased political participation is often viewed positively as a sign of progressive democracy because minority rights are asserted and responded to as important.

Battered women, as one such marginal group, and their advocates were very effective in articulating domestic violence as a public, not private, concern. One argument driving their position was that it was *unnatural* for women to experience male violence despite the fact that societal support facilitated the illusion that it was natural. Challenging the multiple reasons used to justify male violation of women—that they deserved it, that men had a right to commit it, that it was private, and that women were inferior and therefore not entitled to better treatment—these previously accepted conclusions about battering lost their potency as its consequences became more public and women's status rose.

From Private to Public

Wife abuse received no academic consideration until 1969, was not on the public policy agenda (Conway, Aheren, and Steurnagel 1995), and the public paid virtually no attention to the problem until the 1970s.[1] Even the National Organization Women (NOW), founded in 1966, did not acknowledge wife abuse as a women's issue until 1977, in part because members of the women's movement—mostly white and middle-class women—were believed to be less impacted by violence, although there is evidence to the contrary.[2] The dearth of attention paid to wife abuse was due to it being viewed as a private familial concern

separate from public interests and state intervention. This was true except in cases when violence escalated to murder.

Insulating wife abuse within the private sphere has its roots in various realms of society where violent male behavior was religiously, culturally, and legally sanctioned. In legal terms, Roman law protected male privilege in abusing women and English law, which greatly influenced early American legal systems, affirmed the right of men to "chastise" their wives (Sewell 1989). The concept of privacy is found in cultural and social constructions of secrecy and, in terms of violence, facilitated the solidification of male dominance, particularly in the home. Within this context, the dimensions of private interactions, which encompass violence were viewed as normal in twentieth-century America. Consequently from about the 1900s until the 1960s, women who were victimized were neither protected by the law nor viewed with much sympathy.[3]

The private/public dichotomy was legally institutionalized in that courts of domestic relations were set up between 1910 and 1920 and their policy was to "urge reconciliation" in cases when some women sought divorce. Judges often, though not always, viewed cases not as criminal but as familial problems (Pleck 1987). In addition to the privatized privilege that justified wife abuse, another perspective reiterated the presumption of women's low status, by placing the blame for victimization on women due to their sexual and biological problems. In the 1930s, public opinion about wife beating was influenced by the discipline of psychoanalysis. Psychoanalytic approaches and theories sought to uncover how victims were complicit in causing abuse. These views had broad implications for the way in which members of the helping professions such as therapists provided assistance to clients. Thus, what in the nineteenth-century had been understood as a private issue, mutated into attacks on women's personalities, with the presumption that they had disorders that caused men to be violent toward them.

Later in the 1960s, the privatization of family violence and the victim blaming approach were translated by social service workers and the police. Del Martin (1976), in her groundbreaking book, describes the stunning inadequacy of institutional response to women who were assaulted by their husbands. For example, the crime of rape within marriage was not recognized as a legitimate criminal act. Arrest procedures by police were essentially nonexistent and, in fact, arrest avoidance was the norm among many police departments across the country. Further,

social service institutions, such as mental health clinics and welfare agencies, often advised women to return home.

With the rebirth of the feminist movement in the 1960s, riding on the crest of civil rights and antiwar activism, as well as women's shifting societal roles, wife battering became the center of women's activism. Members of the women's movement broached violence against women in terms of the right to bodily integrity and aspirations of fulfillment. They challenged patriarchal norms and organized formal and informal networks and support groups. Within these groups and networks, women reconsidered male privilege and abuse of women. The most concrete outcome of women's activism was in raising the visibility of wife abuse and positioning it as a social problem that demanded public response rather than as a private family matter deserving of no intervention. As Schneider (1994) argues, the social meanings of privacy became complex as battered women's advocates forced society to recognize the role violence played in reasserting women's lack of privilege by ignoring abuse.

Normative notions of women's subjugation were challenged, as were the cultural and social constructions of privacy arguments that legitimated men's right to abuse women. As battered women and their advocates identified various patterns of oppression, they developed leadership skills and increasingly engaged in advocacy and political organizing. These were all contributing factors in the development of coherent responses to violence and heightened the issue as a political one. Drawing from personal experiences, women critiqued services, provided support, and organized with other women.[4] Out of their grassroots efforts, four broad strategies emerged to address the violence in women's lives. These were community organizing and education; the creation of shelters; advocacy; and use of the law enforcement and court systems. By educating and making protective and helping institutions accountable, the shift in discourse from private to public necessarily meant an increase in state intervention and public responsibility. Below is a sketch of the events leading up to the insertion of violence against women into the public domain.

The Politics of Violence Against Women

In terms of political activism, as Schechter (1982) notes, "[B]attered women were the major grassroots organizing effort in the women's movement" (136). They were the ones who provided testimony at the

first White House meeting in 1977 to secure federal support for and federal acknowledgment of domestic violence. By publicizing battered women's needs government interest in violence against women grew and government hearings were held to inform policy makers of the scope of the problem. Legislators attempted to secure assistance by introducing bills. In 1977, Rep. Barbara Mikulski (D-MD) introduced a House bill titled the Family Violence Prevention and Treatment Act. This bill called for $125 million in federal funds to create a National Center for Community Action Against Family Violence. Simultaneously Newton Steers (R-MD) and Lindy Boggs (D-LA) also introduced a bill, the Domestic Violence Prevention and Treatment Act, which would establish a research and demonstration program within the Department of Health Education and Welfare (HEW). The bill was defeated at that time and then again.

Nonetheless, battered women's advocates continued to organize around eliminating women's victimization. Shortly after the White House meeting in 1977, the U.S. Commission on Civil Rights sponsored a hearing, "Consultation on Battered Women: Issues of Public Policy." Activists who had been working together participated in this hearing, out of which emerged the National Coalition Against Domestic Violence (NCADV). NCADV is an umbrella organization representing state battered women's coalitions and was the first national group to support shelter legislation and continues to coordinate shelter-oriented education and advocacy for battered women nationwide. As a result of the formation of NCADV and organizing efforts, the movement successfully raised the public's knowledge about domestic violence.

Another outcome of increased awareness of domestic violence was the creation of the Interdepartmental Committee on Domestic Violence by President Jimmy Carter in 1979. There was also a short-lived Office on Domestic Violence, a branch of HEW, which closed shortly after Ronald Reagan took office. These initiatives were limited in scope and did not focus on service provision but rather on technical assistance, education, and outreach. While some congressional members pressed on and introduced domestic violence legislation for a third time in 1980, the legislative process was contentious. Conservatives viewed the proposal as evidence that the American family was breaking down. The New Right, according to Pleck (1987), was ideologically predisposed against any enactment that would exorcise the "rightful authority" of fathers and the sanctity of the family. Within this context, domestic violence became associated with feminism "which in turn was associated

with an attack on motherhood, the family and Christian values" (Pleck 1987, 197). Two vocal opponents of the 1980 legislation were conservative Senators Orrin Hatch (R-UT) and S. I. Hayakawa (R-CA). They argued that federal intervention into such matters was inappropriate and should be dealt with by states and local communities.[5] The tactics undertaken to defeat the measure were ensconced in fear; fear that by subsidizing the legislation, the federal government was really subsidizing the disintegration of the American family. This perspective was linked to the belief that providing financial support for shelters would ultimately mean that women would not be in their "rightful place," the home.

Ironically, republican President Reagan signed the first domestic violence bill providing money for shelters in 1984. This bill, the Family Violence Prevention and Services Act,[6] which allocated $6 million for shelter funding, was opposed by the Reagan administration but was passed because it was attached to the Child Abuse and Prevention Treatment Act of 1984. The connection between the two acts reflects politicians' interest in addressing child abuse[7] and in framing violence against women as a problem of family violence—a theoretical framework taking its cue from such scholars as Straus, Gelles, and Steinmetz (1980), who argued that violence, when present, is perpetrated by both spouses. In spite of this uncomfortable link, after ten years of struggle, the battered women's movement had scored some accomplishments including the establishment of shelters, programs, and federal funding.

The Media and Public Identity

The legitimacy of domestic violence and its particular impact on women was revealed as women publicly shared their stories of abuse and as victims' advocates negotiated receipt of services from social welfare, legal entities, and police departments. In their roles, advocates met with institutional personnel and served as mediators between women and often inhospitable, or at the very least unknowledgeable, staff. Additionally, as more and more women made their presence known in public institutions, the subject of violence against women took shape in two spheres: the media and through academic and scientific research. Both the media and research unveiled the secrecy of women's victimization to broad national audiences.

In the 1970s and '80s, the media became a potent force in representing a range of feminist issues including various forms of violence. Mov-

ies marked the beginning of domesticating social issues on television. For example the subject of sexual violence was portrayed in two movies, *A Case of Rape* and *Cry Rape*, shown during the 1973–'74 season. *Something About Amelia* (1984) addressed the issue of child sexual abuse. That same year, the secret of domestic violence was laid bare with *The Burning Bed*, starring Farah Fawcett (Rapping 1994). Based on a true story, the made-for-television movie retold the story of Francine Hughes, a battered wife, drawing 75 million viewers. Movies such as this and *Something About Amelia* were viewed as national events (Rapping 1994), and their import was heightened as publishers produced study guides that were sent to high schools and colleges across the country. The movies and the books they were based on continue to be listed as resources by groups engaged in activities to end violence against women.

Although it served as a bridge to raising awareness of social issues, ironically the media was also important in the public identity of violence against women because of the role it played in *perpetuating* violence against women. Both print and film were interrogated for the derogatory and in some cases mutilating representations of women (see for example Radford and Russell 1992).

Research and Public Identity

During the 1970s and '80s, both social science and scientific researchers greatly contributed to the public identity of violence against women. Sociologists Murray Straus, Richard Gelles, and Suzanne Steinmetz are well known for publishing a considerable body of scholarship on the subject of violence (Straus 1976; Steinmetz 1977; Strauss 1978; Straus, Gelles, and Steinmetz 1980). Collectively they illustrated the pervasiveness of violence, and showed that, far from affecting only poor women of color it permeates all classes and racial/ethnic groups—a crucial factor in raising interest among policymakers. Their perspective about violence is one that has received a number of critiques because their work situates violence as an inherent component of family dynamics (Berk et al. 1983; Russell 1982). Rather than theorizing why men are violent toward women, which is a feminist perspective, they argue that where violent conflict exists, it is equal or nearly equal among spouses, overemphasizing relational gender equity.

Feminist researchers investigating the same issue provided an alternative analysis for the public. For example, Stark (1990) argues that

men use violence to control women and that institutions are partially responsible for sustaining violence against women, as evidenced by the gross negligence of health care system workers in their response to women who are battered. Stark et al. (1979) note that patriarchal medical ideology and practice leads to failure in recognizing battery. Thus, women seeking medical attention for violence are treated symptomatically.

Simultaneously, British researchers Dobash and Dobash (1979) anlayzed women's widespread victimization and critiqued health services and its inability to address battered women's needs. They posited that the underlying problem was that although women did not receive an adequate response, they continued to seek help from medical professionals. In so doing, the woman was eventually defined as the problem. Her credibility as a victim was diminished if she developed any of the post-traumatic effects of abuse, which included anxiety or depression, or even substance abuse (Dobash and Dobash, 1979). These and other research findings (Bowker 1986; Finkelhor 1983) underscored the limitations of treatment in medical settings, revealing that the medical model institutionalized socially sanctioned hierarchies of domination and control that mimic the dynamics of abuse and battering. Thus, despite the fact that existing data showing battered women sought treatment in medical settings, health care providers routinely avoided dealing with the issue.

Of course not all health care personnel closed their eyes to the problem. In the early 1970s, emergency service nurses established protocols to provide crisis intervention for sexual assault victims. Building on this foundation, several hospitals introduced domestic violence protocols, but many found that even in hospitals with protocols, the issue continued to be ignored (McLeer 1989; Warshaw 1989). Several studies examined the health care needs of victims of violence and a number of researchers offered a gendered medical analysis of domestic violence.

More recent findings reveal that public contact with physicians serve as an important resource for women who are victimized, and women who are often victimized visit their physicians 6.9 times per year, twice as often as nonvictimized women (Koss 1994, 193). Further, domestic violence provides the primary context for other health issues, including suicide, depression, drug and alcohol abuse, STDs, hypertension, chronic pelvic pain, irritable bowel syndrome, asthma, and a variety of psychiatric disorders (Heise 1994).

Domestic violence came to be understood as one of the most serious

public health problems facing women in the United States. But it was
not officially considered a public health problem until 1985 when Sur-
geon General Koop sponsored an invitational workshop on violence
and public health (DHHS 1986) and claimed violence against women
was a public health issue.[8] Regional conferences and campaigns fol-
lowed Surgeon General Koop's leadership in this area, many of which
were orchestrated by such organizations as the American College of
Obstetricians and Gynecologists (ACOG) to help physicians detect and
assist victims of domestic violence (Stark and Flitcraft 1991, 147).

Embracing a public health approach means that resources have to be
focused on understanding the epidemiology, risk factors, and manifes-
tations of prevention-oriented programs. A science-based understand-
ing of the perspectives of survivors of domestic violence, children, and
community residents is essential in developing an effective public health
response to violence (Alpert et al. 2002). The Centers for Disease Con-
trol's (CDC) efforts in violence prevention followed Surgeon General
Everett Koop's, convening a conference on violence and public health.
The conference focused on stress and violent behavior as a key priority
area for public health. Subsequently the CDC established a Violence
Epidemiology Branch in 1983.[9] This unit assessed the feasibility of
starting a national domestic violence surveillance system to encourage
projects in trauma registry and injury prevention and control. By 1993,
the CDC established the Division of Violence Prevention, within the
National Center for Injury Prevention and Control.

By the time the Violence Against Women Act of 1994 was signed into
legislation, grassroots women's groups, the media, and social and natu-
ral science research had converged on the public and policymakers, ul-
timately securing tremendous support for ending violence against
women.

THE VIOLENCE AGAINST WOMEN ACT (1994)

The decades leading up to VAWA's passage were marked by dra-
matic struggles of women's groups who mobilized around the issue of
wife abuse.[10] For example, from the late 1970s to the early '80s, many
bills addressing the needs of battered women were introduced in Con-
gress but all were defeated. But the movement gained momentum and
was spurred on as women vehemently claimed their right to control
their own bodies, "an idea that extended to a right to control the vio-

lence in their lives" (Silva 1994, 290). On a local level, loosely organized individuals and groups opened up safe houses and began shelters, the first of which opened in 1973, with little or no financial support. Battered women's increased need for support resulted in the growth of services and by 1991, there were over one thousand battered women's shelters in the United States. Nationally, task forces and coalitions sprung up, including the National Organization for Women (NOW) Task Force on Violence against Women, founded in 1976, and the National Coalition Against Domestic Violence (NCADV), created in 1977.

After nearly twenty-five years of advocacy from the women's movement, fifteen years of research by academics, and nine years of medical acknowledgment, a federal response to the problem of violence against women was introduced and signed into legislation in 1994.[11] The Violence Against Women Act was embedded in Title IV of the Violent Crime Control and Law Enforcement Act of 1994.[12] Under the bill, enforcement and educational and social programs are used to prevent crimes. Traditionally, police have reluctantly arrested perpetrators, district attorneys have failed to prosecute, sentences have been suspended, and charges have been dismissed. Seen as a conciliatory measure among the House of Representatives, the final vote results for roll call on November 20, 1993, for the bill titled, Violence Against Women Act of 1993, had 421 yes votes and 13 not voting, but no nays. [13]

The VAWA is landmark legislation and contains many provisions including:

- $800 million in funds to assist states in restructuring law enforcement response to crimes of violence against women;
- A nationwide 24-hour domestic violence hotline (1–800–799-SAFE);
- Enforcement of protective orders across state lines;
- Establishment of the Violence Against Women Office in the Department of Justice;
- Establishment of the National Advisory Council on Violence Against Women;
- Funding the National Academy of Sciences to develop a research agenda to increase the understanding of and control of violence against women; and
- Increased rights for victims.

Some considered the legislation very successful (but see Garfield 1998) due to declines in crimes committed against women. For example, violence against women fell by 21 percent from 1993 through 1998.

More specifically intimate partners committed fewer murders in
1996–98 than in any other year since 1976 (Tjaden and Thoennes
2000a).

When President Clinton signed VAWA under the Omnibus Crime
Control Act, it was considered historic in its ability to fund criminal law
enforcement against perpetrators of violence. When Congress passed
VAWA, it provided $1.6 billion for programs over five years to be used
to increase women's safety. Funds would provide personnel, training,
technical assistance, and data collection for the apprehension, prosecu-
tion, and adjudication of persons committing violent crimes against
women, including the crimes of sexual assault and domestic violence; in
addition, grants would encourage arrest policies. Penalties were created
for interstate stalking or in cases when abusers crossed state lines to
injure or harass another, or forced another to cross state line and then
harmed them. Existing penalties for repeat sexual offenders were
strengthened and VAWA also demanded pretrial detention in federal
sex offense cases of child pornography. The law set new rules of evi-
dence specifying that a victim's past sexual behavior generally was not
admissible in federal civil or criminal cases. Title III of the bill, a civil
rights provision, gave women victims of violence access to federal
courts making violence against women a violation of rights guaranteed
by the U.S. Constitution. Title III was analogous to civil rights suits for
injury motivated by race, underscoring the gender bias in state and fed-
eral courts. Unfortunately, this provision was later struck down as un-
constitutional (*United States v. Morrison et al.* No. 99–5, decided May 15,
2000). The federal response to domestic violence emphasized technical
assistance and research, although some states formed state level com-
missions or agencies to oversee domestic violence programs including
training for health, mental health, and social service personnel.

A report by the National Center for Injury Prevention and Control
(2003) estimates the economic cost of intimate partner violence to be
$5.8 billion per year, though it acknowledges this is a low estimate; oth-
ers estimate it to be $10 billion (Meyer 1992). Nonetheless, according
to Clark et al. (2002), the net benefit of VAWA was established to be
$16.4 billion. Since the cost of implementation was only $1.6 billion,
$14.8 billion in costs would be averted. Thus VAWA costs $15.50 per
U.S. woman and saves $159 per U.S. woman in costs averting criminal
victimization. From a societal perspective the analysis incorporates di-
rect property loss, medical care, ambulance service, mental health care,
initial police response and follow-up, victim services, social services,

lost productivity, and quality of life. The relevance of domestic violence
to the medical and public health profession became clear. But how was
it that after thirty years, VAWA was passed? In the next section, three
events are examined that played a role in its passage.

REMEDIES AND RIGHTS: THE CONFLUENCE OF EVENTS

Women's grassroots advocacy significantly influenced the positive
outcome of the legislation. Under the rubric of the National Task Force
on Violence Against Women (now the National Task Force to End Sex-
ual and Domestic Violence), over one thousand groups, including labor
unions, civil rights groups, religious organizations, and community
groups, and groups such as the National Women's Law Center,
NCADV, and the Women's Legal Defense Fund, galvanized to support
its passage. A broad spectrum of political groups helped convince mem-
bers of Congress that the issue was popular with and important to con-
stituents, particularly women. Circulating around the public identity of
violence against women were a series of events reflecting two important
dimensions that contributed to VAWA's passage: remedies and rights
that were inextricably linked to the politicization of violence against
women.

Women turned to the government and legal sphere to remedy the
egregious violations embedded in the violence women suffered. Once
domestic violence was viewed as a violation of women's rights, then it
was incumbent on the government to provide a remedy. It was believed
that the state was capable of delivering justice; thus, advocates articu-
lated a statist intervention rooted in the concept of rights. Rights are
those expressions that reflect revolt against specific wrongs. Articula-
tion of rights represents a dramatic break with and disruption of past
practices, requiring a new order. As women worked to secure the pro-
tections they needed from male privilege and abuse, they knew that
they had to be present in the halls of power. Thus, three events are
particularly influential in VAWA's passage.

First, to remedy the fact that women's voices were barely audible in
policy decisions, many entered electoral politics as a corrective for
women's lack of representation, spurred by the Thomas-Hill hearings.
Second, was the growing applicability of a human rights perspective in
a domestic context. Women and their supporters felt strongly that
women had the right to live their lives free of violence, viewing violence

against women as a violation of rights. The third event was embodied
in human rights discourse. Just at the point that human rights activists
translated rights language to a U.S. context, Nicole Simpson, O.J.
Simpson's wife, was murdered. In many ways her death represented the
clearest violation of the right to live free of violence.

"Year of the Woman"

In the decade before VAWA's passage, women were elected in record
numbers to state legislatures, city councils, and county offices across
the country. Their local political participation served as a springboard
to run for national office. Many women took the opportunity with sup-
port from Political Action Campaigns such as Emily's List,[14] which fun-
neled cash to women candidates. The importance of the women's vote
had an effect on both political parties and the Republicans, for example,
set out to close the gender gap by supporting more female candidates.
The outcome was that women's gains in Congress were unprecedented.
According to Wilcox (1994), 1992 was tagged "The Year of the
Woman." Four women won new Senate seats, and one incumbent won
reelection, tripling women's representation in the upper chamber.
Twenty-four women were elected to the House, raising the number of
women from twenty-nine to forty-seven.

The 1992 elections focused on issues to which women responded—
issues raised by presidential candidate Bill Clinton, who promised to
prioritize women's concerns and create a gender and ethnically bal-
anced administration. Consequently, female voter turnout was great,
with women casting 54 percent of the votes. There was a critical mass
of women positioned for national office as a result of having garnered
local political acumen. One of the reasons for women's participation in
electoral politics was the charges brought against Clarence Thomas, the
Republican nominee for the U.S. Supreme Court, by Anita Hill.

Anita Hill's dramatic testimony during the 1991 Senate hearings on
the confirmation of Clarence Thomas as Supreme Court Justice
shocked America. Anita Hill had come forward and charged Thomas
with sexual harassment when she worked with him at the Equal Em-
ployment Opportunity Commission. Hill provided the Judicial Com-
mittee with a sworn statement that Thomas had harassed her and, after
Hill went public with her accusations Thomas's confirmation was post-
poned to allow the Judiciary Committee to hear both Thomas's and

Hill's arguments. What ensued was a complex web of events shrouded in racism and sexism.

Thomas was deemed an appropriate representative of black life as many were swayed by his potential. Ultimately he was confirmed but his stellar trajectory to the Supreme Court was a slap in the face to many women because an all-white, all-male Senate Committee decided to recommend Thomas's appointment to the Supreme Court. That a group of white men so blatantly displayed their dismissal of a woman, a black woman, riled feminists. But while Hill's charges of sexual harassment were believed by many professional women, some black women had divided loyalties because, as Morrison (1993) points out, undiscriminating racial unity had passed, and not all viewed Hill's charges as legitimate. As Crenshaw points out (1994), the political implication of the Thomas-Hill hearings was that feminism was recast in order to reach women who did not see gender as relevant to an understanding of their own disempowerment.

America's temperature rose and women across the country were poised to reconsider the logical conclusion of an all-male Senate because the hearings "forced the political under-representation of women into dramatic focus" (Byrson 1999, 107). Women's PACs such as Emily's List and WISH List raised $6 million to support female candidates within the Democratic Party. Hill, whose class and professional status had become inextricably linked to white women's view of themselves, motivated 170 women to run for Congress including Carol Moseley-Braun (D-IL), Patty Murray (D-WA), and Lynn Yeakel.

Hill's public commentary was the impetus that led women to contest gender underrepresentation. Anita Hill's class status and professional choices were close enough to those of many white professional women and feminists that she became the icon that motivated them to challenge white male privilege and power. The remedy, of course, was political participation and increased representation in the 1992 elections.

Violence Against Women as a Human Rights Issue

The burgeoning human rights movement in the United States influenced VAWA's passage as the framework incorporated women's rights as salient rights obligations. International feminist activism in the 1970s resulted in the United Nations adopting the Convention on the Elimination of All Forms of Discrimination Against Women (CEDAW) in 1979. The convention broadened the human rights framework to in-

clude women's rights and was the first treaty devoted to the advancement of women's human rights. Pressure exerted by women internationally resulted in UN recognition of violence against women as a human rights issue and an affirmation by the committee that monitors the implementation of CEDAW that both public and private violence against women be recognized as a violation of human rights (Abdullah 2000).[15]

The United Nations World Conference on Human Rights held in Vienna in 1993 became a vehicle to underscore alternative visions of human rights thinking and practice. A broad collaborative effort resulted in the inclusion of women into the conference agenda. Insertion of private and public violence against women in the Vienna Declaration and Programme of Action was successful. As Roxanna Carrillo (1994) notes, this conference presented the opportunity for women to raise awareness and put the issues of violence against women on the international agenda. Out of that conference important gains were made in relation to violence against women. Three things happened at the conference:

1. Women's rights were presented in the principles of the Vienna Declaration as an integral, inalienable, and indivisible part of human rights discourse;
2. The international community acknowledged violence against women in both the public and private spheres; and
3. Women influenced the decision by the World Conference on Human Rights to declare the need to appoint a Special Rapporteur on Violence Against Women. It is the rapporteur's job to report each year to the commission on such issues as violence and what the UN and governments should be doing about it. (Bunch 1999, vii)

Increased gender-based violence and women's activism precipitated the development of another instrument, the Declaration on the Elimination of Violence Against Women, adopted by the UN General Assembly in 1993. The Declaration on the Elimination of Violence Against Women defined violence against women as any act of gender-based violence that results in or is likely to result in physical, sexual, or psychological harm or suffering to women, including plans of such acts, coercion, or arbitrary deprivation of liberty, whether occurring in public or in private life.

Although there are limitations to these instruments, a discussion of

which is beyond scope of this chapter, both CEDAW and the Declaration were crucial turning points in expanding the international community's understanding of what constitutes violations of human rights. On the domestic front, violence as a violation of women's human rights found its articulation in the death of Nicole Brown Simpson.

O. J. Simpson and Nicole Brown Simpson

On June 12, 1994, Nicole Brown Simpson and Ronald Goldman were stabbed to death, their bodies found in the front courtyard of the Nicole's condominium in Brentwood, California; she had been stabbed ten times and her throat had been slashed while her friend had been stabbed seventeen times.

That summer the nation was embroiled in the murder of Nicole Brown Simpson, wife of O. J. Simpson. O. J., nicknamed "The Juice," had been a running back for the Buffalo Bills and the San Francisco 49ers. He became a familiar face on television as a charismatic sports announcer and actor. Simpson, who was beloved by America, had transcended race, and as a black man, became a model to which young men could aspire.

During the investigation, Simpson was accused of murdering his wife and the revelation of his abusive history came into public view shocking the nation. During Simpson's trial, old 911 tapes of Nicole's pleas for help were replayed for the jury. The publicity surrounding the trial meant that the public was exposed to the reality of domestic violence on a daily basis, to which some attributed the national rise in domestic violence hotline calls. Nicole Simpson became the face of a problem that had been identified by the surgeon general ten years earlier. Nicole, an upper-class white woman, brought such an unprecedented degree of legitimacy to the problem that Rep. Jane Harman (D-CA) referred to her death at a June 30 proceeding of the 103rd Congress (Congressional Record, 1994) in an effort to garner support for VAWA's passage, stating:

Mr. Speaker, the tragic murder of Nicole Simpson has raised our consciousness about domestic violence. If a man beats a woman in the middle of the street, no ones debates whether it is a crime. But when an assault is committed against a woman by her husband in her own home, behind closed doors, some view the facts differently. Even the victims in many cases—including

Nicole Simpson—choose not to report acts of violence or not to press charges.

We must raise awareness that domestic violence is indeed a horrible crime; unreported domestic violence is a crime unpunished. And we must help the women who cry out for help. In the last 2 weeks since the Simpson murder, calls to shelters in my district from battered women have increased dramatically. (1)

Nicole Brown Simpson became America's frame of reference for understanding that women had the right to live free of violence. The fact that Nicole had been beaten by Simpson for years, and the fact that there had been nine calls for help, none of which lead to Simpson's arrest, exemplifies a situation where lawful intervention was not actualized. Nicole Brown Simpson's death in 1994 was a cue for intervention and posed the possibility that a remedy to domestic violence was in order.

Just three months after Nicole Brown Simpson's death in September 1994, VAWA was signed. By that time domestic violence and violence against women were firmly established as grave public health issues. Public understanding of violence against women had been framed as a criminal act. Given that women are more likely to experience domestic violence than anyone else and that clinical data indicates that abuse may be the single most important source of injury among women (Stark and Flitcraft 1979), the issue simply had to be seen as a responsibility of the federal government. While domestic violence has become one of the most serious public health problems facing women in this country, and although organized medicine addressed this issue early on, it has largely been the work of the battered women's movement that generated the increased awareness of violence as a public health problem.

To learn more about the proposed legislation, Congress held three hearings as it considered VAWA in 1993: in Maine; Washington, D.C.; and Utah. One might conclude that violence against women had developed a successful public identity, ripe for policy intervention, based on comments made by the president-elect of the American Medical Association, Dr. Robert McAfee, who testified at the Maine hearings on VAWA in 1993. First he stated that domestic violence should be treated as a public health epidemic, echoing Koop's declaration made almost a decade before. Also in his testimony, McAfee noted that the "AMA and physicians are very active in efforts to address the issues of family violence in general and violence against women in particular" (McAfee 1993).

The American Medical Association (AMA) devoted two issues of the *Journal of American Medical Association* (*JAMA*) to violence against women in 1992. In the 1990s health care provider organizations, such as the American Academy of Family Physicians (1994), the American Academy of Pediatrics (1998), the American College of Obstetricians and Gynecologists (1999), and the American Medical Association (1992), increasingly paid attention to the issue of domestic violence and developed domestic violence guidelines.

The AMA initiated Physician's Campaign against Family Violence and the American Medical Women's Association developed a training course to teach medical practitioners how to recognize and treat domestic violence. The courses teach one how to ask questions of women in a supportive manner and how to treat the whole woman, not just the physical injuries, when domestic violence is suspected.

VAWA was a conciliatory bill unifying conservatives, liberals, and those on the political left. It was supported by such politically disparate legislators as Sen. Orrin Hatch (R-Utah), Sen. William R. Cohen (R-ME), an independent republican on the left of the Republican Party of Maine, and Sen. Dianne Feinstein (D-CA).[16]

Conclusion

VAWA's passage was prompted by the attention that battered women activists and their advocates demanded in the 1960s. A democratic process required legislators to consider the issue to generate genuine public and political interest in solving the problem (Barber 1984, 13). There was no way policymakers could ignore domestic violence because there was strength in several constituents' positioning of domestic violence as a legitimate concern worthy of debate and intervention. But first the challenge was to wrest the reality of violence against women out of the restrictive private domain. It had to be and was successfully situated in public terms, as a public problem requiring broad responses. Women's activism raised the issue and situated it as a social problem, which resulted in access to funding for shelters and services. Shifting the identity of violence against women from the private to the public domain was a dramatic and hard-won battle. But the deliberations were successful in that the harm caused by domestic violence came to light. The work of battered women's activists solidified the interest and com-

mitment of the media, medical practitioners, and public health advocates.

Post 1970s, violence against women was framed within the context of rights and remedies. The rights and remedies analysis proposed here exemplifies the nuanced factors that led to increased legitimacy of violence against women as a *real* social problem, which ultimately validated the passage of VAWA as appropriate public policy. Antiviolence advocates' efforts to gain public acknowledgment of gender-based violence as a significant social and political issue, along with reframing the problem as a violation of women's rights that requires a legal remedy, facilitated the federal government's assumption of obligation for women's safety. While the unintended consequence of government involvement represents a major shift away from advocacy-led discourse, as Garfield (1998) notes, what we see is that battered women's activists situated women's safety as a matter of justice. Advocates pursued aggressive legal reforms in hope that there would be increased institutional accountability. As Susan Schechter (1982) points out, one of the most important goals of the battered women's movement was that battered women should have the same rights as any other crime victim.

6

Conclusion: Beyond Reproduction . . .
and Back Again
Karen L. Baird

THE WOMEN'S HEALTH MOVEMENT OF THE 1990S ACHIEVED MANY POL-
icy changes in a variety of key health areas for women—notably medi-
cal research, AIDS, breast cancer, and violence against women. The
previous chapters detailed how and why such changes occurred with
regard to each specific health issue. In this concluding chapter, a macro-
level perspective of the movement will be taken. The use of discursive
and interest groups politics, insiders and outsiders, institutional protest,
strategic positioning, level of state involvement, the transformation of
the meaning of women's health, and claims-making will be discussed,
as well as how this analysis contributes to the literature on women's
movements and social movements in general. The chapter concludes
with a discussion of the longer term impacts of this era of women's
health activism and what the landscape of women's health looks like
early in the twenty-first century.

CONCLUSION: THE WOMEN'S HEALTH MOVEMENT OF THE 1990S

Discursive Politics vs. Interest Group Politics—Institutional Protest

As discussed in chapter 1, discursive politics refers to the politics of
meaning-making and interest group politics refers to more conventional
forms of political engagement such as making claims of equality and
rights, utilizing influence-seeking tactics such as lobbying, and per-
forming these acts in traditional political settings such as Congress and
the courts. These two forms exist on a continuum, and women's health
activists of the 1990s engaged in both types of politics though some

groups relied more heavily on one strategy than the other. Additionally, all issues explored herein involved federal-level executive institutions such as the CDC, DOD, DOJ, FDA, and NIH; most of the groups also pursued legislative changes in Congress.

At one end of the spectrum, breast cancer activists transformed the meaning of breast cancer so they could invoke traditional forms of political engagement.[1] Following the AIDS activists and the model of "disease-specific" activism, they converted breast cancer from a medical issue to a political problem with political causes and political solutions. As the controversy about women and medical research was occurring at the same time, the lack of successful research on breast cancer served as a prime example of the problem, and thus the two issues and activism around them and reinforced each other. Individuals fighting to end violence against women and for passage of VAWA also had to shift the meaning of domestic violence from a private problem to a public crime so it could be deemed an appropriate subject matter of federal legislation.

At the other end of the spectrum, advocates for women's medical research engaged more often in interest group politics. They first pursued change at the NIH, a federal-level executive institution, by pressure tactics and documentation of the problem. Once clearly documented, the problem of the exclusion or underrepresentation of women research was easily accepted, thus little need existed for discursive political tactics. And then when activists pursued legislative change in Congress, insiders introduced legislation; insiders and outsiders testified at hearings; outsiders met with legislators; and insiders influenced and pressured other members of Congress.

Mary Fainsod Katzenstein's (1998) work shows how discursive politics and institutional protest were dominant tools of the feminist activists she studied. The research presented herein supports her findings. The women's health movement of the 1990s greatly utilized such tools, adding corroborative evidence to the view that these are principal strategies of the newly fashioned women's movement of the 1990s. As Woliver (2002) states, "Katzenstein cautions us against the view that inside activism signals the end of the challenges that movement politics initiates" (212). The research herein supports the notion that the women's activism is alive and well, though it looks drastically different from the activism of earlier eras.

But what factors account for the different levels of use of the two strategies? Levels of support from outsiders and insiders, and the gen-

eral level of acceptance of activists' claims by political institutions are two determining factors.

Insiders and Outsiders — Institutional Protest, Women's Health Advocacy Groups, and the State

As discussed in chapter 1, institutional protest refers to social movement actors who are insiders — people who occupy formal positions in government — who pursue their goals through bureaucratic channels. As Banaszak (2005) argues, in order to "understand the tactics, strategies, and outcomes of a social movement, particularly decisions to undertake moderate tactics or to take to the streets, we must reexamine the boundaries we draw between a movement and 'others,' especially the state" (149). This issue is exemplified in the women's health movement. Most of the issues discussed herein found many supportive people in government, and thus activists (insiders and outsiders) utilized the state to pursue their goals. Following Katzenstein (1998) and Beckwith (2007), I break down movement strategies into discursive politics and interest group politics, as discussed above. The notion of interest group politics more commonly refers to outsiders, whether they are members of interest groups or social movement actors, and activities such as lobbying and pressuring members of Congress, for example. It seems odd to state that insiders engage in interest group politics and lobby other insiders. With new forms of protest and activism, new concepts and terms must be developed that more specifically describe such activities, and the concept of institutional protest attempts to capture these actors and activities. These are some of the issues that Banaszak (2005) refers to in her notion of "state-movement intersection." Additionally, we do not want to conflate movement tactics with presence of insiders, as the two are related but separate issues (Banaszak 2005; Beckwith 2007).

The women's health advocacy organizations consisted primarily of outsiders, though at least one woman — Florence Haseltine of the NIH — was a founding member of the main advocacy group (SAWHR) working to have more women included in medical research. And though active members of Congress may not have been on the membership lists of the respective advocacy organizations, such insiders pursued the health concerns in a vigorous manner, many times *as if* they were outsiders with utmost concern for the health problem(s). Such actors have also been called "policy entrepreneurs" (Kingdon 1984,

1995). Rep. Mary Rose Oakar (D-OH) with regard to breast cancer and Rep. Patricia Schroeder (D-CO) with regard to medical research serve as examples of such activists or policy entrepreneurs engaging in institutional protest. Sen. Joseph Biden (D-DE) instigated the first VAWA legislation in 1990 and outsiders joined the cause subsequent to this initial bill (Brooks 1997). It is difficult to say how the story would have turned out if either pressure from the inside or from the outside was absent, but it is clear that the presence of both was necessary. This is an important finding for agenda setting research; such research should pay more explicit attention to the role of outsiders and insiders.

Karen Beckwith (2007) discusses various strategies used by feminist movements. One strategic decision concerns the level of state involvement. Are movement actors and organizations completely separate from the state or are they closely involved with the state? As explored herein, the women's health movement of the 1990s resides at the state involvement end of this continuum, whereas the earlier movement of the 1960s and '70s strove to be autonomous. Why did activists choose to be highly involved with the state?[2] Actors chose to make claims and request policy changes from the state for a number of reasons. One, activists could utilize accepted language and norms of the state—equality, rights, inclusion, etc. This was exemplified in the passage of VAWA. Women's rights were generally accepted—a reflection of the success of the women's rights movement of the 1960s and '70s—and reinforcing this acceptance was the more contemporary issue of women's rights as human rights. Addressing violence and crime also enjoyed great public support. The two issues came together by moving domestic violence from the private to the public arena by publicizing women's experience of violence and invoking women's right to live free of violence. Second, the state contained many supportive individuals, primarily in Congress and in the executive office after President Clinton was elected. Third, because of changes in the social and political context, and accumulated evidence of the harms of rejecting state involvement in women's health, the state now appeared to be the appropriate location at which to pursue change.

The second strategic continuum Beckwith (2007) identifies is insider-outsider positioning. Insider positioning involves working to increase the number of women in the state and using insiders to advance movement goals (323). Outsider positioning refers to engaging the state without gaining access and involves relying on outsiders to pressure the state for change. The women's health movement varied on this issue.

Activists fighting for more women in medical research, increased breast cancer research funds, and passage of VAWA, relied heavily on insider positioning because such supportive people existed. Conversely, AIDS activists relied heavily on outsider positioning, as few supportive people existed in Congress or the executive branch. Breast cancer activists, in addition to insider positioning, relied heavily on outsider tactics as demonstrated by the activities of the NBCC. Unlike the other groups, AIDS protesters rarely pressured Congress; their force was targeted toward the CDC, NIH, and the FDA. "Outsider strategies are necessary where feminist movements are not positioned inside the State or when their presence is weak, or where the issues are highly contentious" (Beckwith 2007, 323; also see Banaszak 2005). The issues explored herein support this position. Only AIDS activists primarily utilized outsider strategies, as they found little support from members of Congress. Additionally, AIDS was a contentious issue, often associated with homosexual men, drug use, and prostitutes, and thus was more controversial than any other health concern discussed herein.

Politicized Notion of Women's Health and Claims-Making

Many of the health concerns explored herein were shifted from a medical domain where biomedical researchers, scientists, and physicians assert control over knowledge to the political domain where individuals can assert claims of inclusion, equality, and enforcement of rights. Additionally, advocates fighting violence against women shifted the problem from the private to the public, political realm. These shifts occurred in a variety of ways.

AIDS and breast cancer activists educated themselves and others about the scientific, biomedical processes of research and biomedical information about the disease. Once armed with such knowledge, they could more persuasively communicate with NIH and CDC officials and participate in biomedical discussions with researchers and funders. Interestingly, these activists as well as the ones arguing for the inclusion of women in medical research, all challenged while simultaneously embracing biomedical and institutional norms and practices. For example, AIDS activists argued that the biomedical definition of AIDS excluded women; this exclusion resided in how AIDS was diagnosed. The activists knew the biological aspects of the disease and could in biomedical terms explain the problem about women's symptoms or indicator diseases. They did not challenge the CDC's authority to develop an epide-

miologically based definition; they did not challenge the basic process
of developing a definition, meaning one based on presence of antibodies
and indicator diseases. They only argued that the definition excluded
women's symptoms and that therefore women's development of AIDS
remained invisible. Similarly, advocates for the inclusion of women in
medical research did not challenge the status quo of the use of federal
money for scientific research, nor the NIH's general authority regard-
ing how money should be spent. They did challenge the NIH practices
of excluding or underrepresenting women and the amount of money
devoted to women's health research; they wanted NIH to correct these
issues.

Activists fighting domestic violence had to shift the problem from the
private realm and the view of violence as natural to the political realm
and a view that such violence is a crime. Unlike the other issues dis-
cussed herein, much activity on domestic violence had previously ex-
isted at the state level. Only when Senator Joseph Biden (D-DE)
decided to introduce legislation in Congress did activists move their ad-
vocacy efforts to the federal level. Senator Biden was also the one who
later decided to include VAWA in crime legislation. Of course, activists
had been fighting to have domestic violence recognized as a crime but
Senator Biden recognized and seized the specific opportunity of includ-
ing it in the crime bill. Activists, both insiders and outsiders, supported
the use of the criminal legal system to address domestic violence.
Greater state involvement in the issue of violence against women was
needed, advocates argued. Once again, the authority of the hegemonic
institution, the state, was not challenged; in this case, it was encouraged.
An Office of Violence Against Women (OVW) was established in the
Department of Justice (DOJ), cementing the authority of the state to
handle the problem.

As Katzenstein (1998) finds in her study of feminists in the military
and the Catholic Church, women's health activists utilized and adopted
the dominant norms and rhetoric of the very institutions they were chal-
lenging. They invoked the power of the state and other institutions to
include and better serve women, simultaneously challenging and sup-
porting them. Laura Woliver (2002) states, "Katzenstein deftly proves
that by demanding a coequal place inside *male-dominant institutions*, fem-
inists have transported protest into mainstream institutions and have
changed institutional and social givens" (212). "Less lawbreaking than
norm-breaking, these feminists have challenged, discomfited, and pro-
voked, unleashing a wholesale disturbance of long-settled assumptions,

rules, and practices" (Katzenstsein 1998, 7). The same can be said of the women's health movement of the 1990s.

Activists claimed that federal institutions and their policies were harming women's health. They claimed that such institutions were engaging in gender discrimination, perpetuating gender inequality, and ignoring women and women's rights. The present analysis shows, once again, that problem framing is critical. Utilizing commonly accepted norms and values such as equality, inclusion, nondiscrimination, and rights was key to women's health issues reaching agenda status. Applying accepted values to new arenas—to ones that previously appeared nonpolitical—proved successful as it also revealed the political and gendered nature of biomedicine, science, funding, and criminal laws. Moreover, publicizing what was previously private and hidden makes unaware individuals, whether they are average citizens or members of Congress, less able to ignore life-threatening issues in women's lives.

Please see Table 6.1 for an overview of the women's health movement of the 1990s.

CONSEQUENCES OF THE WOMEN'S HEALTH MOVEMENT OF THE 1990s

Assessment of Policy Changes

What are the impacts of the many policy changes from the vantage point of a decade later? Have the policies been implemented in a successful fashion? Has women's health improved? The data kept at the NIH and the ORWH show unequivocally that women's inclusion in NIH-funded research has drastically increased. In 2004, 57.5 percent of participants in NIH extramural and intramural research were female (DHHS 2006). The Women's Health Initiative (WHI) resulted in some stunning revelations. In 2002, a portion of the study was stopped after it was found that combination hormone replacement therapy (HRT) greatly increased the risk of breast cancer and heart disease, making the risk of taking combination therapy outweigh the benefits in many cases. The estrogen-only HRT portion of the study was stopped in 2004. Prior to this, thousands of women took HRT as it was routinely prescribed for menopausal women.

With regard to the change in the definition of AIDS—many more women were diagnosed with AIDS, making the number of cases of

Table 6.1. Women's Health Movement of the 1990s

Dimensions of the Women's Health Movement

Issue	Protest Strategy	Outsider vs. Insider positioning	Level of State Involvement	Target of Activism	Claims Made	Goals	Achievements
Medical Research	Interest group politics — institutional protest	Insiders (primarily) and outsiders	High level of state involvement	NIH, FDA, Congress	Gender inequality, exclusion, discrimination	Inclusion of women in clinical research; increased research on women's issues	NIH Revitalization Act; ORWH; increased research on women's issues
AIDS	Street protest, interest group politics	Outsiders	High level of state involvement	CDC, NIH, FDA, pharmaceutical companies	Women ignored and invisible	Include women's symptoms in AIDS definition; increased research on AIDS and women	Change in CDC definition of AIDS; more research on AIDS and women
Breast Cancer	Discursive politics, interest group politics — institutional protest	Insiders and outsiders	High level of state involvement	NIH, Congress	Gender inequality, exclusion, discrimination; women ignored	More funding and research on breast cancer; increased participation in research decisions	Increased funds for research; much legislation for mammography, etc.; NAPBC
Violence Against Women	Discursive politics, interest group politics — institutional	Insiders (primarily) and outsiders	High level of state involvement	Congress, DOJ	Women's rights and crimes of violence against women ignored	Recognize such violence as a violation of rights; prosecute and	VAWA; OVW

AIDS appear to make a drastic leap in 1993. In 1992, 6,037 women were diagnosed with AIDS and in 1993, 16,671 were diagnosed (CDC 1997). But as the number of HIV-infected women continues to rise, we have done little to successfully curtail the epidemic, especially for women of color. With regard to breast cancer, though much research ensues, we still do not know the cause of or the cure for the disease. Regarding violence against women, the annual rate of nonfatal violent intimate partner violence for women has declined; in 1993, it was 9.8 per 1,000 females and in 2004 the rate had decreased to 3.8 (Catalano 2007). Though the numbers indicate a positive situation for women, such data are difficult to interpret because the connection between actual incidence and reported incidence is unclear. It appears that the women's health movement and policy changes have had mixed results but that overall the policy changes have been fairly successful.

No Broad Concept of Women's Health

In the 1990s, there were few large, effective organizations addressing women's health issues in general and perhaps drawing connections between various health care concerns.[3] Links of sexism, racism, and poverty, to name a few, could theoretically be drawn and highlighted. But disease- or issue-specific groups only address their single cause and no overarching analysis is being advanced, possibly to the detriment of women's overall health.

No Overarching Framework of Gender Inequality

The issue-specific activism not only hindered the development of an overarching concept of women's health, it also obstructed the development of a more explicitly feminist perspective that recognizes and fights against gender inequality. As discussed in chapter 1, the women's health movement of the 1990s is considered a women's movement but placing a feminist label on it is quite problematical. Though many activities and arguments appear to be feminist oriented, most participants did not consider themselves to be feminists[4] and most were not tied to any larger feminist or women's rights movement. Many activists framed their specific issue as a problem of exclusion or inequality, but few developed larger, societal level claims of gender inequality. Stated another way, few took a societal-level perspective of viewing their concern as just one specific instance or example of gender injustice, embedded in

and arising from a much larger system of gender oppression. This is both a result of and produced by a weak women's rights movement in the United States in the 1990s. Meyer (2003), speaking of the women's movement in general, notes, "Issue activists within the women's movement found it easier to build support and to mobilize resources in support of more focused campaigns . . . based on much narrower claims. At the same time, appeals to other women to mobilize as feminists, rather than as women, became less frequent and less effective, as fewer women self-identified with feminism" (287).

Implications of Engaging with the State

Unlike the women's health movement of the 1960s and '70s, the women's health movement of the 1990s engaged with the state to improve women's health. Interestingly, the movement was operating in an era of state *reduction* of responsibilities. Lee Ann Banaszak, Beckwith, and Rucht (2003) note how Western, democratic states have recently engaged in offloading, downloading, and lateral loading, rarely increasing their responsibilities. This is a quite unpromising political context in which to work. The women's health movement provides a counterexample to this trend as the state *increased* its responsibility for women's health. This contextual information shows again how great the movement's achievements were.

The present research has primarily discussed the success of a state engagement strategy, but there are potential negative consequences as well. The state is in control of such policies, and not women or women's health institutions and organizations. Policies and laws change, and policy change rarely reflects a straightforward, logical process regarding a policy's worth and success. Laws expire and programs and funding have to be continually renegotiated. Placing control with the state requires constant vigilance to preserve the attained benefits. The 1980s was one period for feminists in which they had to vigorously fight to maintain the achievements of the 1960s and '70s. And as we enter the twenty-first century, reproductive rights is an area in which some previously established rights are being eroded (this is discussed below). Additionally, the continual presence of women and supportive men in Congress is also necessary as programs are renegotiated. Elections may or may not yield such supportive members.

Creation of many Federal Level Offices of Women's Health

During the 1990s, the federal government restructured and opened many women's health offices. These include the Office of Research on Women's Health (ORWH) at the NIH; the Office on Women's Health and Deputy Assistant Secretary for Health (Women's Health) at the DHHS (1991), which also runs a national women's health information center; the Office of Women's Health at the FDA (1994); the Office of Women's Health at the CDC; the Office for Women's Services at the Substance Abuse and Mental Health Services Administration; and the Office of Violence Against Women (OVW), created in 1995 at the DOJ. The various offices were opened for different reasons, only sometimes at the behest of activists.

In the 1960s and '70s, the women's health movement created autonomous woman-centered organizations. Throughout the 1980s and '90s, many mainstream providers created specific women's health centers, alternative birthing centers, and "well women" health care plans, mainstreaming what was previously seen as alternative or radical. In the 1990s, such trends continued with the addition of offices of women's health in federal-level executive institutions; many would call this a further cooptation of women's health. In fact, "[m]any women's health activists have argued that the language of the [women's health movement] has been co-opted by larger institutions that remain generally unresponsive to women's needs" (Norsigian 1996, 82).

Such offices provide further evidence of how women and women's issues have transformed mainstream, often male-dominated, institutions, but their presence does not mean that women have great influence, can set the larger agency's agenda, or even engage in advocacy efforts within government (institutional protest). Some offices, such as the FDA's Office of Women's Health, appear to be a clearinghouse of information for consumers to access and utilize. Such offices could just be tokens that make it appear that the government is addressing women's health concerns. Presence does not equal voice, influence, or power. An in-depth analysis of the effects of the many new offices of women's health remains to be conducted.

BEYOND REPRODUCTION . . . AND BACK AGAIN

As the decade of the 1990s closed, the landscape of women's health policy looked drastically different than when it began. Though Presi-

dent Clinton's health care reform plan was never enacted, women's health care policy had been radically altered. As we enter the twenty-first century, the implementation of the policy changes of the 1990s continues. But unfortunately, many other changes have been made and are being attempted. With the election of President George W. Bush and many conservative, fundamentalist, and/or right wing members of Congress in 2000 and 2002, the reproductive rights of women have been challenged once again; in some manner, we have returned to the struggle of the 1960s and '70s. Many attempts at curtailing women's reproductive rights have commenced in the states and continued at the federal level. A partial listing of new federal policies and laws include:

- reinstatement of the global gag rule
- the partial-Birth Abortion Ban Act
- the Born Alive Fetus Protection Act
- Teen Endangerment Act
- declaration of the "Sanctity of Life" day
- the Unborn Victims of Violence Act
- denial of abortions to women in the military
- withholding of funds to the United Nations Population Fund (UNFPA)
- funding of abstinence-until-marriage sex education programs

In addition, many states have enacted restrictions on abortion rights and there is a lack of abortion providers and abortion clinics. Many doctors are not being trained in the procedure, and others choose not to offer the service. And not surprisingly, the basic right to an abortion as established by *Roe v. Wade* was challenged in South Dakota. The legislature passed and the governor signed a bill banning all abortions except those to save the life of the mother. It declares that life begins at the moment of conception. This was subsequently put before the citizens of South Dakota as a ballot measure and was defeated.

In April 2007, the Supreme Court ruled on the constitutionality of the Partial-Birth Abortion Ban Act of 2003 (18 U.S.C. §1531(a), 2000 ed., Supp. IV) in *Carhart v. Gonzales* (550 U.S. __ ruling that the law is valid and constitutional. In 1992, the Supreme Court in *Planned Parenthood of Southeastern Pa.* v. *Casey* (505 U.S. 833) upheld the right of a woman to obtain an abortion before viability without undue interference from the state and granted the right of the state to regulate abortions after viability as long as restrictions allow for exceptions when a women's life or health is endangered. *Carhart* allowed the exception of

when a woman's life is endangered to be eroded because the Partial-Birth Abortion Ban Act does not contain such an exception. Justice Ruth Bader Ginsberg notes in her dissenting opinion: "Today's decision is alarming. It refuses to take *Casey* and *Stenberg* seriously. It tolerates, indeed applauds, federal intervention to ban nationwide a procedure found necessary and proper in certain cases by the American College of Obstetricians and Gynecologists (ACOG). It blurs the line, firmly drawn in *Casey*, between previability and postviability abortions. And, for the first time since *Roe*, the Court blesses a prohibition with no exception safeguarding a woman's health" (550 U.S. __).

In reaction to these many attacks on reproductive rights, women, women's groups, and reproductive rights organizations organized many responses. We have experienced the most political activity focused on reproductive rights since the 1960s and '70s. Organizations such as NARAL Pro-Choice America, National Organization for Women (NOW), Planned Parenthood, Feminist Majority, National Latina Institute for Reproductive Health, American Civil Liberties Union (ACLU), and the Black Women's Health Imperative have been very active and organized a March for Women's Lives in April 2004. The turnout for the march was massive.

These events remind us that progress is fragile and potentially reversible. As the political setting of the United States continues to change, and as women's reproductive rights appear to hinge on each election, we will have to wait and see what the landscape of women's health settles into. Reproductive rights may survive the current assault and remain established rights for women, and the pursuit of other women's health issues may continue. Alternatively, we may return to the era of the 1960s in which women lacked reproductive freedom. Indeed, we may have moved beyond reproduction only to return to the fight once again.

Notes

CHAPTER 1. INTRODUCTION

1. But see David Meyer, Valerie Jenness, and Helen Ingram, eds. (2005), *Routing the Opposition: Social Movements, Public Policy, and Democracy* in which the connection of social movement and public policy literatures are explored.

2. Only a brief summary of this movement is provided here. Please see Morgen (2002) for a more complete history of this era.

3. The 1960s movement is not *the* first women's health movement. There have been at least four previous movements in the history of the United States (see Weisman 1998).

4. Of course the earlier movement also politicized women's health but the politicization was of a different form.

5. The AIDS activists attribute many of their conceptions and actions to the earlier women's health movement, as well as the civil rights movement.

6. In 1987, only 13.5 percent of the NIH budget was devoted to the broadly defined category of women's health issues (Berney 1990), but this number is contested by some as constituting *more* than what men's issues receive (Kadar 1994).

7. Though the activists proposed this notion of inclusiveness, many issues that poor and women of color face were not a major focus of the movement of the 1990s. Such issues include access to abortion as the federal government did not allow Medicaid to cover abortion services, and the lack of access to overall health care. In addition, after the CDC definition of AIDS was changed, activism around women and AIDS declined, and continues to be very low, as the number of new infections in women of color drastically increases.

8. One might also consider the rise of breast augmentation surgery in this time period; in the 1970s, silicone implants were developed and thought to be one of the first safe methods. These implants, and breast enhancement surgery, grew in popularity in the 1980s (Ferguson 2000).

9. For example, the EEOC reports that sexual harassment complaints increased 70 percent in 1992 (McGlen et al. 2005, 155).

10. There are two important issues regarding women and medical research. One is the exclusion or underrepresentation of women in all medical studies of diseases common to women and men and drugs or treatment for such diseases. The other issue is the study of diseases or conditions that only occur or more commonly occur in women, such as breast cancer and osteoporosis.

11. Lung cancer kills more women each year (ACS 2006).

CHAPTER 2. PROTECTING THE FETUS

This research was partially supported by NSF grant 97–10035. In addition, a portion of this research was supported by the American Association of University Women (AAUW). The author had a dissertation fellowship.

1. Clinical research or clinical study refers to "any investigation or analysis of a question, process, or phenomenon that has, or is presumed to have, some immediate or future clinical relevance" (*Institute of Medicine* vol. 1, 1994, 95). The focus in this chapter will be on clinical trials that can be defined as "experiment[s] designed to assess the safety and efficacy of one treatment relative to another in comparable groups of human beings treated according to a given protocol and observed for change in an outcome or measure or for occurrence of some event." Furthermore, in a stricter sense, the term "clinical" refers to the subset of trials that are done in a clinical setting and based on outcome measures with obvious clinical implications (*Institute of Medicine* 1994, vol. 1, 96).

2. Some debate exists regarding the issue of the exclusion or underrepresentation of women in clinical trials. Specifically, the debate centers on the issue of what constitutes underrepresentation and thus, in the converse, adequate representation. See the *Institute of Medicine* (vol. 1, 1994) report, pp. 47–70, for a full discussion of this issue.

3. DES stands for diethylstilbestrol.

4. And as Karen Rothenberg (1996) notes, despite all the attention given to the Tuskegee experiment since the 1970s, little concern has been noted about the women who were the sexual partners of the men exposed to syphilis.

5. The Public Health Service is part of the Department of Health and Human Services. The National Institutes of Health; the Alcohol, Drug Abuse, and Mental Health Administration; and the Food and Drug Administration are all housed under the Public Health Service.

6. There are two important issues regarding women and medical research. One is the exclusion or underrepresentation of women in all medical studies of diseases common to women and men and drugs or treatment for such diseases. The other issue is the study of diseases or conditions that only occur or more commonly occur in women, such as breast cancer, cervical cancer, and osteoporosis. In 1987, only 13.5 percent of the NIH budget was devoted to the broadly defined category of women's health issues (Berney 1990), but this number is contested by some as constituting *more* than what men's issues receive (Kadar 1994).

7. Extramural research is research performed outside of the NIH at other institutions, usually universities. Intramural research is research the NIH does in-house at its own facilities in Bethesda, Maryland.

8. Institutional review boards (IRBs) are local administrative bodies established to protect the rights and welfare of human research subjects participating in studies at the institutions under the IRB's jurisdiction. All research involving human subjects must be approved by an IRB and the IRB has the authority to approve, require modifications, or disapprove research activities (*Institute of Medicine,* vol. l, 1994, 131). IRBs are composed of local scientists, ethicists, and nonscientists.

9. Approval for a new drug with the FDA is a long involved process. After preclini-

cal testing (testing in laboratory and in animals), sponsors submit an Investigational New Drug (IND) application to the FDA. This application includes the plan for Phase 1 studies on humans. If approved by the FDA and a local IRB, clinical trials begin. Phase I involves 20 to 80 healthy individuals to determine safety and dosage of the drug. Phase II involves 100 to 300 subjects to evaluate effectiveness and to look for any side effects. Phase III uses 1,000 to 3,000 subjects to verify effectiveness and to monitor adverse reactions from long-term use. Each phase lasts one, two, and three years respectively. After this, a new drug application is filed with the FDA and the review/approval process begins. If the drug is approved, Phase IV studies begin, which are postmarketing testing studies (Wierga and Eaton 1993).

CHAPTER 3. VESSELS, VECTORS, AND VULNERABILITY

This piece is dedicated to my dear friends Ray Navarro, Anthony Ledesma, Tom Cunningham, and Katrina Haslip, and to the untold others we have lost to this plague.

1. AIDS, or Acquired Immune Deficiency Syndrome, is diagnosed when a person has a positive test for HIV antibodies, and has either a T4 cell count below 200 or has developed one or more of the common infections that people contract when their immune systems are compromised.

2. For instance, a survey of welfare recipients in Massachusetts found that *two-thirds* had experienced significant, repeated episodes of domestic violence. Allard et al. 1997.

3. For a more detailed analysis of the impact of this matrix of oppression by class, race, gender, and heterosexism/homophobia on women's HIV vulnerability, see Christensen 1990. See also Christensen 1998.

4. PCP pneumonia, Kaposi's sarcoma, and a number of other opportunistic infections often develop in HIV-positive people with compromised immune systems; healthy people are usually able to fight them off.

5. "Dr. Craig Wright, of the infectious disease clinic at Walter Reed Army Hospital, called the increased deaths from obstructive pulmonary disease, 'very, very unusual. That's a disease of older men, not younger women. I have to suspect that some of those deaths are undiagnosed pneumocystis [PCP] deaths'" (Norwood 1988, 65).

6. See, e.g., Michael Fumento, 1990, *The Myth of Heterosexual AIDS* (Washington, D.C.: Regnery Gateway). See also Helen Singer Kaplan, 1987, *The Real Truth About Women and AIDS* (New York: Simon & Schuster). See also, "Reassuring News About AIDS: A Doctor Tells You Why You May Not Be at Risk," an article by Robert Gould in *Cosmopolitan* in January 1988 that assured young heterosexual women that they had "nothing to fear" from HIV/AIDS if they didn't inject drugs and if their boyfriends weren't bisexual.

7. Heterosexual sex has been the leading cause of HIV infection in women since at least 1992 (Garrett 1995).

8. For example, the two top causes of death in the world today are malaria and tuberculosis. Yet funding for research into prevention and treatments for these two deadly conditions is minuscule compared to their mortality tolls. The Global Fund for AIDS, Tuberculosis, and Malaria was recently created to attempt to address this situation.

9. For further information on the treatment of women as "fetal vessels," see Daniels 1996.

10. For a detailed look at the representation of women in NIH- and CDC-sponsored HIV/AIDS research, see Fadden et al. 1996.

11. NIAID (the National Institute for Allergies and Infectious Diseases), a division of the NIH, now sponsors three government clinical trials networks for HIV/AIDS drugs: the ACTG (AIDS Clinical Trials Group, the original network, based mostly in university research centers), the CPCRA (Community Program for Clinical Research on AIDS, a more "community-based" network), and the DATRI (Division of AIDS Treatment Research Initiative, established in 1991). Of the three, the CPCRA has the best track record for including women and/or people of color (Fadden et al. 1996, 260–62).

12. By focusing on ACT UP Women's Caucus, I do not mean to imply that it was the only group of activists focusing on these issues. I concentrate on ACT UP/NY due to my affiliation with, and familiarity with, that organization. But women activists around the globe have been working on these and related issues since the beginning of the epidemic and continue to do so today.

13. For a detailed chronology of ACT UP actions, see the ACT UP/NY Web site at http://www.actupny.org/

14. "Prophylaxis" refers to routinely taking antibiotics or other medications to *prevent* the onset of opportunistic infections, rather than to treat an already-existing infection.

15. A T4-cell is a type of cell that is crucial to immune function and destroyed by HIV. A healthy, HIV-negative person generally has approximately 1,000 T4-cells per cubic milliliter of blood. 200 or fewer T4-cells is an indication of profound immune dysfunction.

16. At that time, people of color were 54 percent of Persons with AIDS (PWAs) but only 17 percent of those enrolled in drug trials; women were then only 5 percent of enrollees (Denenberg 1990, "What the Numbers Mean," p. 74).

17. For an interesting, if incomplete, account of the race, class, and gender tensions within ACT UP/NY and their role in the organization's eventual demise, see Cvetkovich, 2003, especially chapter 5, "AIDS Activism and Public Feelings: Documenting ACT UP's Lesbians."

18. See, for example, *T & D Handbook on Treatment Decisions*, by John Bohne, Tom Cunningham, Jon Engbretson, Ken Fornataro, and Mark Harrington.

19. For more detailed information on these challenges, see Christensen 1998.

20. For further information about the causes and consequences of women's economic inequality, see Albelda and Tilly 1997. For further information on the interaction of poverty with HIV vulnerability, see Christensen 1998.

Chapter 4. One in Eight

1. Lung cancer kills more women each year (ACS 2006).

2. For example, Rep. Mary Rose Oakar's (D-OH) sister had breast cancer.

3. This was despite the fact that breast cancer was not the leading cause of death

among women, nor, after 1986, even the leading *cancer* death among women (Weisman 2000, 218).

4. The NAPBC ended in 2000.

5. This was introduced as part of the Women's Health Equity Act (WHEA) of 1990. The WHEA is a legislative package of many different bills focusing upon women's health research, prevention, and services; it was first introduced in 1990, and then every session thereafter. The WHEA is modeled after the Women's Economic Equity Act, a package of bills dealing with equal pay and nondiscrimination in the workplace that were introduced in the 1960s–'70s, and brought forth many of the gender equality policies of that era.

CHAPTER 5. RIGHTS AND REMEDIES

1. According to Elizabeth Pleck, the *Journal of Marriage and the Family*, the major journal in family sociology, had no articles on family violence from its inception in 1939 until 1969. She also notes that newspapers did not report on the subject until 1974. See Pleck 1987.

2. Betty Friedan and Andrea Dworkin both revealed abuse by their partners. See Friedan 1983, 31–36, and Dworkin 1978.

3. In the late nineteenth century domestic violence raised the ire of many groups including social purist reformers and members of the Temperance movement. Although they viewed the causes of violence differently, Temperance campaigners worked to protect abuse victims from alcoholic husbands and Social Purists sought to remove the ownership of women's bodies to which husbands had the right.

4. Although the movement was often represented by white women (Garfield 1998; Schechter 1982), many women of color played crucial roles in developing responses to battered women (Davis 1998). Because of the differential institutional treatment that women of color experience, sometimes the provision of support and organizing activities were race/ethnic specific. For a critique of institutional response to battered women of color see Richie and Kanuha 1993.

5. Senators Hatch and Hayakawa circulated a letter to their colleagues opposing the legislation. See *Congressional Quarterly*, v. 38 (25) June 23, 1980, 1689–99.

6. The Family Violence Prevention and Services Act (FVPSA) was enacted as Title III of the Child Abuse Amendments of 1984, P. L. 98–457.

7. The Child Abuse and Prevention Treatment Act of 1983 emerged out the New Right's concern that doctors sometimes permitted extremely premature infants to die.

8. Surgeon General C. Everett Koop first included violence prevention as one of the nation's top fifteen health priorities in 1979.

9. Under the direction of Mark Rosenberg, the Centers for Disease Control and Prevention established its Violence Epidemiology Branch.

10. I use the term "wife abuse" here to situate the content of concern as it was articulated in the 1970s. Shifts in terminology reflect both different and broader concerns. For example, "family violence" captures a perspective that argues all members of a familial unit may engage in conflict. Broader concerns are exemplified by the term "violence against women," which takes into account that intramarital abuse was not the

only type of victimization women experienced. It includes a range of violent acts, such as rape, structural violence, and sexual assault.

11. The Violence Against Women Act was first introduced in 1990.

12. P.L. 103–322; 108 Stat. 1902; 42 U.S.C. 13701.

13. The Final Vote Results for HR Bill 1133 can be viewed at http://clerkweb.house.gov/cgi-bin/vote.exe?year=1993&rollnumber=593.

14. Emily is the acronym for Early Money Is Like Yeast (it makes the dough rise).

15. The recommendation establishes the link between violence against women and gender discrimination and states: "Violence against women is both a consequence of systematic discrimination against women in public and private life, and a means by which constraints on women's rights are reinforced. Women are vulnerable because of disabilities imposed on them in economic, social, cultural, civil and political life and violence impairs the extent to which they are able to exercise de jure rights." (Mertus, Flowers, and Dutt 1999, 104).

16. As part of the larger Violence Crime Control and Law Enforcement Act of 1994, however, the roll call votes for H.R. 3355 was 61 yeas, 38 nays and 1 not voting.

CHAPTER 6. CONCLUSION

1. Actually, activists engaged in these two forms of protest at the same time, though conceptually it is useful to separate them.

2. Especially when women's health services had, since the 1970s, been widely incorporated into hospitals and physician services. Activists could have approached private institutions to address their concerns.

3. But the National Women's Health Network is one such organization.

4. An exception is AIDS activists; many of them considered themselves feminists.

Works Cited

Abdullah, Hussaina J. 2000. "Religious Revivalism, Human Rights Activism and the Struggle for Women's Rights in Nigeria." In *Beyond Rights Talk and Culture Talk: Comparative Essays on Political Rights and Culture*. Edited by Mahmood Mamdani. Cape Town, South Africa: David Philip Publishers. 96–120.

ACT UP. 1988. "Seize Control of the FDA! October 11, 1988!"

ACT UP/NY. 1990. "Storm the NIH: Your Guide to Action. AIDS Demonstration and Civil Disobedience, National Institutes of Health, Bethesda, Maryland, May 21, 1990."

ACT UP/NY. 1991a. "A Call for the Immediate Revision of the Centers for Disease Control Surveillance Definition of AIDS."

———. 1991b. "Women Don't Get AIDS. They Just Die From It." *New York Times* (paid ad). June 19.

———. 1993. "Target Hoffman-LaRoche! Tear Down the Walls! Demands for 02/09/93 Action."

———. 2004. "An ACT UP Chronology: Capsule History." Accessed at www.actupny.org (click on "documents," then on "ACT UP/NY Capsule History").

ACT UP/NY Women and AIDS Book Group. 1990. *Women, AIDS & Activism*. Boston: South End Press.

ACT UP Women's Caucus/Majority Actions Committee (MACWAC). 1988. "AIDS Doesn't Discriminate—Our Government Does! The HHS and FDA Must be Held Accountable for the Exclusion of Women and People of Color from Access to Treatment and Drug Protocols!" October 11.

Albelda, Randy, and Chris Tilly. 1997. *Glass Ceilings and Bottomless Pits: Women's Work, Women's Poverty*. Boston: South End Press.

Allard, Mary Ann, Randy Albelda, Mary Ellen Colten, and Carol Cosenza. 1997. "In Harm's Way? Domestic Violence, AFDC Receipt, and Welfare Reform in Massachusetts." Boston: McCormack Institute and Center for Survey Research, University of Massachusetts Press.

Alpert, Elaine J., David Shannon, Alisa Velonis, Maura Georges, and Rachel A. Rich. 2002. "Family Violence and Public Health Education: A Call for Action." *Violence Against Women* 8(6): 746–78.

Altman, Roberta. 1996. *Waking Up/Fighting Back: The Politics of Breast Cancer*. London: Little & Brown.

American Academy of Family Physicians. 1994. "Family violence: An AAFP White Paper." *American Family Physician* 50: 1636–46.

American Academy of Pediatrics. 1998. "The Role of the Pediatrician in Recognizing and Intervening on Behalf of Abused Women." *Pediatrics* 101: 1091–92.

American Association of University Women (AAUW). 1993. *National Health Care Reform: Position Paper.* Washington, DC: AAUW Press.

American Cancer Society (ACS). 2006. "What are the Key Statistics for Breast Cancer?" http://www.cancer.org/docroot/CRI/content/CRI_2_4_1X_What_a reethe_key_statistics_for_breast_cancer_5.asp?sitearea.

American College of Obstetricians and Gynecologists (ACOG). 1999. "Domestic Violence." *ACOG Educational Bulletin,* No. 257.

American Medical Association 1992. "American Medical Association Diagnostic and Treatment Guidelines on Domestic Violence." *Archives of Family Medicine* 1: 39–47.

Ameswith, Katherine. 1990. "Our Bodies, Their Selves." *Newsweek.* December 17, p. 60.

Anastos, Kathryn, and Carola Marte. 1989. "Women—The Missing Persons in the AIDS Epidemic." *Health/PAC Bulletin* (Winter): 6–11.

Associated Press. 1992. "Women Rap AIDS Exclusions." *New York Newsday.* September 3.

Auerbach, Judith D. 1992. "The Emergence of the Women's Health Research Agenda: Some Preliminary Analysis." Paper presented at the Annual Meeting of the Association for Public Policy Analysis and Management, Denver, CO, October 29–31.

Auerbach, Judith D., and Anne Figert. 1995. "Women's Health Research: Public Policy and Sociology." *Journal of Health and Social Behavior* 36(Special Ed.): 115–31.

Baird, Karen L. 1998. *Gender Justice and the Health Care System.* New York: Garland Publishing.

———. 1999. "The New NIH and FDA Medical Research Policies: Targeting Gender, Promoting Justice." *Journal of Health, Policy, Politics and Law* 24, 3 (June): 531–66.

Banaszak, Lee Ann. 2005. "Inside and Outside the State: Movement Insider Status, Tactics, and Public Policy Achievements." In *Routing the Oppression: Social Movements, Public Policy, and Democracy.* Edited by Davis S. Meyer, Valerie Jenness, and Helen Ingram. Minneapolis: University of Minnesota Press. 149–76.

Banaszak, Lee Ann, Karen Beckwith, and Dieter Rucht. 2003. "When Power Relocates: Interactive Changes in Women's Movements and States." In *Women's Movements Facing the Reconfigured State.* Edited by Lee Ann Banaszak, Karen Beckwith, and Dieter Rucht. New York: Cambridge University Press. 1–29.

Batt, Sharon. 1994. *Patient No More: the Politics of Breast Cancer.* Charlottetown, PEI, Canada: Gynergy.

Baumgartner, Frank R., and Bryan D. Jones. 1993. *Agendas and Instability in American Politics.* Chicago: University of Chicago Press.

Beckwith, Karen. 2007. "Mapping Strategic Engagements: Women's Movements and the State." *International Feminist Journal of Politics* 9, 3 (September): 312–38.

Bernstein, Anya. 2001. The Moderation Dilemma: Legislative Coalitions and the Politics of Family and Medical Leave. Pittsburgh: University of Pittsburgh Press.

Berk, R. S. Berk, D. Loseke, and D. Rauma. 1983. "Mutual Combat and Other Family Violence Myths." In *The Dark Side of Families: Current Family Violence Research.* Edited by David Finkelhor, Richard J. Gelles, Gerald T. Hotaling, and Murray A. Strauss. Beverly Hills, CA: Sage Publications. 197–212.

Berney, B. 1990. "In Research, Women Don't Matter." *The Progressive* (October), 24–27

Blackstone, Amy. 2004. "'Its Just about Being Fair': Activism and the Politics of Volunteering in the Breast Cancer Movement." *Gender and Society* 18, 3 (June): 350–68.

Boehmer, Ulrike. 2000. *The Personal and the Political: Women's Activism in Response to the Breast Cancer and AIDS Epidemics.* Albany: State University of New York Press.

Bosso, Christopher J. 1994. "The Contextual Bases of Problem Definition." In *The Politics of Problem Definition: Shaping the Policy Agenda.* Edited by David A. Rochefort and Roger W. Cobb. Lawrence: University Press of Kansas Press. 182–203.

Boston Women's Health Collective. 1996. *The New Our Bodies, Ourselves: A Book by and for Women.* New York: Touchstone.

Bowker, Lee H. 1986. "Ending the Violence." Holmes Beach, FL: Learning Publications.

Brenner, Barbara. 2000. "Sister Support: Women Create a Breast Cancer Movement." In *Breast Cancer: Society Shapes an Epidemic.* Edited by Anne S. Kasper and Susan J. Ferguson. New York: St. Martin's Press. 325–53.

Brooks, Rachelle. 1997. "Feminists Negotiate the Legislative Branch: the Violence Against Women Act." In *Feminists Negotiate the State: The Politics of Domestic Violence.* Edited by Cynthia R. Daniels. Lanham, MD: University Press of America.

Bunch, Charlotte. 1999. "Forward." In *Local Action Global Change: Learning about the Human Rights of Women and Girls.* Edited by Julie Mertus, with Nancy Flowers and Mallika Dutt. UNIFEM and the Center for Women's Global Leadership. v–vii.

Byrson, Valerie. 1999. *Feminist Debates.* New York: New York University Press.

Campaign for Women's Health. 1993. "Model Benefits Package for Women in Health Care Reform." Washington, D.C.: Campaign for Women's Health.

Carden, Maren Lockwood. 1974. *The New Feminist Movement.* New York: Russell Sage Foundation.

Carrillo, Roxanna. 1994. "Violence Against Women as a Human Rights Issue." In *The Indivisibility of Women's Human Rights: a Continuing Dialogue.* Edited by Susana T. Fried. New Brunswick, NJ: Center for Women's Global Leadership, Douglass College, Rutgers University. 25–27.

Carroll, Susan. 2000. "Representing Women: Congresswomen's Perceptions of Their Representational Roles." Paper presented at the conference *Women Transforming Congress: Gender Analyses of Institutional Life.* Carl Albert Congressional Research and Studies Center, University of Oklahoma. April 13–15.

Casamayou, Maureen. 2001. *The Politics of Breast Cancer.* Washington, D.C: Georgetown University Press.

Caschetta, Mary Beth. 1992. "A Review of Reports on Women and HIV from the Eighth International Conference on AIDS/Amsterdam." In *Treatment Issues: The GHMC Newsletter of Experimental AIDS Therapies,* 1–5.

Catalano, Shannon. 2007. "Intimate Partner Violence in the United States." U.S. Dept. of Justice, Office of Justice Programs, Bureau of Justice Programs. http://www.ojp.usdoj.gov/bjs/intimate/ipv.htm.

Centers for Disease Control and Prevention (CDC). 1997. "Update: Trends in AIDS

Incidence, Deaths, and Prevalence—United States, 1996." *MMWR* 46, 08 (February 28): 165–73.

———. 2004a. "HIV/AIDS Among US Women: Minority and Young Women at Continuing Risk." http:/www.cdc.gov/hiv/pubs/facts/women.htm.

———. 2004b. "HIV/AIDS and US Women Who Have Sex With Women (WSW)." http:/www.cdc.gov/hiv/pubs/facts/wsw.htm.

———. 2006. "HIV/AIDS Among Women." http://www.cdc.gov/hiv/topics/women/resources/factsheets/women.htm.

Christensen, Kimberly. 1991. "Teaching Undergraduates About AIDS: An Action-Oriented Approach." *Harvard Educational Review* 61, 3 (August). Anthologized in Kathryn Geismar and Guitele Nicholeau, ed. 1993. *Teaching for Change: Addressing Issues of Difference in the College Classroom.* Cambridge: Harvard University. Also anthologized in Ira Shor and Caroline Pari, ed. 2000. *Education is Politics: Critical Teaching Across Differences, Postsecondary.* Portsmouth, N.H.: Boynton/Cook, an imprint of Heinemann Press.

———. 1998. "Economics Without Money, Sex Without Gender: A Critique of Philipson and Posner's *Private Choices and Public Health: The AIDS Epidemic in an Economic Perspective.*" *Feminist Economics* 4, 2 (Summer): 1–24.

Clancy, Carolyn, and Charlea Massion. 1992. "American Women's Health Care: A Patchwork Quilt with Gaps." *JAMA* 268, 14 (October 14): 1918–20.

Clark, Kathryn Anderson, Andrea K. Biddle, Sandra L. Martin. 2002. "A Cost-Benefit Analysis of the Violence Against Women Act of 1994," *Violence Against Women* 8, 4 (April): 417–28.

Cobb, Roger, and Charles Elder. 1983. *Participation in American Politics: The Dynamics of Agenda-Building.* 2nd ed. Baltimore: Johns Hopkins University Press.

Commonwealth Fund. 1993. *The Commonwealth Fund Survey of Women's Health.* New York. July 14.

Commonwealth Fund Commission on Women's Health. 1996. "Violence Against Women in the United States: A Comprehensive Background Paper." New York: Commonwealth Fund.

Congressional Quarterly. 1980. v.38(5) June 23: 1689–99.

Congressional Record, Jane Harman. House of Representatives. 1994. "Violence Against Women," June 30. Proceedings and Debates of the 103rd Congress, Second Session. http://www.house.gov/harman/issues/statements/103/063094ST_ViolenceAgainstWomen.html.

Conway, M. Margaret, David W. Ahern, and Gertrude A. Steuernagel. 1995. *Women and Public Policy: A Revolution in Progress.* Washington, D.C.: Congressional Quarterly.

Corea, Gena. 1992. *The Invisible Epidemic: The Story of Women and AIDS.* New York: HarperCollins.

Corea, Gena, Renate Duelli-Klein, J. Hammer, H. B. Holnes, and B. Hoskins, eds. 1987. *Man-Made Woman.* Indianapolis: Indiana University Press.

Costain, Anne N. 1994. *Inviting Women's Rebellion: A Political Process Interpretation of the Women's Movement.* Baltimore: Johns Hopkins University Press.

Costello, Cynthia, and Anne J. Stone, eds. (WREI). 1994. *The American Woman, 1994–95: Where We Stand, Women and Health.* New York: W. W. Norton.

Cotton, Paul. 1990. "Examples Abound of Gaps in Medical Knowledge Because of Groups Excluded from Scientific Study." *Journal of the American Medical Association* 263, 8 (February 23): 1051–52.

———. 1992. "Women's Health Initiative Leads Way as Research Begins to Fill Gender Gaps." *Journal of the American Medical Association* 267, 4 (January 22): 469–73.

Council on Ethical and Judicial Affairs, AMA. 1991. "Gender Disparities in Clinical Decision Making." *Journal of the American Medical Association* 266 (4, July 24/31): 559–62.

Crenshaw, Kimberle. 1994. "Whose Story Is It, Anyway? Feminist and Antiracist Appropriations of Anita Hill." In *Race-ing Justice, En-gendering Power: Essays on Anita Hill, Clarence Thomas and the Construction of Social Reality.* Edited by Toni Morrison. New York, Pantheon Books. 402–40.

Cress, Daniel M., and David A. Snow. 2000. "The Outcomes of Homeless Mobilization: The Influence of Organization, Disruption, Political Mediation and Framing." *American Journal of Sociology* 105: 1063–104.

Crittenden, Ann. 2002. *The Price of Motherhood: Why the Most Important Job in the World Is Still the Least Valued.* New York: Owl Books-Henry Holt & Company.

Cure Breast Cancer. 2005. "Research Stamp." May 30. http://www.curebreastcancer .org/cs/.

Cvetkovich, Ann. 2003. *An Archive of Feeling: Trauma, Sexuality, and Lesbian Public Cultures.* Durham, NC: Duke University Press.

Dan, Alice, ed. 1994. *Reframing Women's Health: Multidisciplinary Research and Practice.* Thousand Oaks, CA: Sage Publications.

Daniels, Cynthia R. 1996. *At Women's Expense: State Power and the Politics of Fetal Rights.* Cambridge: Harvard University Press.

Davis, D. 1998. "Violence in the Lives of African American Adults." In *Domestic Violence Across the Lifespan of African Americans: Traditional Strategies and Contemporary Practices—Exploring the Possibilities of Popular Culture Interventions.* Institute on Domestic Violence in the African American Community. Conference Proceedings. San Francisco, CA. December 4.

Davis, Dana-ain. 2006. *Battered Black Women and Welfare Reform: Between a Rock and a Hard Place.* Albany: State University of New York Press.

Declercq, Eugene, and Diana Simmes. 1997. "The Politics of 'Drive-Through Deliveries': Putting Early Postpartum Discharge on the Legislative Agenda." *Milbank Quarterly* 75, 2: 175–202.

Denenberg, Risa. 1990. "Unique Aspects of HIV Infection in Women," "What the Numbers Mean," and "Treatment and Trials." In *Women, AIDS & Activism*, ACT UP/ NY Women and AIDS Book Group. Boston: South End Press.

Dobash, R. Emerson, and Russell Dobash. 1979. *Violence Against Wives.* New York: Free Press.

Dodson, Debra L., Susan J. Carroll, Ruth B. Mandel, Katherine E. Kleeman, Ronee Schreiber, and Debra Liebowitz. 1995. *Voices, Views, Votes: the Impact of Women in the 103rd Congress.* New Brunswick, NJ: Center for the American Women and Politics (CAWP), Eagleton Institute of Politics, Rutgers, the State University of New Jersey.

Dresser, Rebecca. 1992. "Wanted Single, White, Male for Medical Research." *Hastings Center Report* (January–February): 24–29.

Duggan, Paul. 1988. "One Thousand Swarm FDA's Rockville Office to Demand Approval of AIDS Drugs." *The Washington Post*, October 12, p. B-1.

Dworkin, Andrea. 1978. "The Bruise that Doesn't Heal." *Mother Jones* 3 (July): 31–36.

———. "Trapped in a Patter of Pain Where No One Can Help." *Los Angeles Times*, June 26.

Edelman, Murray. 1967. *The Symbolic Uses of Politics.* Urbana: University of Illinois Press.

Ehrenreich, Barbara, and Deidre English. 1979. *For Her Own Good; 150 Years of the Experts' Advice to Women.* Garden City, NY: Anchor/Doubleday.

Epstein, Steve. 1996. *Impure Science: AIDS, Activism, and the Politics of Knowledge.* Berkeley, CA: University of California Press.

Faden, Ruth, Nancy Kass, and Deven McGraw. 1996. "Women as Vessels and Vectors: Lessons from the HIV Epidemic." In *Feminism & Bioethics.* Edited by Susan Wolfe. New York: Oxford University Press. 252–81.

Farmer, Paul, Margaret Connors, and Janie Simmons, eds. 1996. *Women, Poverty, and AIDS: Sex, Drugs, and Structural Violence.* Monroe, ME: Common Courage Press.

Fee, Elizabeth, ed. 1982. *The Politics of Sex in Medicine.* Farmingdale, NY: Baywood.

Ferguson, Susan J. 2000. "Deformities and Diseased: The Medicalization of Women's Breasts." In *Breast Cancer: Society Shapes an Epidemic.* Edited by Anne S. Kasper and Susan Ferguson. New York: St. Martin's Press. 51–86.

Ferraro, Susan. 1993. "You Can't Look Away Anymore: The Anguished Politics of Breast Cancer." *New York Times Magazine*, August 15: 25–27, 58, 62.

Ferree, Myra Marx, and Beth B. Hess. 1994, rev. ed. *Controversy and Coalition. The New Feminist Movement Across Three Decades of Change.* New York: Twayne Publishers.

Finkelhor, David, Richard Gelles, Gerald Hotaling, and Murray Straus, eds. 1983. *The Dark Side of Families: Current Family Violence Research.* Beverly Hills, CA: Sage Publications.

Folbre, Nancy. 2001. *The Invisible Heart: Economics and Family Values.* New York: New Press.

Freeman, Jo. 1975. *The Politics of Women's Liberation.* New York: David McKay.

Friedan, Betty. 1983. "Dossier: Betty Naomi Friedan." *Esquire* (December), p. 518.

Fumento, Michael. 1990. *The Myth of Heterosexual AIDS.* Washington DC: Regnery Gateway.

Garfield, Gail. 1998. "Knowing What We Know: African-American Women's Self-defined Experiences of Violence." Unpublished manuscript.

Garrett, Laurie. 1995. "'Hetero' Sex Gaining as AIDS Cause." *New York Newsday*, February 1.

Goldzieher, J. W., L. Moses, E. Auerkin, C. Sheel, and B. Taber. 1971a. "A Placebo Controlled, Double-Blind Crossover Investigation of the Side Effects Attributed to Oral Contraceptives." *Fertility and Sterility*, 22, 9:609–23.

———. 1971b. "Nervousness and Depression Attributed to Oral Contraceptives: A

Double-Blind, Placebo-Controlled Study." *American Journal of Obstetrics and Gynecology* 22: 1013–20.

Gordon, Linda. 1982. "The Politics of Birth Control, 1920–1940: The Impact of Professionals." In *The Politics of Sex in Medicine*. Edited by Elizabeth Fee. New York: Baywood Publishing. 151–175.

Gorman, Christine, with Bernard Baumohl and Raji Samghabadi. 1988. "Cutting Red Tape to Save Lives: The FDA Vows to Speed Up Approval of Breakthrough Drugs." *Time*, October 3.

Gould, Robert. 1988. "Reassuring News About AIDS: A Doctor Tells You Why You May Not Be at Risk." *Cosmopolitan* (January).

Hancock, Ange-Marie. 2004. *The Politics of Disgust: The Public Identity of the Welfare Queen*. New York: New York University Press.

Hanmer, Jalna. 1987. "Transforming Consciousness: Women and the New Reproductive Technologies." In *Man-Made Woman*. Edited by Gena Corea, Renate Duelli-Klein, J. Hammer, H. B. Holnes, and B. Hoskins. Indianapolis: Indiana University Press. xx.

Haseltine, Florence. 1998. Personal Interview. March 4, with Karen Baird.

Haseltine, Florence P., and Beverly Greenberg Jacobson, eds. 1997. *Women's Health Research: A Medical and Policy Primer*. Washington, DC: Health Press.

Hawkesworth, Mary, Kathleen J. Casey, Krista Jenkins, and Katherine E. Kleeman. 2001. *Legislating By and For Women: a Comparison of the 103rd and 104th Congresses*. Rutgers, NJ: Center for American Women and Politics (CAWP), Eagleton Institute of Politics, Rutgers, the State University of New Jersey.

Heise, Lori, with J. Pitanguy and A. Germaine. 1994. "Violence Against Women: The Hidden Health Burden." Washington, DC: World Bank.

Heiwa-Loving, Jesse. 1997. "All in Good Time: Ten Years of ACT UP Actions and Reactions." *POZ* (March): 50–51.

Hilts, Phillip. 1990. "82 Held in Protest on Pace of AIDS Research." *New York Times*, May 22, C2.

Hole, Judith, and Ellen Levine. 1971. *Rebirth of Feminism*. New York: Quadrangle.

Horton, Jacqueline A. 1995. *The Women's Health Data Book*. 2nd ed. Washington, DC: Jacob's Institute of Health.

Howes, Joanne, and Amy Allina. 1994. "The Women's Health Movement." *Social Policy* (Summer): 6–14.

Institute for Women's Policy Research (IWPR). 1994. *Women's Access to Health Insurance*. Washington, DC: Institute for Women's Policy Research.

Institute of Medicine, Division of Health Sciences Policy, Committee on the Ethical and Legal Issues Relating to the Inclusion of Women in Clinical Studies. 1994. *Women and Health Research, Volumes 1 and 2*. Edited by Anna Mastroianni, Ruth Faden, and Daniel Federman. Washington, DC: National Academy.

Jaschik, S. 1990. "Report Says NIH Ignores Own Rules on Including Women in its Research." *Chronicle of Higher Education* 27 (June): A27.

Jennings, Veronica, and Malcolm Gladwell. 1990. "One Thousand Rally For More Vigorous AIDS Efforts: 82 Arrested at NIH in Demonstration to Support Additional Research, Expended Testing." *The Washington Post*, May 22, p. B-1.

Johnson, Tracey, and Elizabeth Fee. 1994. "Women's Participation in Clinical Research: From Protectionism to Access." In Institute of Medicine, Division of Health Sciences Policy, Committee on the Ethical and Legal Issues Relating to the Inclusion of Women in Clinical Studies, *Women and Health Research*, vol. 2. Edited by Anna Mastroianni, Ruth Faden, and Daniel Federman. Washington, DC: National Academy.

Jones, Bryan D., and Frank R. Baumgartner. 2005. *The Politics of Attention: How Government Prioritizes Problems*. Chicago: University of Chicago Press.

Jones, Jim. 1981. *Bad Blood: The Tuskegee Syphilis Experiment*. New York: Free Press.

Jones, Wanda K., and Frances M. Visco. 2000. "NAPBC Closeout Memo." October 15. http://www.womenshealth.gov/napbc/catalog.wci/napbc/closeout.htm.

Kadar, Andrew. 1994. "The Sex Bias in Medicine." *Atlantic Monthly* 274, 2: 66–71.

Kane, Penny. 1991. *Women's Health*. New York: St. Martin's Press.

Kaplan, Helen Singer. 1987. *The Real Truth About Women and AIDS*. New York: Simon & Schuster.

Kasper, Anne S., and Susan J. Ferguson. 2000. *Breast Cancer: Society Shapes an Epidemic*. New York: St. Martin's Press.

Katzenstein, Mary Fainsod. 1998. *Faithful and Fearless: Moving Feminist Protest Inside the Church and Military*. Princeton, NJ: Princeton University Press.

Katzenstein, Mary Fainsod, and Carol McClurg Nueller, eds. 1987. *The Women's Movement of the United States and Western Europe*. Philadelphia: Temple University Press.

Kaufert, Patricia. 1998. "Women, Resistance, and the Breast Cancer Movement." In *Pragmatic Women and Body Politics*. Edited by Margaret Lock and Patricia Kaufert. Cambridge: Cambridge University Press. 287–309.

Kedrowski, Karen, and Marilyn Stine Sarow. 2007. *Cancer Activism: Gender, Media, and Public Policy*. Urbana: University of Illinois Press.

King, Martin Luther. 1963. "Letter From the Birmingham Jail." In *Why We Can't Wait*. New York: Mentor Book/New American Library. 77–100.

Kingdon, John W. 1984, 1995. *Agendas, Alternatives, and Public Policies*. 2nd ed. New York: HarperCollins.

Kinney, E. L. 1981. "Underrepresentation of Women in New Drug Trials: Ramifications and Remedies." *Annals of Internal Medicine* 95, 4: 495–99.

Klein, Renate. 1989. *Infertility: Women Speak Out about their Experiences of Reproductive Medicine*. London: Pandora.

Kolker, Emily S. 2004. "Framing as a Cultural Resource in Health Social Movements: Funding Activism and the Breast Cancer Movement in the U.S. 1990–1993." *Sociology of Health and Illness* 26, 6: 820–44.

Komen. 2008. Susan G. Komen for the Cure. http://cms.komen.org/komen/index.htm.

Koss, Mary P. 1994. "The Negative Impact of Crime Victimization on Women's Health and Medical Use." In *Reframing Women's Health: Multidisciplinary Research and Practice*. Edited by Alice J. Dan. Thousand Oaks, CA: Sage Publications. 189–200.

Kushner, Rose. 1975. *Breast Cancer: A Personal and Investigative Report*. New York: Harcourt Brace Javanovich.

———. 1984. *Alternatives: New Developments in the War on Breast Cancer*. New York: Kensington.

Langer, Amy. 1992. "The Politics of Breast Cancer." *Journal of the American Medical Women's Association* 47, 5 (September–October): 207–9.

Lantz, Paula M., and Karen M. Booth (1998). "The Social Construction of the Breast Cancer Epidemic." *Social Science & Medicine* 46, 7 (April 1): 907–18.

LaRosa, J., B. Seto, C. Caban, and E. Hayunga. 1995. "Including Women and Minorities in Clinical Research." *Applied Clinical Trials* 4:31–38.

Lauver, Diane. 1994. "Factors Related to Secondary Prevention Behaviors for Breast Cancer." In *Reframing Women's Health*. Edited by Alice J. Dan. Thousand Oaks, CA: Sage Publications. 367–76.

Legato, Marianne. 1991. *The Female Heart*. New York: Avon.

Leonard, Zoe, and Polly Thisthethwaite. 1990. "Prostitution and HIV Infection." In ACT UP/NY Women and AIDS Book Group. In *Women, AIDS & Activism*, ACT UP/NY Women and AIDS Book Group. Boston: South End Press. 177–86.

Lerner, Barron H. 2001a. "No Shrinking Violet: Rose Kushner and the Rise of American Breast Cancer Activism." *Western Journal of Medicine* 174: 362–65.

———. 2001b. *The Breast Cancer Wars: Hope, Fear and the Pursuit of a Cure in Twentieth-Century America*." New York: Oxford University Press.

Lewin, Ellen, and Virginia Olesen. 1985. *Women, Health and Healing*. New York: Tavistock.

Lock, Margaret, and Patricia Kaufert. 1998. *Pragmatic Women and Body Politics*. New York: Cambridge University Press.

Love, Susan M., and Karen Kindsey. 1995. *Dr. Susan Love's Breast Book*. Reading, MA: Addison-Wesley.

Mainsbridge, Jane. 1995. "What is the Feminist Movement?" In *Feminist Organizations: Harvest of the New Women's Movements*. Edited by Myra Marx Ferree and Patricia Yancey Martin. Philadelphia: Temple University Press. 27–34.

Marieskind, Helen. 1975. "Restructuring Ob-Gyn." *Social Policy* 6 (September–October): 48–49.

Martin, Del. 1976. *Battered Wives*. San Francisco: Glide Publications.

McAfee, Robert. 1993. Statement of Dr. Robert McAfee. Senate Hearing 103–878, 12 November 1993. Hearing before the Committee on the Judiciary, United States Senate, 103rd Congress, First Session on Examining the Rise of Violence Against Women in the State of Maine and in Other Rural Areas. Serial No. J-103–36. http://womhist.binghamton.edu/vawa/doc9.htm.

McGlen, Nancy E., Karen O'Connor, Laura van Assendelft, and Wendy Gunther-Canada. 2005. *Women, Politics, and American Society*. 4th ed. New York: Pearson Longman.

McLeer, S. V. 1989. "Education Is Not Enough: A Systems Failure in Protecting Battered Women." *Annals of Emergency Medicine* 18: 651–53.

Meisler, Jodi G. 1998. "New Drugs in Development Targeted to Women's Health." *Journal of Women's Health* 7, 1: 93–117.

Mertus, Julie, with Nancy Flowers and Mallika Dutt, eds. 1999. *Local Action Global Change: Learning about the Human Rights of Women and Girls*. UNIFEM and the Center for Women's Global Leadership.

Meyer, David S. 2003. "Restating the Question: Women's Movements and State Re-

structuring." In *Women's Movements Facing the Reconfigured State*. Edited by Lee Ann Banaszak, Karen Beckwith, and Dieter Rucht. New York: Cambridge University Press. 275–94.

————. 2004. "Protest and Political Opportunities." *Annual Review of Sociology* 30: 125–45.

————. 2005. "Introduction: Social Movements and Public Policy: Eggs, Chicken, and Theory." In *Routing the Oppression: Social Movements, Public Policy, and Democracy*. Edited by David S. Meyer, Valerie Jenness, and Helen Ingram. Minneapolis: University of Minnesota Press. 1–26.

Meyer, David S., Valerie Jenness, and Helen Ingram, eds. 2005. *Routing the Oppression: Social Movements, Public Policy, and Democracy*. Minneapolis: University of Minnesota Press.

Meyer, H. 1992. "The Billion Dollar Epidemic." *American Medical News*, January 6.

Mollioris, Tony and Gary Kleinman. 1990. "Final Hour: Storm the NIH." (Rap song on tape "Actions.")

Moreno, Jonathan. 1994. "Ethical Issues Related to the Inclusion of Women of Childbearing Age in Clinical Trials." In Institute of Medicine, Division of Health Sciences Policy. Committee on the Ethical and Legal Issues Relating to the Inclusion of Women in Clinical Studies, *Women and Health Research*, vol. 2, edited by Anna Mastroianni, Ruth Faden, and Daniel Federman. Washington, DC: National Academy.

Morgen, Sandra. 2002. *Into Our Own Hands: The Women's Health Movement in the United States, 1969–1990*. New Brunswick, NJ: Rutgers University Press.

Morrison, Toni, ed. 1983. *Race-ing Justice, En-gendering Power: Essays on Anita Hill, Clarence Thomas the Construction of Social Reality*. New York: Pantheon Books.

Moss, Kathy L., ed. 1996. *Man-Made Medicine: Women's Health, Public Policy, and Reform*. Durham, NC: Duke University.

Mueller, Keith. 1993. *Health Care Policy in the United States*. Lincoln: University of Nebraska.

Muller, Charlotte. 1990. *Health Care and Gender*. New York: Russell Sage Foundation.

Myhre, Jennifer. 1999. "The Breast Cancer Movement: Seeing Beyond Consumer Activism." *JAMWA* 54, 1 (Winter): 29–30, 33.

National Breast Cancer Coalition (NBCC). 1993. *National Breast Cancer Coalition: A Grassroots Advocacy Effort, Annual Report 1991–1993*. Washington, DC

————. 2006. "NBCC—History, Goals, and Accomplishments." http://www.natlbcc .org/bin/index.asp?strid=22&depid=1&btnid=1.

National Center for Injury Prevention and Control. 2003. "Costs of Intimate Partner Violence Against Women in the United States." Atlanta, GA: Centers for Disease Control and Prevention.

Navarro, Mireya. 1991. "AIDS Definition is Widened to Include Blood Cell Count." *New York Times*. August 8, p. D21.

Nechas, Eileen, and Denise Foley, eds. 1994. *Unequal Treatment*. New York: Simon and Schuster.

NIH Revitalization Act. 1993. Pub. L. No 103–43, sec. 131, sec. 492[B][a], 107 Stat. 122).

Norsigian, Judy. 1994. "Women and National Health Care Reform: A Progressive Feminist Agenda." In *Reframing Women's Health*. Edited by Alice J. Dan. Thousand Oaks, CA: Sage Publications. 111–17.

———. 1996. "The Women's Health Movement in the United States." In *Man-Made Medicine: Women's Health, Public Policy, and Reform*. Edited by Kathy L. Moss. Durham, NC: Duke University Press. 79–97.

Norwood, Chris. 1988. "Alarming Rise in Deaths: Are Women Showing New 'AIDS' Symptoms?" *Ms.* (July), 65–66.

Nourse, Victoria F. 1996. "Where Violence, Relationship, and Equality Meet: The Violence Against Women Act's Civil Rights Remedy." *Wisconsin Women's Law Journal* 11 (Summer): 1–36.

Olson, Amanda. 2005. "A Narrative Construction of Breast Cancer: A Comparative Case Study of the Susan G. Komen Foundation and National Breast Cancer Coalitions Campaign Strategies, Messages and Effects." Ph.D. Dissertation, College of Communication, Ohio University.

O'Neill, Cliff. 1990a. "Demonstrators Rain Fire and Brimstone on NIH Headquarters: Action Provokes More Than 80 Arrests." *Outweek* (June 6): 14–16.

———. 1990b. "Arrests in AIDS Protest at Centers for Disease Control: Demo Demands Wider Definition of AIDS." *Outweek* (January 21): 18–19, 30.

Overton, Spencer. 2002. "But Some are More Equal: Race, Exclusion, and Campaign Finance." *Texas Law Review* 80 (April): 987–1056.

Palca, Joseph. 1990. "Women Left Out at NIH." *Science* 248, 4963 (June 29): 1601–2.

Patterson, James. 1987. *The Dread Disease*. Cambridge: Harvard University Press.

Patton, Cindy. 1990. "Why We Can't Get Women and AIDS on the Agenda" (with subsections: "Women as Vaginas" and "Women as Uteruses"). *Z Magazine* (December): 99–103.

Pharmaceutical Manufacturer's Association (PMA). 1991. *New Medicines in Development for Women*. Washington, DC.

Pies, Cheryl. 1994. "AIDS, Ethics, Reproductive Rights: No Easy Answers." In *Women Resisting AIDS: Feminist Strategies of Empowerment*. Edited by Beth Schneider and Nancy Stoller. Philadelphia: Temple University Press. 322–44.

Pleck, Elizabeth. 1987. *Domestic Tyranny: The Making of American Social Policy against Family Violence from Colonial Times to the Present*. New York: Oxford University Press.

Primer, Lesley. 1998. Personal Interview. March 26, with Karen Baird.

Radford, Jill, and Diana E. H. Russell, eds. *Femicide: The Politics of Woman Killing*. New York: Twayne.

Rapping, Elayne. 1994. *Media-tions: Forays into the Culture and Gender Wars*. Boston: South End Press.

Reyes, Nina. 1991. "AIDS Activists Slam CDC's Proposed New AIDS Definition." *NYQ* (December 8): 18.

Richie, Beth, and Valli Kanuha. 1993. "Battered Women of Color in Public Health Care Systems: Racism, Sexism, and Violence." In *Wings of Gauze: Women of Color and the experience of Health and Illness*. Edited by Barbara Bair and Susan E. Cayleff. Detroit: Wayne State University Press. 288–99.

Ries, L. A. B., B. A. Miller, B. F. Hankey, C. L. Kosary, A. Harras, and B. K. Edwards, eds. 1994. *SEER Cancer Statistics Review, 1973 ± 1991: Tables and Graphs.* NIH Publication No. 94–2789, National Cancer Institute, Bethesda, MD, as cited in Lantz, Paula and Karen Booth. 1998. "The Social Construction of the Breast Cancer Epidemic." *Social Science & Medicine* 46, 7: 907–18.

Rochefort, David A., and Roger W. Cobb. 1994. "Problem Definition: An Emerging Perspective." In *The Politics of Problem Definition: Shaping the Policy Agenda.* Edited by David A. Rochefort and Roger W. Cobb. Lawrence: University Press of Kansas. 1–31.

Rodriquez-Trias, Helen. 1984. "The Women's Health Movement: Women Take Power." In *Reforming Medicine: Lessons of the Last Quarter Century.* Edited by Victor W. Sidel and Ruth Sidel, New York: Pantheon. 107–26.

Rossi, C. 1998. "*Cosmo* Confessions: When the Plague Stepped into HGB's Parlor." *POZ* (June).

Rosser, Sue V. 1994. "Gender Bias in Clinical Research: The Difference It Makes." In *Reframing Women's Health.* Edited by Alice J. Dan. Thousand Oaks, CA: Sage Publications. 253–65.

Roth, Nancy, and Linda K. Fuller, eds. 1998. *Women and AIDS: Negotiating Safer Practices, Care, and Representation.* New York: Haworth.

Rothenberg, Karen. 1996. "Gender Matters: Implications for Clinical Research and Women in Health Care." *Houston Law Review* 32, 5:121–72.

Russell, Diana. 1982. *Rape in Marriage.* New York: McMillan.

Russo, Vito. 1998. "Why We Fight," Speech given at ACT UP demonstration in Albany, NY. May 9.

Ruzek, Sheryl Burt. 1978. *The Women's Health Movement: Feminist Alternatives to Medical Control.* New York: Praeger.

Ruzek, Sheryl, and Julie Becker. 1999. "The Women's Health Movement in the United States: From Grassroots Activism to Professional Agendas." *Journal of American Medical Women's Association* 54, 1: 4–8, 40.

Sabatier, Paul A., ed. 1999. *Theories of the Policy Process.* Boulder, CO: Westview Press.

Sabatier, Paul A., and Hank C. Jenkins-Smith. 1993. *Policy Change and Learning: An Advocacy Coalition Approach.* Boulder, CO: Westview Press.

———. 1999. "The Advocacy Coalition Framework: An Assessment." In *Theories of the Policy Process.* Edited by Paul A. Sabatier. Boulder, CO: Westview Press. 117–68.

Sacco, William, Richard Rickman, Karla Thompson, Brian Levine, and David Reed. 1993. "Gender Differences in AIDS-Relevant Condom Attitudes and Condom Use." *AIDS Education and Prevention* 5, 4: 311–26.

Santoro, Wayne A., and Gail M. McGuire. 1997. "Social Movement Insiders: The Impact of Institutional Activists on Affirmative Action and Comparable Worth Policies." *Social Problems* 44, 4: 503–20.

Schattschneider, E. E. 1960. *The Semi-sovereign People: A Realist's View of Democracy in America.* New York: Holt, Rinehart and Winston.

Schechter, Susan. 1982. *Women and Male Violence: The Visions and Struggles of the Battered Women's Movement.* Boston: South End Press.

Schiebinger, Londa. 2003. "Women's Health and Clinical Trials." *Journal of Clinical Investigations* 112, 7 (October): 973–77.

Schneider, Anne, and Helen Ingram. 1993. "Social Construction of Target Populations." *American Political Science Review* 87, 2: 334–47.

———. 1997. *Policy Design for Democracy.* Lawrence: University of Kansas Press.

Schneider, Beth, and Nancy Stoller. 1994, 1995. *Women Resisting AIDS: Feminist Strategies of Empowerment* Philadelphia: Temple University Press.

Schneider, Elizabeth M. 1994. "The Violence of Privacy." In *The Public Nature of Private Violence: The Discovery of Domestic Abuse.* Edited by Martha Albertson Fineman and Roxanne Mykitiuk. New York: Routledge. 36–58.

Schroeder, Patricia, and Olympia Snowe. 1994. "The Politics of Women's Health." In *The American Woman: 1994–95, Where We Stand, Women and Health.* Edited by Cynthia Costello and Anne Stone (WREI). New York: W. W. Norton. 91–108.

Schur, Edwin M. 1983. *Labeling Women Deviant.* Philadelphia: Temple University Press.

Sewell, Bernadette Dunn. 1989. "History of Abuse: Societal, Judicial, and Legislative Responses to the Problem of Wife Beating," *Suffolk University Law Review* 23: 983–1017.

Sherwin, Sue. 1992. *No Longer Patient: Feminist Ethics and Health Care.* Philadelphia: Temple University Press.

———. 1994. "Women in Clinical Studies: A Feminist View." In Institute of Medicine, Division of Health Sciences Policy, Committee on the Ethical and Legal Issues Relating to the Inclusion of Women in Clinical Studies. *Women and Health Research,* Vol. 2. Edited by Anna Mastroianni, Ruth Faden, and Daniel Federman. Washington, DC: National Academy.

Shivji, Issa G. 2000. "Contradictory Perspectives on Rights and Justice in the Context of Land Tenure Reform in Tanzania." In *Beyond Rights Talk and Culture Talk: Comparative Essays on Political Rights and Culture.* Edited by Mahmood Mamdani. Cape Town, South Africa: David Philip Publishers. 37–60.

Sidel, Victor W., and Ruth Sidel, eds. 1984. *Reforming Medicine: Lessons of the Last Quarter Century.* New York: Pantheon.

Silva, Nanette. 1994. "Toward a Feminist Methodology in Research on battered Women." In *Reframing Women's Health: Multidisciplinary Research and Practice.* Edited by Alice J. Dan. Thousand Oaks, CA: Sage Publications. 290–98.

Simmons, Janie, Paul Farmer, and Brooks Schoepf. 1996. "A Global Perspective." In *Women, Poverty, and AIDS: Sex, Drugs, and Structural Violence.* Edited by Paul Farmer, Margaret Connors, and Janie Simmons. Monroe, ME: Common Courage Press. 39–90.

Skocpol, Theda. 1996. *Boomerang: Clinton's Health Security Effort and the Turn Against Government in U.S. Politics.* New York: W.W. Norton.

Smith, John M. 1992. *Women and Doctors.* New York: Atlantic Monthly.

Sollom, Terry. 1997. "State Actions on Reproductive Health Issues in 1996." *Family Planning Perspectives* 29, 1: 35–40.

Sonder, Ben. 1995. *Epidemic of Silence: The Facts About Women and AIDS (Women Then — Women Now).* London: Franklin Watts.

Stabiner. Karen, 1997. *To Dance with the Devil: The New War on Breast Cancer; Politics, Power, People.* New York: Delacorte.

Stacey, Margaret. 1985. "Women and Health: The United States and the United Kingdom Compared." In *Women, Health and Healing.* Edited by Ellen Lewin and Virginia Olsen. New York: Tavistock.

Stark, Evan 1990. "Rethinking Homicide: Violence, Race and the Politics of Gender." *International Journal of Health Services,* 20 (1): 3–26.

Stark, Evan, and Anne H. Flitcraft 1991. "Spouse Abuse." In *Violence in America: A Public Health Approach.* eds. Edited by Mark L. Rosenberg and Mary Ann Fenley. 123–57. New York: Oxford University Press.

Stark, Evan., Anne H. Flitcraft, and William Frazier. 1979. "Medicine and Patriarchal Violence: The Social Construction of a 'Private' Event." *International Journal of Health Services* 9: 461–92.

Starr, Paul. 1982. *The Social Transformation of American Medicine.* New York: Penguin.

———. 1994, 1992. *The Logic of Health Care Reform.* New York: Penguin.

Steinbock, Bonnie. 1994. "Ethical Issues Related to the Inclusion of Pregnant Women in Clinical Trials (II)." In Institute of Medicine, Division of Health Sciences Policy, Committee on the Ethical and Legal Issues Relating to the Inclusion of Women in Clinical Studies. *Women and Health Research,* Vol. 2. Edited by Annd Mastroianni, Ruth Faden, and Daniel Federman. Washington, DC: National Academy.

Steinmetz, Suzanne K. 1977. *The Cycle of Violence: Assertive, Aggressive, and Abusive Family Interaction.* New York: Praeger.

Stolberg, Sheryl Gay. 1997. "Many Women Wary of Congress's Newfound Interest in Female Health Issues." *New York Times,* May 26: A9.

Stoller, Nancy. 1998. *Lessons from the Damned: Queers, Whores, and Junkies Respond to AIDS.* New York: Routledge.

Stone, Deborah. 1988. *Policy Paradox and Political Reason.* New York: HarperCollins.

———. 1997. *Policy Paradox: The Art of Political Decisionmaking.* New York: W. W. Norton.

Straus, Murray A. 1976. "Sexual Inequality, Cultural Norms, and Wife-beating." *Victimology* I: 54–76.

———. 1978. "Wife Beating: Causes, Treatment, and Research Needs." In *U.S. Commission on Civil Rights, Battered Women: Issues of Public Policy.* Washington, DC: U.S. Commission on Civil Rights.

Straus, Murray A., Richard J. Gelles, and Suzanne K. Steinmetz. 1980. *Behind Closed Doors: Violence in the American Family.* Garden City, NY: Anchor Press/Doubleday.

Surgeon General's Workshop, 1986. "Recommendations on Spouse Abuse." *Response to the Victimization of Women and Children* 9, 10: 19–21.

Tarrow, Sidney. 1998. *Power in Movement: Social Movements and Contentious Politics.* 2nd ed. New York: Cambridge University Press.

Taylor, Humphrey. 1999. "Perceptions of Risks: The Public Overestimates the Risk of Major Diseases and Types of Accidents—Breast and Prostate Cancer in Particular." Harris Poll Release, January 27.

Theodolu, Stella Z. 1996. *AIDS: The Politics and Policy of Disease.* Upper Saddle River, NJ: Prentice Hall.

Tjaden, Patricia, and Nancy Thoennes. 2000a. "Extent, Nature, and Consequences of Intimate Partner Violence." Washington, DC: National Institute of Justice and the Centers for Disease Control. July, NCJ 181867.

———. 2000b. "Full Report of the Prevalence, Incidence, and Consequences of Violence Against Women." Washington, DC: National Institute of Justice and the Centers for Disease Control and Prevention. November. NCJ 183781.

Tyson, Ann Scott. 1998. "Another Day, Another 75 Cents." *Christian Science Monitor* (July 17): 7.

U.S. Bureau of the Census. 1996a. *Statistical Abstract of the United States: 1996.* http://www.census.gov/prod/2/gen/96statab/income.pdf.

———. 1996b. "Health Insurance Coverage 1995." http://www.census.gov/hhes/www/hlthins/cover95/c95tabb.html.

U.S. Congress. House. Human Resources and Intergovernmental Relations Subcommittee. Committee on Government Operations. 1993. *Standard Health Benefits: The Impact on Women's Health.* 103rd Congress, 1st Session, October 15. Washington, DC: U.S. Government Printing Office.

U.S. Congress. House. Select Committee on Children, Youth, and Families. 1992. *Health Care Reform: How Do Women, Children, and Teens Fare? Fact Sheet.* 103rd Congress, 1st Session, May 5. Washington, DC: U.S. Government Printing Office.

U.S. Congress. House. Subcommittee on Health. Committee on Ways and Means. 1993a. *Health Care Reform: Consideration of Benefits for Inclusion in a Standard Health Benefit Package.* 103rd Congress, 1st Session, March 30. Washington, DC: U.S. Government Printing Office.

———. 1993b. *Health Care Reform: Current Trends in Health Care Costs and Health Insurance Coverage.* 103rd Congress, 1st Session, January 26. Washington, DC: U.S. Government Printing Office.

———. 1993c. *Health Care Reform: Expansion of Medicare Benefits to Include Prescription Drugs.* 103rd Congress, 1st Session, June 22. Washington, DC: U.S. Government Printing Office.

U.S. Congress. House. Subcommittee on Housing and Consumer Interests. Select Committee on Aging. 1990. *Women Health Care Consumers: Short-Changed on Medical Research and Treatment.* 101st Congress, 2nd Session, July 24. Washington, DC: U.S. Government Printing Office.

U.S. Congress. Senate. Committee on Finance. 1994a. *Health Care Benefits Package.* 103rd Congress, 2nd Session, March 3. Washington, DC: U.S. Government Printing Office.

———. 1994b. *Long-term Care and Drug Benefits Under Health Care Reform.* 103rd Congress, 2nd Session, April 19. Washington, DC: U.S. Government Printing Office.

U.S. Congress. Senate. Subcommittee on Aging. Committee on Labor and Human Resources. 1994. *Women's Health Care in the President's Health Care Plan.* 103rd Congress, 2nd Session, March 9. Washington, DC: U.S. Government Printing Office.

U.S. Dept. of Health and Human Services (DHHS) & U.S. Department of Justice (DoJ). 1986, October 27–29, 1985. *Proceedings of the Surgeon General's Workshop on Violence and Public Health.* Surgeon General's Workshop on Violence and Public

Health. Washington, DC: Health Resources and Services Administration (HRSA), U.S. Public Health Service, U.S. Department of Health and Human Services.

U.S. Dept. of Health and Human Services (DHHS). Food and Drug Administration (FDA). 1993. "Guideline for the Study and Evaluation of Gender Differences in the Clinical Evaluation of Drugs." *Federal Register* 58, 139 (July 22): 39406–416.

U.S. Dept. of Health and Human Services (DHHS). Food and Drug Administration (FDA). 1998. "FDAMA Women and Minorities Working Group Report." July 20. http://www.fda.gov/cder/guidance/women.pdf.

U.S. Dept. of Health and Human Services (DHHS). Food and Drug Administration (FDA). 2000. "Investigational New Drug Applications; Amendment to Clinical Hold Regulations for Products Intended for Life-Threatening Diseases and Conditions." *Federal Register* 65, 106 (June 1): 34963–971.

U.S. Dept. of Health and Human Services (DHHS). National Institutes of Health (NIH). 1994a. "NIH Guidelines on the Inclusion of Women and Minorities as Subjects in Clinical Research." *Federal Register* 59, 59 (March 28): 14508–513.

———. 1994b. "Outreach Notebook for the NIH Guidelines on Inclusion of Women and Minorities as Subjects in Clinical Research" (August). Bethesda, MD: NIH.

U.S. Dept. of Health and Human Services (DHHS). National Institutes of Health (NIH). National Cancer Institute (NCI). 1996. "NCI Fact Book."

———. 2000. "NCI Fact Book."

———. 2003. "Monitoring Adherence to the NIH Policy on the Inclusion of Women and Minorities as Subjects in Clinical Research. Comprehensive Report: Tracking of Human Subjects Research Funded in Fiscal Year 2000 (Reported in FY 2000) and Fiscal Year 2001 (Reported in FY 2002)." http://orwh.od.nih.gov/inclusion/GoldReport_2000–01.pdf.

———. 2005. "NCI Fact Book."

———. 2006. "Monitoring Adherence to the NIH Policy on the Inclusion of Women and Minorities as Subjects in Clinical Research. Comprehensive Report: Tracking of Human Subjects Research As Reported in Fiscal Year 2004 and Fiscal Year 2005." http://orwh.od.nih.gov/inclusion/ar_2004–2005–11–30–06.pdf.

U.S. Dept. of Health and Human Services (DHHS). National Institutes of Health (NIH). Office of Research on Women's Health (ORWH). 1992. *Report of the National Institutes of Health: Opportunities for Research on Women's Health.* September. Bethesda, MD: NIH. NIH Publication No. 92–3457.

U.S. Dept. of Health and Human Services (DHHS). Public Health Service (PHS). 1985. *Report of the Public Health Service Task Force on Women's Health Issues, Volumes I and II.* May. Hyattsville, MD: PHS. DHHS Pub. No. (PHS):85–50206.

U.S. Dept. of Health and Human Services (DHHS). Public Health Service (PHS). Health Resources and Services Administration. 1990. *Health Status and the Disadvantaged.* Hyattsville, MD: PHS. DHHS Pub. No. (HRSA) HRS-P-DV 90–1.

U.S. Dept. of Health and Human Services (DHHS). Public Health Service (PHS). National Center for Health Statistics. 1993. *Health, United States, 1992.* Hyattsville, MD: PHS. DHHS Pub. No. (PHS) 93–1232.

U.S. Dept. of Health, Education, and Welfare (DHEW). Public Health Service. Food

and Drug Administration. 1977. *General Considerations for the Clinical Evaluation of Drugs.* Washington, DC. HEW/FDA-77-3040.

U.S. Dept. of Labor (DOL). U.S. Bureau of Labor Statistics, 2006. *Highlights of Women's Earnings in 2005.* September. Report 995.

U.S. General Accounting Office (renamed Government Accountability Office, GAO). 1990. "National Institutes of Health: Problems in Implementing Policy on Women in Study Populations." Testimony of Mark Nadel before the Subcommittee on Health and the Environment, Committee on Energy and Commerce, House of Representatives. Washington, DC: Government Printing Office, GAO/T-HRD-90-50.

———. 1992. *Women's Health. FDA Needs to Ensure More Study of Gender Differences in Prescription Drug Testing.* October. GAO/HRD-93-17.

———. 2001. *Women's Health. Women Sufficiently Represented in New Drug Testing, but FDA Oversight Needs Improvement.* July. GAO-01-754.

———. 2003. *Breast Cancer Research Stamp, Effective Fund-Raiser, but Better Reporting and Cost-Recovery Criteria Needed.* September. GAO-03-1021.

———. 2005. *U.S. Postal Service. Factors affecting Fund-Raising Stamp Suggest Lessons Learned.* September. GAO-05-953.

Van Willigen, Marieke. Nd. "Ideology, Collective Identity, and Activist Strategies in the Breast Cancer Movement: Reconceptualizing the Sick Role." http://garnet.acns.fsu.edu/~jreynold/bcactivism.pdf.

Wallis, Lila A. 1994. "Why a Curriculum on Women's Health?" In *Reframing Women's Health.* Edited by Alice J. Dan. Thousand Oaks, CA: Sage Publications. 13-26.

Warshaw, Carol. 1989. "Limitations of the Medical Model in the Care of Battered Women." *Gender and Society* 3, 4: 506-17.

———. 1994. "Domestic Violence: Challenges to Medical Practices." In *Reframing Women's Health: Multidisciplinary Research and Practice.* Edited by Alice J. Dan. Thousand Oaks, CA: Sage Publications. 201-18.

Weeks, Margaret, Jean Schensul, Sunyna Williams, Merrill Singer, and Maryland Grier. 1995. "AIDS Prevention for African-American and Latina Women: Building Culturally and Gender-Appropriate Interventions." *AIDS Education and Prevention* 7, 3: 251-63.

Weijer, Charles. 1995. "Reviews: Our Bodies, Our Science." *The Sciences* (May/June): 41-45.

Weisman, Carol S. 2000. "Breast Cancer Policymaking." In *Breast Cancer: Society Shapes an Epidemic.* Edited by Anne S. Kasper and Susan J. Ferguson. New York: St. Martin's. xx.

———. 1998. *Woman's Health Care: Activist Traditions and Institutional Change.* Baltimore: Johns Hopkins University Press.

Wermeling, D. P., and A. S. Selwitz. 1993. "Current Issues Surrounding Women and Minorities in Drug Trials." *The Annals of Pharmacotherapy* 27, 7: 904-11.

White House Domestic Policy Council. 1993. *The President's Report to the American People.* New York: Touchstone.

White, Evelyn, ed. 1990. *The Black Women's Health Book.* Seattle, WA: Seal.

Wierga D. E. and C. Eaton. 1993. "The Drug Development and Approval Process." In

In Development: New Medicines for Older Americans. Washington, DC.: Pharmaceutical Manufacturers Association.

Wilcox, Clyde. 1994. "Why Was 1992 the 'Year of the Woman'? Explaining Women's Gains in 1992." In *The Year of the Woman: Myths and Realities.* Edited by Elizabeth Adell Cook, Sue Thomas, and Clyde Wilcox. Boulder, CO: Westview Press. 1–24.

Wilson, Scott, and Brenda Lein. 1992. "HIV Disease in Women." *Treatment Issues: GMHC Newsletter of Experimental AIDS Therapies* (Summer/Fall): 1–6.

Wolf, Susan M., ed. 1996. *Feminism & Bioethics.* New York: Oxford University Press.

Woliver, Laura. 2002. "Book Review: Faithful and Fearless: Moving Feminist Protest Inside the Church and the Military." *American Political Science Review* 96, 1 (March): 212.

Women's Law Project and Pennsylvania Coalition Against Domestic Violence. 2002. "FYI: Insurance Discrimination Against Victims of domestic Violence, 2002 Supplement." http://www.womenslawproject.org/brochures/InsuranceSup_DV2002.pdf.

Women's Policy, Inc. 1997. "Women's Health Legislation in the 105th Congress." Washington, DC: Women's Policy, Inc.

———. 1996. "The Women's Health Equity Act of 1996: Legislative Summary and Overview." Washington, DC: Women's Policy, Inc.

Wyatt, G. E. 1991. "Ethnic, and Cultural Differences in Women's Sexual Behavior?" In *Women and AIDS: Promoting Health Behaviors.* Edited by S. Blumenthal, E. Erlich, and G. Weissman. Washington, DC: DHHS.

Zimmerman, B. et al. 1980. "People's Science." In *Science and Liberation.* Edited by R. Aditta and S. Cavarak. Boston: South End Press.

Zinn, Maxine Baca, Pierrette Hondagneu-Sotelo, and Michael A. Messner, eds. 2000. *Gender through the Prism of Difference.* 2nd ed. Upper Saddle River, NJ: Allyn & Bacon. 129–37.

Authors

KAREN L. BAIRD, PhD, is Associate Professor of Political Science and Women's Studies at Purchase College, State University of New York, where she is also Chair of the Political Science Program and past Coordinator of the Women Studies program. She is the author of *Gender Justice and the Health Care System* (1998), "The New FDA and NIH Medical Research Policies: Targeting Gender, Promoting Justice" (*Journal of Health Politics, Policy and Law*, 1999), and "Globalizing Reproductive Control: Consequences of the Global Gag Rule" in *Linking Visions* (2004). She also engages in research on women's international health issues, primarily women and HIV/AIDS in Sub-Saharan Africa, and has published "Carrying the World on Her Back: Reproductive Health, HIV/AIDS, and Women's Rights" in *Women and Politics Around the World* (ABC-CLIO, 2009). Her research has been supported by the American Association of University Women (AAUW), the National Science Foundation (NSF), and various other organizations. Baird has recently been researching HIV/AIDS policies and women of color in the U.S. and is a member of the New York City HIV Prevention Planning Group (PPG), and the Interventions Behavioral Science Committee, a working group of the PPG.

KIMBERLY CHRISTENSEN, PhD, is Associate Professor of Economics and Women's Studies at Purchase College, State University of New York, and the immediate past Coordinator of Purchase College's Women's Studies/LGBT Studies Program. Her latest research ("Campaign Finance and Electoral Reform: A Feminist Economics Perspective," *Buffalo Public Interest Law Journal*) focuses on the intersection of money and politics; namely, the economic impact of current and proposed schemes for reform of the campaign finance system. Her other publications include "'With Whom Do You Believe Your Lot is Cast?' White Feminists and Racism" (*Signs*, 1997), several pieces on welfare "reform," and articles that examine the economic context for, and implications of, the HIV/AIDS crisis. Christensen was a member of the ACT

UP/NY editorial collective that wrote and produced *Women, AIDS &
Activism* (1990), the first comprehensive treatment of women in the
AIDS crisis. She is the recipient of the SUNY Chancellor's Award for
Distinguished Teaching and the Purchase College President's Award
for Innovative Pedagogy. Christensen is also a member of the Board of
Directors of CLAGS (The Committee for Lesbian and Gay Studies) at
the CUNY Graduate Center, the Vice-President of the NYC Branch of
the Ehlers-Danlos National Foundation, and the founder of the NYC
chapter of IAFFE (the International Association for Feminist Eco-
nomics).

DANA-AIN DAVIS, PhD, is Associate Professor of Urban Studies at
Queens College, City University of New York. She is also Associate
Chair of Worker Education at the Queens College Extension Center,
Joseph Murphy Institute. Her research areas include: Domestic Vio-
lence, Urban Anthropology, Black Feminist Theory, Poverty Policy,
HIV/AIDS issues and Reproductive Health. Geographically, her work
is conducted in the United States and Namibia. She is the author of
several articles on poverty policy and the book *Battered Black Women and
Welfare Reform: Between a Rock and a Hard Place* (2006). Dana-Ain Davis
is also Board Chair of the New York Foundation and works with the
Adco Foundation, both of which provide grants to community-based
groups in New York City. Davis is president of the Association of Black
Anthropologists and has served on the board of the Association of Fem-
inist Anthropologists and was previously program chair for the Society
for the Anthropology of North America.

Index

abortion: *Carhart v. Gonzales*, 124–25; de-
nial of (military), 124; legalizing, 11–
12, 37; Partial-Birth Abortion Ban Act
(2003), 124–25; *Planned Parenthood of
Southeastern Pa. v. Casey*, 124; restric-
tions on, 124; *Roe v. Wade*, 12, 37,
124–25; South Dakota and, 124
abstinence sex education, 124
ACT UP/ACT UP NY: on access to
AIDS drugs, 67–68; accomplishments
of, 69; on AIDS and inequality, 70–71;
clinical AIDS drugs trials and, 67–69;
commitment of, 70; Dan Rather on, 63;
direct democracy and, 72–73; early
demonstrations of, 63; factors contrib-
uting to success of, 69–73; formation of,
62–63; "Invisible Women" affinity
group, 69; MAC/WAC demands in, 68,
69; makeup of, 72; meeting with Berna-
dine Healy, 69; Mollioris/Kleinman rap
song of, 71, 73; Office of Research on
Women's Health (ORWH), 69; protest
at FDA, 67–68; protest at NIH, 68;
protest of T cell definition, 65–66; re-
sponse to HIV/AIDS, 55, 62–67; Terry
McGovern of, 65; Treatment and Data
Committee (T&D) of, 72; use of media,
71; Women's Caucus (WAC) and, 68
activist breast cancer groups, 30–31
agenda setting, defined, 22
American Cancer Society's "Reach to Re-
covery" Program, 79
American Civil Liberties Union (ACLU),
64, 125
American College of Clinical Pharmacy
(ACCP), 48
American College of Obstetricians and
Gynecologists (ACOG), 38, 102, 111,
124

American Medical Association (AMA),
111
American Medical Women's Association
(AMWA), 38, 111
American Nurses Association (ANA), 38
American Psychiatric Association (APA),
38
American Society for the Control of Can-
cer, 78

Banaszak, Lee Ann (2003), 122, 133
Banaszak, Lee Ann (2005), 17, 115, 133
Batt, Sharon: on breast cancer, 84, 133;
on breast cancer activism, 87
Becker, Julie (1999), 20, 143
Becker, Julie: on 1960s grass-roots
groups, 18
Beckwith, Karen (2003), 122, 133
Beckwith, Karen (2007), 115–16, 133
Biden, Senator Joseph, 17, 116, 118
birthing methods, 11
bisexuality, 57, 75
Black, Shirley Temple, 78
Black Women's Health Imperative, 125
Blackstone, Amy: on the Komen Founda-
tion, 81, 134
Boehmer, Ulrike on women's movements,
13, 134
Born Alive Fetus Protection Act, 124
Boston Women's Health Collective, 11,
18, 38, 134
breast cancer: activist breast cancer
groups, 30–31; American Cancer Soci-
ety's "Reach to Recovery" Program,
79; breast cancer stamp, 22; Breast
PAC, 80; Carol Weisman on, 80; "cold-
war dividend" and, 25–26, 31; cost of,